Fashion Artist

Drawing Techniques to Portfolio Presentation

Third Edition

WITHDRAWN

Sandra Burke

fashionbooks.info

D1406479

Fashion Artist - *Drawing Techniques to Portfolio Presentation* (3rd Edition)

Burke, Sandra

ISBN: 978-0-9582733-8-1

Third Edition:	**2013**
Second Edition:	2006
First Published:	2003

Copyright ©:	Burke Publishing
	Email: sandra@burkepublishing.com
	Website: www.fashionbooks.info
	Website: www.knowledgezone.net
	Website: www.burkepublishing.com
DTP:	Sandra Burke
Cover Images:	Fashion Illustrations (front and back cover) - Karen Scheetz
	Dress Forms - Frances Howie
Cover Design:	Simon Larkin
Printed:	Everbest, China

English (UK) and English (US) spelling: In keeping with global technology the spelling of *color* is consistent. The UK spelling is *colour*.

Production Notes: Pages Size: 210x297mm, 8.3" x 11.7"

ISBN: 978-0-9582733-8-1

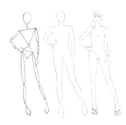

Dedication........_to my husband and skipper, Rory, who inspired me to write_
Fashion Artist, and has project managed me through the complete process yet
again. And to my parents who supported and encouraged me to join the world of
fashion and gave me the education I needed to get there.

PROM0**STYL** TENDANCES FORMES HIVER

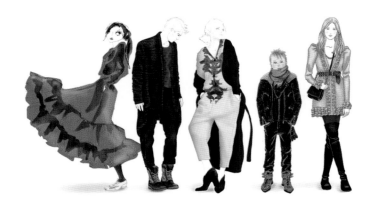

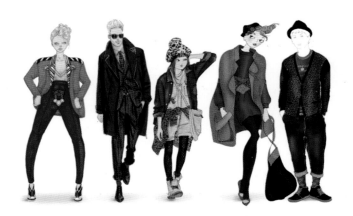

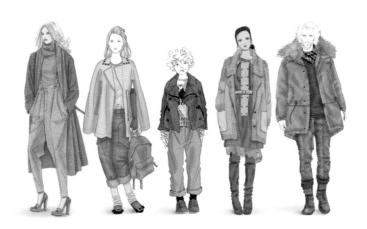

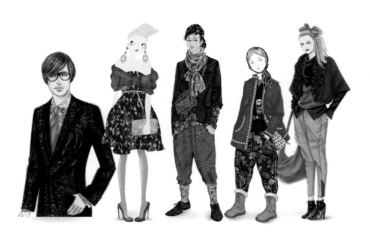

Above, Courtesy of **PROMOSTYL Paris,** international trend forecasting agency,
a selection line up from their Womens, Mens and Kids Winter Trends book.

Contents

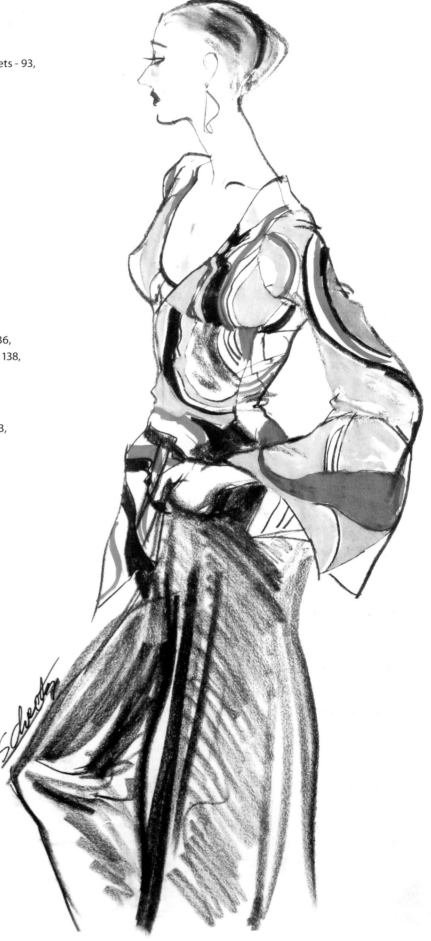

Illustration: Karen Scheetz

Authors Note

Many of us dream about becoming a famous fashion designer with all the glamour, lights and panache that it entails. Names like Chanel, Dior and Dolce & Gabbana conjure up images of stunning models strutting down the fashion runways at the London, Paris, Milan and New York fashion shows in the most amazing creations. Fashion trends and celebrity shots on the net and in glossy fashion magazines, and street fashion also inspire our desire to be creative. However, if you wish to bridge the gap between fantasy and reality, you will need to learn how to draw professionally - an integral part of a fashion designer's portfolio of skills.

Fashion Artist - *Drawing Techniques to Portfolio Presentation* has been designed as a self-teaching book both for the novice and those who wish to enhance their fashion drawing and fashion design skills and communicate their designs ideas on paper and digitally as part of the fashion design process. *Fashion Artist* presents the fundamentals of fashion drawing and fashion design. It progressively guides you through a comprehensive set of fashion drawing and presentation techniques, an integral part of this is the development of several popular fashion poses which become your fashion templates. Starting with very basic and simplistic shapes to create your fashion figure drawings, you will quickly progress along the learning curve to produce visually exciting illustrations and a professional fashion design portfolio - the passport to your career. The text is supported with explanatory drawings and photographs to clearly demonstrate the simple, step-by-step drawing techniques, together with plenty of drawing exercises and examples, and inspiring imagery from designers and illustrators around the world.

In writing this book I have combined my global career in the fashion and manufacturing industry along with my lecturing and educational experience – each discipline supporting the other. The result is a combination of the educational requirements of various levels of fashion courses, from degree, certificate and short courses, together with the practical application of drawing and design techniques used globally in the fashion world.

The fashion industry is a challenging and competitive business, so it is essential to be well equipped with professional drawing skills. The aim of *Fashion Artist* is to inspire and help you to develop your drawing skills, and to be able to communicate your creative and innovative ideas on paper and digitally. To be a successful designer you will need to work hard to develop your talent, believe in your own judgement, and have a certain amount of chutzpah! I wish you every success in the world of fashion.

Sandra Burke

M.Des RCA

(Master of Design, Royal College of Art)

'You cannot teach a person anything; you can only help him find it within himself.'
Galileo (1564-1642)

Foreword

This unique book has been produced to induce a wealth of experimentation, ideas, methods and proven formula within the illustrative context. Illustration has in previous years been marginalized, particularly in magazines and fashion journals, but a renaissance lately brought about by a genuine interest in the creative values of using mixed media by illustrators such as Colin Barnes and Antonio, and an interest in using fashion illustration by such notable designers as Manolo Blahnik, retailers such as Barneys, New York and Harvey Nichols, London, magazines like Wallpaper have imbued fashion illustration and drawing with a new 'cool' raison d'etre.

Sandra has drawn on all the techniques and formula available, utilised her deep knowledge gained within both the fashion industry and as an educator at numerous fashion departments across the world to compile this dynamic and vibrant book. By reading and absorbing its contents you will be inspired, and become aware of fashion illustration in its historical and contemporary context and utilize its structural formulas and processes to encourage better use of this form of 'art'.

Paul Rider, M.Des RCA is a consultant in fashion design. Internationally he has worked in Milan, London, Sydney, Moscow and Cape Town. Paul enjoys an international reputation as an educationalist and academic assessor with visiting lectureship (roles) including Central St Martins School of Art, and institutes of Fashion and Textiles throughout the UK, Eire, South Africa, Australia and New Zealand.

If only I had this book somewhat earlier in my fashion career, my fashion illustrations would have progressed dramatically!

Fashion drawing is an important part of a fashion programme and this book shows how fashion drawing, design and illustration can be effectively integrated into the fashion design curriculum. It also ensures that this area is embraced by the students and cemented in as a linchpin of a fashion design programme.

It is no surprise to me that Sandra has chosen to write a book about Fashion drawing and illustration. Given her international experience in the fashion design industry and in fashion education – who better? I would like to commend this book to fashion students, fashion educators, and designers as an essential text for your bookshelves. Its structure, embracing a point-by-point learning system, lends itself perfectly to self-directed practice or to integration within a fashion programme. It has certainly taken away the fear, for me, of putting my concepts on paper!

Dr Jan Hamon is a educationalist and consultant. She has a background in the apparel industry, in costume design for television and theatre, and operated her own business in both fields for several years. She has been involved in curriculum development for fashion programmes and lecturing in costume design and costume history for twenty years.

Acknowledgements

The research for Fashion Artist - *Drawing Techniques to Portfolio Presentation,* and this third edition, has taken me to some of the most influential fashion schools and companies around the world, and further established the link between the fashion and textile industry and education.

Writing this book has been a team effort. Initially I wish to thank all those who have discussed the development of fashion drawing skills and their commercial application. The sharing of ideas, encouragement and support from talented fashion designers, fashion illustrators, lecturers, students, colleagues and friends from around the world has been absolutely incredible. I would never have been able to write this book without them. My sincere thanks to you all, and to those who have also helped with this and previous editions. In particular:

Fashion Industry

Abigail Back and Foschini, Cape Town

Alissa Stytsenko-Berdnik, Vogue DNA

Angelica Payne, Technical Specialist in Fashion

British Council, London Fashion Week (LFW)

Christian Blanken, Womenswear Designer

Ellen Brookes, Abercrombie and Fitch, London

Frances Howie, Designer (Stella McCartney, & Lanvin, Paris), Central Saint Martins (CSM)

Georgia Hardinge, Womenswear Designer, London (Parsons Paris)

Holly Fulton, Womenswear Designer, London

Jason Brooks, Fashion Illustrator

Laura Krusemark, International Citizen - i.CTZN, Los Angeles

Linda Logan, Fashion Designer

Lynnette Cook, Designer, Illustrator, Central Saint Martins (CSM)

Maria Leeke, Womenswear Buyer, London

Mary Katrantzou, Womenswear Designer, London

Montana Forbes, Fashion Illustrator

Munko, Childrenswear

Paul Rider, Fashion Consultant and Visiting Lecturer

Penter Yip, Fashionary

Peter Lambe, Fashion Illustrator, Gordon Harris & Education

PROMOSTYL Paris, International Styling and Trend Forecasting

Alice, Bronny, Carly, Kerstin, Pumpkin Patch, Childrenswear, NZ

Ricki and Aviva Wolman, Citron, Los Angeles

Sally Moinet, Womenswear Designer, Cape Town

Sarah Beetson, Fashion Illustrator, IllustrationWeb, International

Sheena Gao, International Citizen - i.CTZN, Los Angeles

Soo Mok , Menswear Designer

Stuart McKenzie, Fashion Illustrator

Violet Wilde, Bespoke Corsets, London

Universities and Fashion Schools

Alison Prince, De Montfort University

Allen Leroux, Fedisa

Andrew Groves, University of Westminster

Ann Marie Kirkbride, Fashion Illustrator & Northumbria Uni

Ann Muirhead, Coventry University

David Backhouse, University of Leeds

Gideon Malherbe, Elizabeth Galloway

Irene Dee, Senior Lecturer, University of Wales Newport

Jane Ledbury, Manchester Metropolitan University (MMU)

Jean Oppermann, Fashion Illustrator & California College of Arts

Jonathan Kyle Farmer, Fashion Illustrator & Parsons, New York

Karen Scheetz, Fashion Illustrator & FIT, New York

Kerry Curtis, Bath Spa University

Linda Jones, Auckland University of Technology (AUT)

Lee Harding, Birmingham City University (BCU)

Lisa Mann, Southampton Solent University

Lucy Jones, NAFA, Singapore

Lynnette Murphy, Central Saint Martins (CSM)

Martin Dawber, Liverpool John Moores University (LJMU)

Robert Gillan, Edinburgh College of Art

Steven Stipelman, Fashion Illustrator, FIT, Woman's Wear Daily

Sue Jenkyn Jones, London College of Fashion, IFA Paris, Shanghai

Tim Gunn, Parsons, New York

Wendy Dagworthy, Royal College of Art (RCA)

Designers and Illustrators

Aina Hussain, Fashion Designer

Amelia Smith, Print Designer

Amy Elizabeth Booth, Lingerie Designer and Corsetiere

Amy Lappin, Fashion Designer

Bindi Learmont, Fashion Designer

Cherona Blacksell, Fashion Designer

Chloe Jones, Fashion Designer

Chris Davies, Photographer

Dale McCarthy, Fashion Illustrator

Donica Sterling, Fashion Designer

Elina Shripova, Fashion Designer

Elle Hoi Ming Lau, Womenswear Designer

Esther Simmonds, Fashion Designer

Frances Shilling, Knitwear Designer

Gemma Aspland, Fashion Designer

Gemma Linnell, Fashion Illustration & Direction

Hamza Arcan, Fashion Illustrator

Helen Butcher, Fashion Designer

Jason Ng, Fashion Designer

Judy Nell, Fashion Designer

Kathryn Hopkins, Fashion Designer

Lidwine Grosbois, Fashion Illustrator

Lorraine Boyle, Costume Designer

Lucy Upsher, Womenswear Designer

Lynnette Cook (Illustrators Group Jason Brooks, Hamza Arcan)

Martin Percival, Menswear Designer

Melika Madani, Fashion Designer

Nadeesha Godamunne, Fashion Illustrator

Rachel Williams, Fashion Designer

Satya James, Fashion Designer

Victoria Eskdale, Fashion Designer

Yiunam Leung, Fashion Illustrator

Cover Design: Simon Larkin

Front and Back Cover Illustration: Karen Scheetz

Photography (Esther)**:** Louise Davies, Fashion Designer

Model: Esther Simmonds

Desk Top Publishing: Writing this book was one challenge, but having to become a complete technocrat and setting it up using InDesign was another. Particular thanks for guiding me through the hurdles; Alan Taylor, Brian Farley, Bert Parsons, and especially Simon Larkin who also produced the cover.

Proof reading: Thank you to my proof reading team; Rory Burke, Jan Hamon, Mandy Smith, Bronwyn Taylor, Linda Jones and Sharon Evans-Mikellis.

Forewords: I particularly wish to thank Dr Jan Hamon (Fashion and Education), and Paul Rider (Fashion Designer and Consultant, UK) for their inspirational forewords.

Illustration: Karen Scheetz

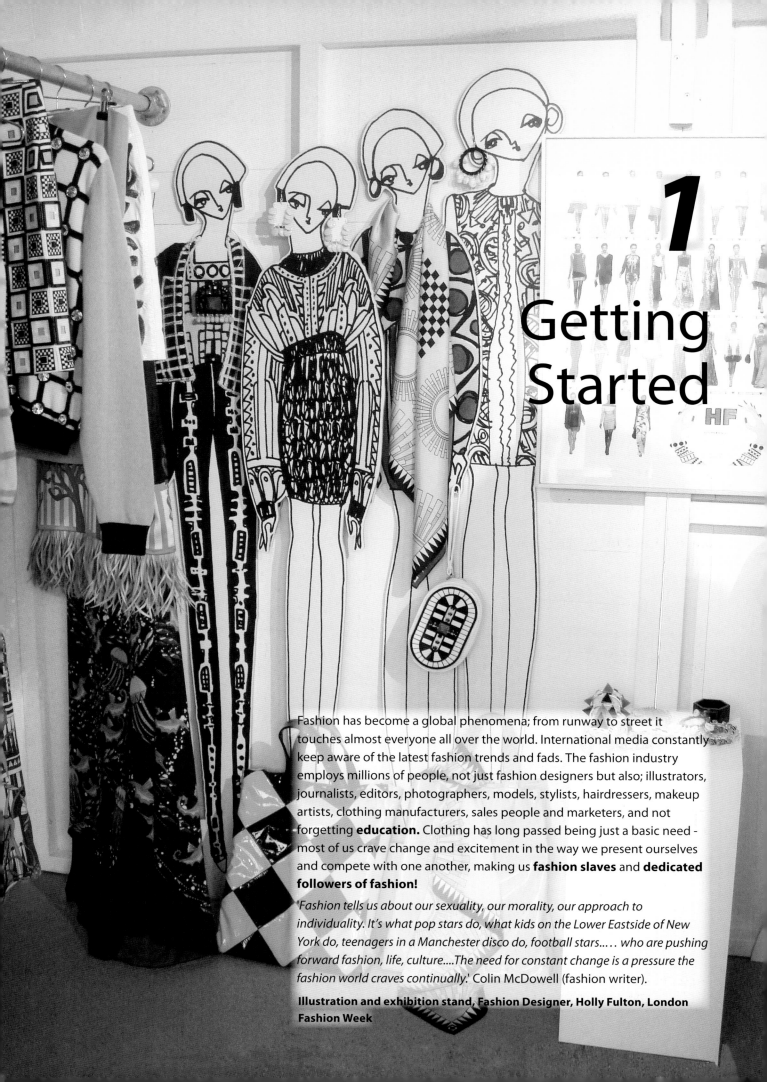

1
Getting Started

Fashion has become a global phenomena; from runway to street it touches almost everyone all over the world. International media constantly keep aware of the latest fashion trends and fads. The fashion industry employs millions of people, not just fashion designers but also; illustrators, journalists, editors, photographers, models, stylists, hairdressers, makeup artists, clothing manufacturers, sales people and marketers, and not forgetting **education.** Clothing has long passed being just a basic need - most of us crave change and excitement in the way we present ourselves and compete with one another, making us **fashion slaves** and **dedicated followers of fashion!**

'Fashion tells us about our sexuality, our morality, our approach to individuality. It's what pop stars do, what kids on the Lower Eastside of New York do, teenagers in a Manchester disco do, football stars….. who are pushing forward fashion, life, culture….The need for constant change is a pressure the fashion world craves continually.' Colin McDowell (fashion writer).

Illustration and exhibition stand, Fashion Designer, Holly Fulton, London Fashion Week

Who This Book Is For

Fashion Artist - *Drawing Techniques to Portfolio Presentation* is for aspiring students of fashion, textiles, and costume, for educationalists, designers, stylists, illustrators, and for those keen to enter the fashion industry. Whether you are a novice or already have a certain amount of talent, *Fashion Artist* will help you develop fundamental fashion drawing and design skills and show you how to apply them in the world of fashion (Fig. 1.1, Drawing Skills Continuum).

Fashion Drawing Skills

Fashion drawing is a practical skill that needs practise to master hand-to-eye coordination. A skill may be defined as an ability or aptitude to perform something well. Just like learning to play the piano or learning to dance, fashion drawing skills need to be learnt and practised over and over again until they become second nature.

The drawing skills continuum (Fig. 1.1) outlines a range of potential abilities from the novice who has paper fright to the designer or illustrator with natural drawing flair. Just as the person who dances with 'two left feet' or the singer who is tone deaf, the paper fright novice needs highly structured guidelines to follow, almost like painting by numbers. Meanwhile, at the other end of the continuum, those with natural flair also need certain guidelines to present their design and art work to an acceptable industry standard. It is these fashion drawing skills and standards that will be developed in *Fashion Artist*.

Digital Fashion/CAD

The aim of *Fashion Artist* is to present hand drawing skills, but it is inevitable that you will be using a combination of hand and digital skills in some aspects of your design work. Using software such as, *Photoshop and Illustrator* will expand your fashion design and presentation options, making the process easier or more enhanced. See my book, **Fashion Computing** - *Design Techniques and CAD,* book 3 in this *Fashion Design Series*.

Figure 1.1: Drawing Skills Continuum

From the novice to those with natural talent and creativity

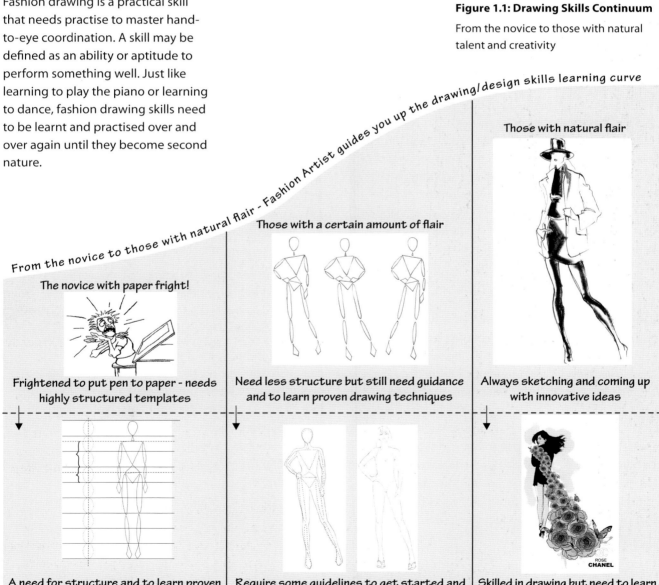

From the novice to those with natural flair - Fashion Artist guides you up the drawing/design skills learning curve

Those with natural flair

Those with a certain amount of flair

The novice with paper fright!

Frightened to put pen to paper - needs highly structured templates

Need less structure but still need guidance and to learn proven drawing techniques

Always sketching and coming up with innovative ideas

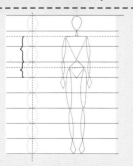

A need for structure and to learn proven drawing techniques

Require some guidelines to get started and learn how to develop their talent

Skilled in drawing but need to learn market presentation formats

Fashion Designers and Fashion Illustrators

Most fashion trends stem from the creative talents of fashion designers and fashion illustrators who use their skills to express the language of fashion to manufacturers and the media. They transfer what is seen in real life to a concise drawing on paper. But there are some distinct differences in the drawing skills that a designer and an illustrator require and these should be clarified.

Fashion Designers sketch their designs to communicate their ideas to a design team, including pattern makers, sample machinists, and buyers. They need to be able to draw well to make their designs understood, but they do not necessarily need to excel in the more stylised art of fashion illustration. Fashion designers create technical drawings and specifications that the pattern maker follows to draft the patterns and produce sample garments/prototypes. After several meetings where corrections are made to the designs, the finished prototypes are shown to the buyers for final approval before manufacturing. See my book, **Fashion Designer** - *Concept to Collection,* book one in this *Fashion Design Series* and website: *www.fashionbooks.info).*

A designer must always be aware of the latest clothing, color and fabric trends and be able to interpret these trends into styles for a particular customer and target market, for example; *Spring/Summer Ready-to-Wear* (*RTW*), *Spring/Summer Resort*, and often with a theme, such as, *Rock 'n Roll Youth Market*. Most importantly, designers must design products that, once in store, the customer will buy and that will not be left on the sales racks! Realistically, although a designer needs to be able to draw well, the emphasis is on the commercial design of the garment and not so much the artistic illustration.

Fashion Illustrators, by contrast, give a signature style to a **fashion designer's** or brand's creation. Using their illustration skills, they build on and enhance basic fashion sketches/designs to present a more flamboyant and creative style. Their illustration might be used for; a fashion design presentation, an advertisement, a marketing presentation or as a journalistic visual representation for editorial presenting, not only the illustration of a single design but the total concept and look of a collection or mood. Fashion illustration is a commercial art form in its own right, a way to express and accentuate a fashion design to present to a client.

How to Use this Book

In simple steps, *Fashion Artist,* will teach you how to draw and present fashion figures and designs, and give you an insight into how your fashion drawing skills can be applied in the world of fashion.

The chapters have been set out in a logical learning sequence to guide you through the fundamental fashion drawing techniques, along with self-explanatory worked examples.

Chapters 2 and 3: Discuss the art kit and sketch books which are the tools of the trade. The starter art kit is a fundamental artist's tool kit, which can be progressively built-up as you learn the drawing techniques throughout the book. Most chapters begin with the art box of items required to complete the exercises in the chapter.

Chapters 4 to 14: Take you through the fashion drawing skills. To encourage you to put pen to paper, you initially learn to sketch a basic nine head figure template using simple lines and shapes that include the oval and triangle technique, and the scribble and the 'S' curve technique. You then quickly progress to develop several popular fashion poses using these simple techniques (Fig. 1.2: Fashion Figure Matrix).

The **Fashion Figure Matrix** is a summary of the key fashion poses, templates 1 to 7, and sets out the sequence of drawing techniques in each chapter. You work closely with this matrix throughout the book as you flesh out the figure, draw flats and cloth the fashion figure, render fabric, create stunning fashion presentations, and finally develop your fashion portfolio. In addition, we look at drawing from life, men, children, and also digital fashion.

Glossary of Terms: Globally, companies and educational establishments use different words for many of the terms in art, fashion and textiles. These will be explained in the glossary and also within the chapters.

The chapters include a gallery of visuals from fashion designers and illustrators around the world, along with explanations of the techniques and media used. These visuals set out to inspire you, and help your creativity and understanding. The fashion drawing techniques, instructions and measurements are **guidelines** and a means of building your confidence in fashion drawing, design and presentation. There are few strict rules and experimentation is widely encouraged to enhance personal and professional style.

Poses	Figure Pose	Oval Triangle Basic Shapes	Fleshing Out	Templates (Faces, etc.)	Clothed	Rendered Fabric
Template 1 Front Facing (Nine Heads)						
Template 2 Front Facing High Hip						
Template 3 Front Facing High Hip						
Template 4 Slight Turn High Hip						
Template 5 Slight Turn High Hip						
Template 6 Side (Turned)						
Template 7 Back (Turned)						

Figure 1.2: Fashion Figure Matrix

The Fashion Figure Matrix shows the progressive development of drawing skills and will be referred to throughout *Fashion Artist*

2
Art Kit

"A poor tradesman always blames his tools", but if you have the following art kit, you might have to find another excuse!!

Most fashion designers and fashion illustrators use a combination of hand drawing materials and digital software, which they use to create their designs, illustrations and presentations.

Although you only need a pencil and paper to learn the principles of fashion drawing, I recommend that you begin by purchasing art media from the **Starter Kit,** which is the fundamental artist's tool kit. This starter kit should give you sufficient art media to work through **all** the exercises in this book. At the beginning of each chapter there is an art box, which is taken from the starter kit and lists the media needed to work through the particular chapter.

The **Extended Art List** is a comprehensive list of additional art media, which you might wish to purchase later as you progressively build up your art kit and develop your drawing style and techniques.

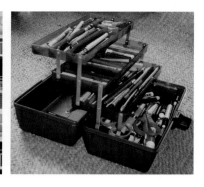

Art Suppliers

The range of artists' products available can be overwhelming. I suggest you start by buying only what you need from the starter kit and from the definitive list at the beginning of each chapter.

- Check out everything from coloring media to paper and portfolios to get a feel for what is available.
- Ask the experts, in store or on the net for guidance.
- Ask for tester samples of media to try before you purchase.
- A brochure/information sheet is often available for proprietary products, especially coloring media.
- Ask about student discounts.

Student and Artist Quality Media

Media is often available in both **student** and **artist** quality.

- Student quality is less expensive so ideal for practising and developing your drawing skills.
- 'Artist' or 'Professional' media use superior pigments and materials; colors last longer, are more true to color, will not streak in mixing or when laid onto the paper. Use this for your final and best artwork and for presentations.

Opposite page and right, Fashion Illustrations by Dale McCarthy: Scarlet Johansson - Pantone pens (flesh, bodice, base of the hair) and the finer details pencil crayons and black fine liner ; Nicole Kidman as Satine in Moulin Rouge - painted in gouache

Starter Art Kit

Art Box : Ideally, you should keep drawing and coloring media in a plastic tool/art box that is compact and portable. The best boxes to keep media in order are those with cantilevered trays.

Drawing Media

- **Graphite pencils**: H, HB, 2B to 6B/9B. Standard HB (H = hard, B = black and softer); **H** a hard line (use for technical drawings), **HB** a medium strength line, **2B** soft to very soft **6B/9B** (use for sketching, shading, drawing from life).

- **Mechanical/propelling pencil:** Provides lines of constant thickness without the need for sharpening. Various lead sizes for different applications - excellent for technical drawing.
- **Black ink fine liners / pigment liner**: Sizes fine to thick - **01** for fine lines, through to **07/09** for bold lines.
- **Charcoals:** Stick and pencil type – required in *Drawing from Life* chapter.
- **Rollerball ink pens** (silver and white): Use for highlights and working over black and dark colors.

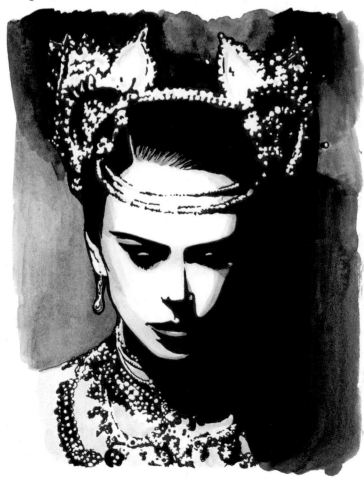

© Fashion Artist (3ed)- Sandra Burke

Coloring Media

Sets (boxes) **and single items:** Small sets of coloring media contain a basic selection of popular colors; larger sets are available.
• Only certain media is available in sets.
• Additional colors can be purchased.

• **Markers:** Expensive but popular in the design studio as they quickly give an acceptable representation of fabric and color. Some have three or four felt points in one pen; broad to fine, some can be refilled. Purchase black, a flesh/nude tone, a blonde and a brunette color for hair, plus a pale grey for shading - purchase other colors as required. Water based markers can give watercolor effects.
• **Colored pencils** (water soluble)**:** Use with or without water, use more water for a watercolor effect.
• **Colored pastels** (water soluble)**:** Stick and pencil type - sticks give more options of line when *drawing from life*, pencils are good for sharper lines. Use fixative to prevent the chalky dust spreading (unnecessary when using water).
• **Brushes** (for paint and water-soluble media): Round brushes No. 1 (fine), No. 7 (medium) and No. 15 (thick): Price and quality are dependent on the fibre and size of the brush tip – synthetic is less expensive than sable.
• **Brush holder:** A tube with a lid - less damage to brush tips when kept in a tube - keep brushes clean and protected to extend their life.

Paper

I encourage students to draw their fashion figures on **A3 (14x17 inch)** paper (no smaller). This scale of work stimulates confidence and creativity. When *drawing from life* draw larger to gain more freedom of expression - use at least **A2 (18x24 inch)** paper.

• **Semi-transparent paper/bank/ layout pad:** 80 gsm – great for sketching and tracing but not suitable for final artwork because it is too light in weight and will not take a lot of coloring media (wrinkles when water is applied). Printing paper can be used but it is not so transparent for tracing.
• **Cartridge paper/general all-purpose pad:** For pencil and markers - if using a lot of water/ paint the paper wrinkles.
• **Marker pads:** Thin, silky, bleed-resistant paper for markers. Perfect for layouts and renderings to produce smooth blends and clean sharp lines.
• **Newsprint, brown paper, sugar paper:** Use in the *Drawing from Life* chapter - any color, plain, textured, etc.; use any inexpensive paper as there will be lots of waste.

Sketch Books, Resource Files

• **Sketch book:** Pocket size for shop/ store reports, street reporting and capturing ideas on the run.
• **Sketch book:** A5 (5x7 inch) and/or A4 (9x12 inch) as a general design ideas book.
• **Sketch book:** A3 (14x17 inch) for design development, drawing fashion figures or croquis (croquis is a french word for a small rough sketch of the figure).
• **Folders/Files:** A4 (9x12 inch) for collating visual resources - magazine clippings, fabrics, photographs, etc. and to keep them in order for quick retrieval.
• See *Sketch Book* chapter.

BRA & BUSTIER
THIERRY MUGLER
A/W COLLECTION

BUG PRINT SKIRT
OWEN GASTER AT
PELLICANO

Above, left to right: Artists media

Right Illustration by Sarah Beetson

Mixed media, edited in Photoshop

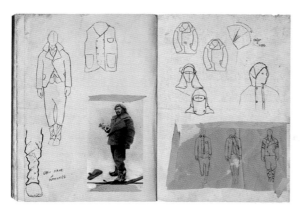

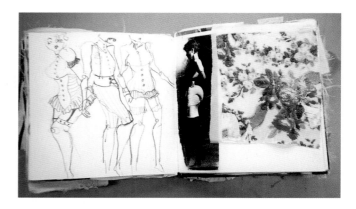

Portfolio

Portfolio: Size A3 (14x17 inch) or A2 (18x24 inch); styles include:
- A simple box type folder.
- Portfolios zipped along three sides with a ring binder to hold the work in place using acetate sleeves.
- Display portfolios that can be folded to make a stand alone display (see photo above).

A quality portfolio should last you a lifetime. A portfolio:
- Protects work, keeps it clean, flat and prevents it from damage.
- Keeps work together and in order.
- Excellent for presentations - a practical and professional solution, ideal in an interview situation or for showing work to clients.
- **Clear acetate sleeves:** Available in various sizes to fit all portfolios - purchase separately.
- See *Fashion Portfolio* chapter, which includes digital portfolios.

Top, left to right: Sketch book by Martin Percival, and Lorraine Boyle - design development sketches and fabric

Below: Display Portfolio (self standing) - sketch in acrylic by Linda Jones

Extras and Optional

- **Eraser:** Plastic for graphite; putty erasers for charcoal and pastels to lighten and blend.
- **Fixative Spray:** Fixes charcoal and pastel drawings preventing the dust spreading and smudging the paper.
- **Full-length mirror:** Observe your body (poses, movement, balance, the way clothes and fabric drape on and around the body); especially useful in the *Oval and Triangle Technique* chapter.
- **Knife/scalpel:** Cuts paper, card and mounting board, sharpens pencils.
- **Masking tape and drawing board clips:** Holds paper in place on the drawing board.
- **Metal metre ruler (36 inch) and 300 mm (12 inch) :** Use when cutting card/thick paper; safer than using plastic or wood rulers.
- **Pinking scissors:** Cut fabric swatches - zigzag edge prevents fraying.
- **Scissors:** Paper and fabric - do not use fabric scissors to cut paper as it will blunt the blades.
- **Double sided tape:** For fabric, etc. for sketchbooks and presentations.

- **Spray adhesive:** Use good quality, leaves no lumps like a glue stick could, adheres on contact, use carefully (difficult to pull apart without tearing the artwork and backing paper), spray over large pieces of scrap paper or over spray will get everywhere; excellent for presentation work.
- **Adhesive sheets:** Good even adhesion and without the fumes that accompany sprays.
- **Paper glue, PVA glue:** Use for paper, card and fabric; cheapest is not always best as it might not bond or spread smoothly and therefore could ruin a presentation.
- **Drawing board**: I recommend using an angled drawing board. Benefits are:
 - Essential for comfort - you are not hunched over your work therefore you draw much better and more freely.
 - Conducive to sitting back to assess work.
 - A flat, sturdy surface to work on.

Drawing boards range from:
- Portable board (off cut from timber merchant - sand smooth).
- Portable plastic angled drawing board and mini lightbox combined (see photograph on next page).
- Angled boards - adjustable surface.
- Easels with or without a seat.

This completes the starter art kit.

Extended Art Kit

Use this list to build up your art kit as your drawing skills develop. Note: New art and craft products continually enter the market.

Drawing and Coloring Media

• **Propelling pencil and leads:** Use for technical and detailed work.
• **Ballpoint and rollerball:** Black, blue, etc. and fine, to thick nibs.
• **Rapidograph pen/Rapidomatic/ Rotring:** For detailed, technical work.

• **Indian ink and inks:** Use with pens or brushes for drawings, calligraphy.
• **Brush felt marker:** Water based markers, produce a wash effect when used with water.
• **Marker blender**: Use for blending the color to prevent streaks, use immediately before the color dries on the paper.
• **Gouache:** Available in tubes - opaque or, with more water added, looks like watercolor, colors change as they dry, good for flat areas of color but not so easy to use for color blending techniques.
• **Acrylics:** Use as a thin watercolor wash or less diluted and thicker, dries in minutes, waterfast, can over paint, gives a more vibrant finish than gouache, use to add texture (white and Gel Gloss acrylic are perfect for adding detail).
• **Watercolor paints:** Available in tubes, palettes or single pans (small cube of pigment - store carefully to avoid damaging).
• **Poster paint:** For a bold painting technique - water based.
• **Oil pastels:** Thick and bold effects - dilute with solvent for washes.
• **Wax crayon:** Waxy, difficult to use with other media - great for effects.

Paper and Board/Card

• **Marker paper, Zeta paper:** Superior quality compared to bank/layout paper, slightly more expensive, marker pens will not bleed.
• **Tracing pad/sheets:** An alternative to bank and layout paper.
• **Watercolor paper**: Some are heavily textured, prices vary, use for watercolor paints and pencils – needs stretching or purchase pre-stretched if totally covering paper with paint.
• **Presentation papers, card and board:** Colored paper, textured papers, decorative papers, buy only when needed as there are so many colors and finishes from matt to shiny, hand made paper looks, grainy surfaces, etc., plus various weights.
• **Mounting board/cards:** Various colors and types for presentations, buy as needed.

Above, opposite, left to right: Illustrator Sarah Beetson at work, and her inspiring artist pallette

Author at small portable lightbox; mannequins (bodies and hand)

Left and opposite: Illustrations by Laura Krusemark

Mixed media - fine undulating lines of a pencil to the soft flowing patterns of watercolor

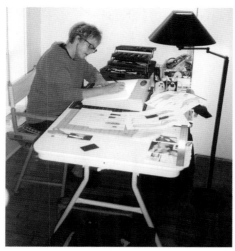
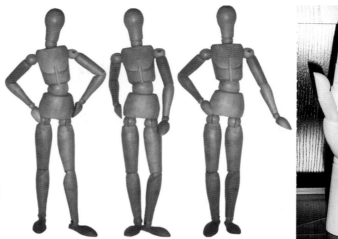
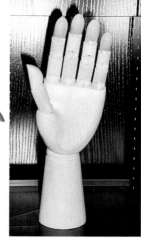

Extras

- **White out marker/correction fluid**: White liquid, use as highlight on compatible media.
- **Masking fluid/film:** Apply to areas to be masked preventing color being applied over the particular area, erase when finished.
- **Palette/mixing dish:** Use for mixing paints and inks.
- **Q tips, baby/cotton buds/tips:** To clean up and for blending media.
- **Turpentine:** Use with a baby bud working into a painted area to create a variety of tones (use on heavy weight paper).
- **Candle (wax):** For a wax resist layer, rub a candle onto the art paper and coloring media will not adhere to it.
- **French curves, set square:** Use for drawing flats/technical drawings.
- **Mannequin:** (See above) Miniature wooden figure with movable joints, useful for displaying body positions, proportions and perspective.

Useful Items

- **Light box:** Use for tracing a sketch onto the drawing paper (aides transparency), commercial and portable light boxes are available (see above). Make your own using books to support a piece of acrylic, and a powerful light below.
- **Cutting mat:** Provides an excellent cutting surface, ensures the knife cuts cleanly through paper or board while protecting the surface underneath.
- **Camera, iPad, iPhone, etc.:** Photograph ideas for resource files, photograph your own work to keep as a backup, integrate images into your sketchbook/iPad, and your designs and presentations.
- **Computer:** Greatly enhances your design and presentation options. See my book, *Fashion Computing - Design Techniques and CAD.*
- **Color printer:** The size limitation is usually A4 (9x12 inch), use a service bureau for larger work.
- **Scanner:** For scanning images.
- **Photocopier:** Handy or use a copy service - resize images, reproduce work, recolor fabric and drawings.

Now you are ready to grab your art box and work through the drawing exercises outlined in the following chapters.

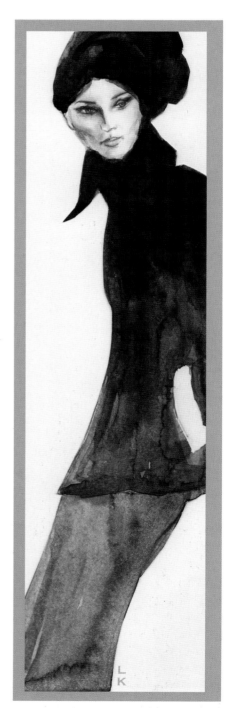

© Fashion Artist (3ed)- Sandra Burke

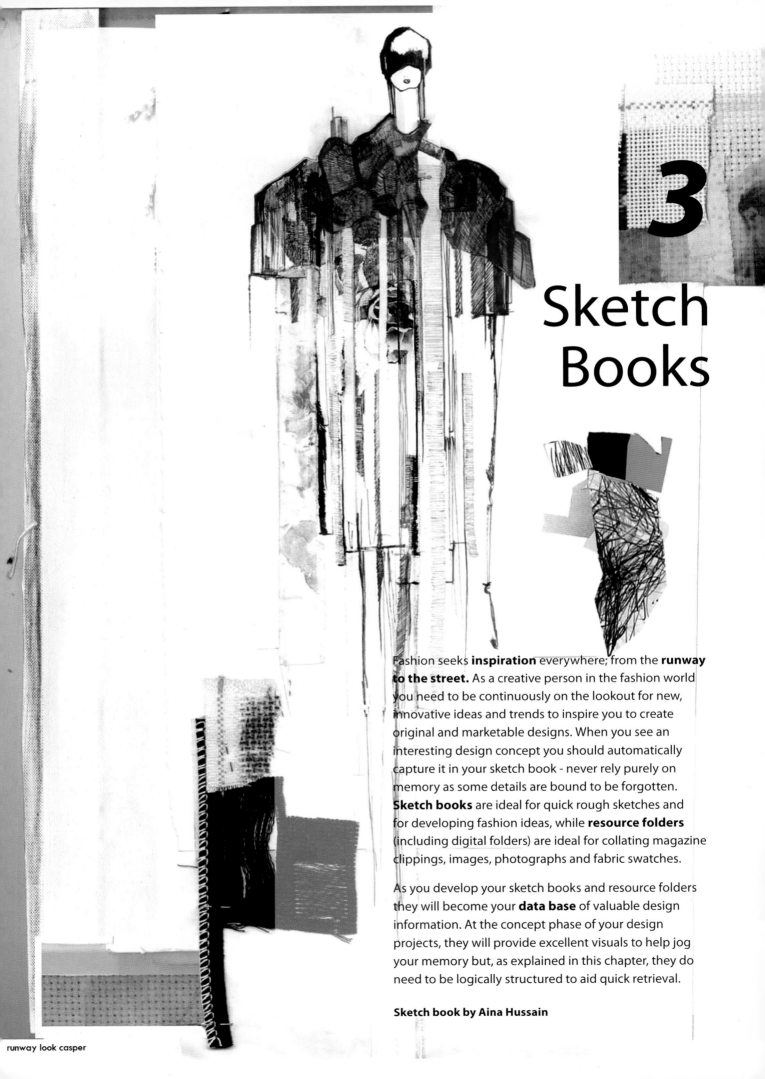

3

Sketch Books

Fashion seeks **inspiration** everywhere; from the **runway to the street.** As a creative person in the fashion world you need to be continuously on the lookout for new, innovative ideas and trends to inspire you to create original and marketable designs. When you see an interesting design concept you should automatically capture it in your sketch book - never rely purely on memory as some details are bound to be forgotten. **Sketch books** are ideal for quick rough sketches and for developing fashion ideas, while **resource folders** (including digital folders) are ideal for collating magazine clippings, images, photographs and fabric swatches.

As you develop your sketch books and resource folders they will become your **data base** of valuable design information. At the concept phase of your design projects, they will provide excellent visuals to help jog your memory but, as explained in this chapter, they do need to be logically structured to aid quick retrieval.

Sketch book by Aina Hussain

runway look casper

Design Inspiration

Design inspiration is derived from many sources local, global, past, present and future, using a mixing pot of ideas to create innovative designs. Fashion design, for example, is not just about drawing fashionable clothing. It embodies a much wider context touching all areas of art and design.

• Seek inspiration from runway to street, from ethnic cultures to art, from music to movies, even from architecture, food and science.

• Keep up-to-date with the latest trends from the most elaborate *Haute Couture* creations, Ready to Wear (RTW), and to the more commercial street fashions.

Source your ideas from:
• Fashion magazines, trend books, and digital sources (websites, social media).
• Fashion shows and exhibitions.
• Fashion retail stores and markets.
• Street fashion - what the public are wearing and the way they put it together.

Be aware of the total look; not just clothing trends but also:
• Accessories - from shoes to bags, hats, jewellery.
• Hair and make-up.
• Fabrics - textures, design and print.
• Colors - fashion colors, color stories (the range of colors or color palette for a particular design presentation or design collection).

Below, left to right:
LFW/London Fashion Week fashionista
Fashion Designer, Holly Fulton, LFW clothing rail
LFW: Stairway to Fashion

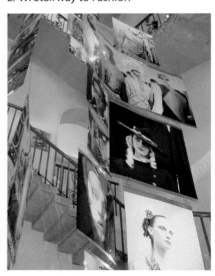

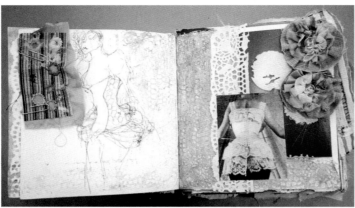
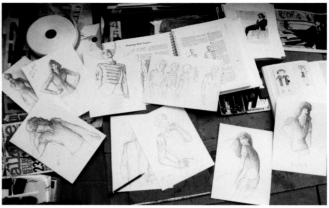

Sketch Book

Fashion sketch book, also called, *fashion journal, fashion diary, work book and croquis sketch book,* are internationally recognised names for drawing books/pads for sketching ideas and designs. Sketch books (including digital versions - iPads, tablets) are your visual reference data base and a valuable source of information for your design projects.

- Sketch everyday and become a doer, not just a doodler.
- Always be ready to make quick sketches, take notes and photos.
- Put pen to paper and cure paper fright. A sketch book is a great confidence builder - draw a few lines and you are away.

Use your sketch book to:
- Document your thinking and design ideas.
- Demonstrate color/fabric sensitivity.
- Sketch clothing design ideas.
- Develop designs, use color to render fabric.
- Keep a small sketch book handy for store reports - visit the stores and take note of what is happening, what styles are in the shops and what is selling or not selling, and the most popular colors, styles, fabrics, etc.

Top to bottom, left to right:
Sketch book - Edinburgh College of Art
Sketch pad - Laura Krusemark, iCTZN.
London Fashion Week - camera click!
Sketch book - Dale McCarthy

Resource Folders

Design resource folders, also called, *cutting, clipping, swipe, picture and personality files,* are recognised names for folders collating visual references. These visuals, used in conjunction with sketch books, are sources of inspiration for design development through to presentation. Collect:
- Images from magazines, fashion and trends sites.
- Inspiring postcards and imagery.
- Fabric and color swatches.

Research and gather information from:
- The arts - theatre, opera, film, music, ballet - clothing and costume, cultural, period costume. Think: *Breakfast at Tiffany's, Marie Antoinette, Moulin Rouge, Grease, West Side Story, Bonnie and Clyde.*
- Art galleries - note the media, colors, styles and techniques used; the figures and clothing of the periods - baroque, impressionism, surrealism. Think: *Salvador Dalí, Gustav Klimt, Michelangelo, Picasso, Gaudi, Egon Schiele, Andy Warhol.*

- History of fashion - note costume design, fabric, trims, hairstyles, shoe styles. Think: *corsets, Chanel suits, past decades (e.g. 40s, 60s, 80s) even previous centuries.*
- Museums - note historical and ethnic costume, textiles and cultural influences. Think: *Chinese paper prints, African tribal dress, Kilim rugs.*
- When travelling take note of national dress as well as street fashion - think: *Indian saris, Japanese kimonos, Pacific prints, Arabian Kaftans.*
- Photography - visuals and techniques, trends and concepts. Think: *Mario Testino, Nick Knight, Cecil Beaton, Patrick Demarchelier, Helmut Newton, Man Ray.*
- Television - past, present, future, cultural, historical. Think: *Downton Abbey, Star Trek, Dr Who.*

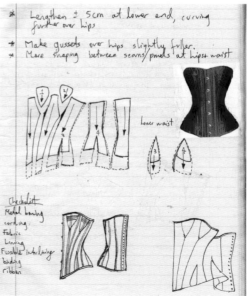

- Sport - styles of clothing, fabrics, colors, trends in sport all influence lifestyle and design. Think: *Olympics, cycling, snow boarding.*
- Architectural and interior design - colors, shapes, textures, fabrics, prints, scale. Think: *minimalist, Gothic, Japanese styling.*
- The world of gastronomic delights - trends in food can influence lifestyle and design and clothing. Think: *Indian spices, Vietnamese, Thai.*

In fact everything around us touches us and inspires our thoughts and attitude to design.

Top to bottom, left to right:
Inspiring lamps and architecture - Angelica Payne
LFW display - 'Sibling'
Sketch book diary - Kyle Farmer (Parsons)
Design development sketch pad - Frances Howie
Sketch pad corset designs - Dale McCarthy.

Filing Visuals

For an organised, quick retrieval method, consider subdividing your resource folders into the following:
- Looks/concepts/moods/themes.
- The figure - female, male, children - as references for figures and poses.
- Clothing - dresses, skirts, shirts, tops, trousers, jackets, day/casual wear, sportswear, evening wear.
- Fabric and trims - fabric designs, textures, prints, lace, buttons, braids, palettes.
- Color - color stories and concepts.
- Historical clothing - era or period.
- Costume design - characters, eras.
- Ethnic Dress - sort by country.
- Design - fonts, theme headings, graphics, presentation layout ideas.

- Style icons that have influenced trends - actors, musicians -*Lady Gaga, Madonna, Marilyn Monroe, Grace Kelly, Jackie Kennedy Onassis, James Dean.*

With sketch books and resource folders in hand, you are now ready to go in search of ideas and inspiration.

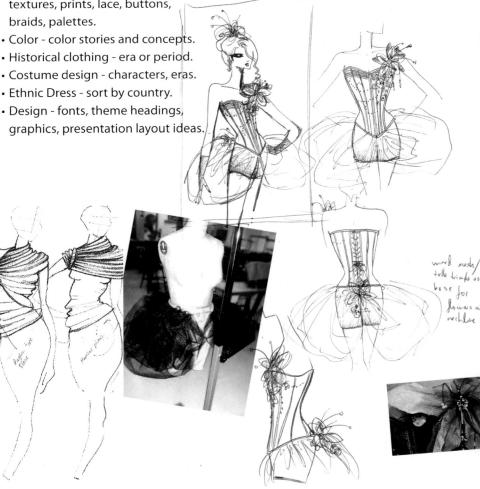

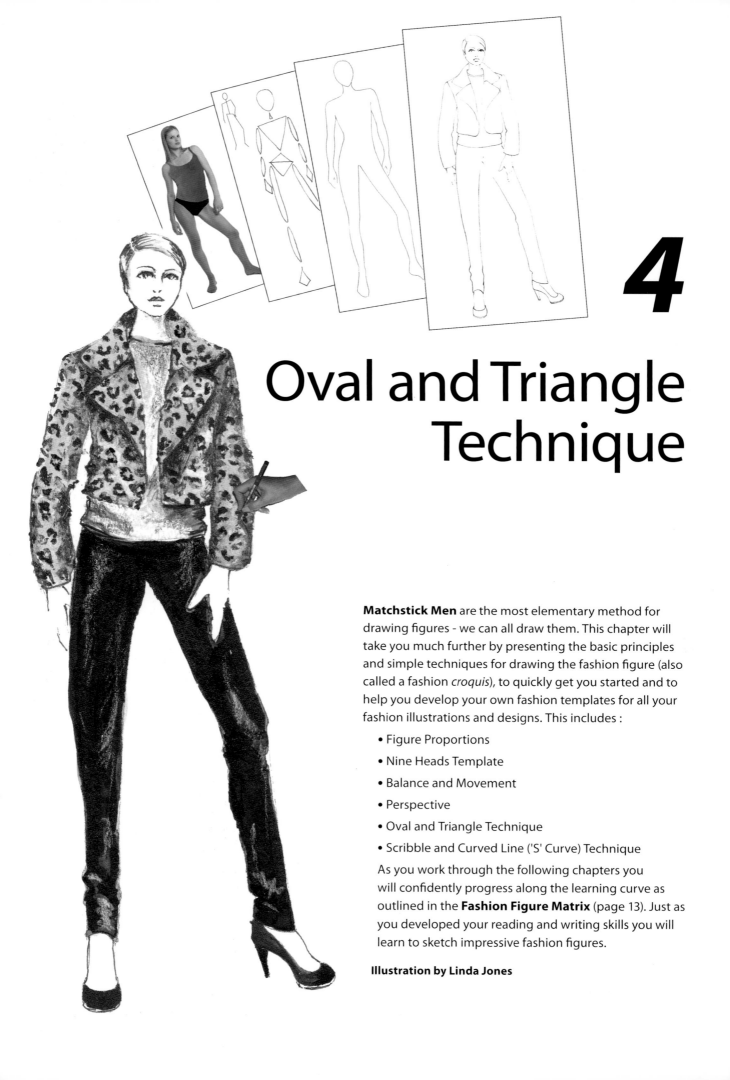

4

Oval and Triangle Technique

Matchstick Men are the most elementary method for drawing figures - we can all draw them. This chapter will take you much further by presenting the basic principles and simple techniques for drawing the fashion figure (also called a fashion *croquis*), to quickly get you started and to help you develop your own fashion templates for all your fashion illustrations and designs. This includes :

- Figure Proportions
- Nine Heads Template
- Balance and Movement
- Perspective
- Oval and Triangle Technique
- Scribble and Curved Line ('S' Curve) Technique

As you work through the following chapters you will confidently progress along the learning curve as outlined in the **Fashion Figure Matrix** (page 13). Just as you developed your reading and writing skills you will learn to sketch impressive fashion figures.

Illustration by Linda Jones

1. Fashion Figure Proportions

The typical female fashion figure is illustrated as young and slender, square shoulders, high bust, small waist, and long legs.

Figures can be measured in **head lengths** and **head widths**, which is the simplest measurement for checking body proportions.

- The **female** figure measures **seven** to **eight** head lengths in height (Fig. 4.1). In contrast, the female **fashion** figure can measure **nine** to **ten** head lengths or more (Fig. 4.2).

- Fashion figures retain the basic proportions of the human form from the head through to the crotch. **Extra length** is added to the **legs** to give a more dramatic, stylised look and to give clothing designs more dynamic appeal (Fig. 4.2).

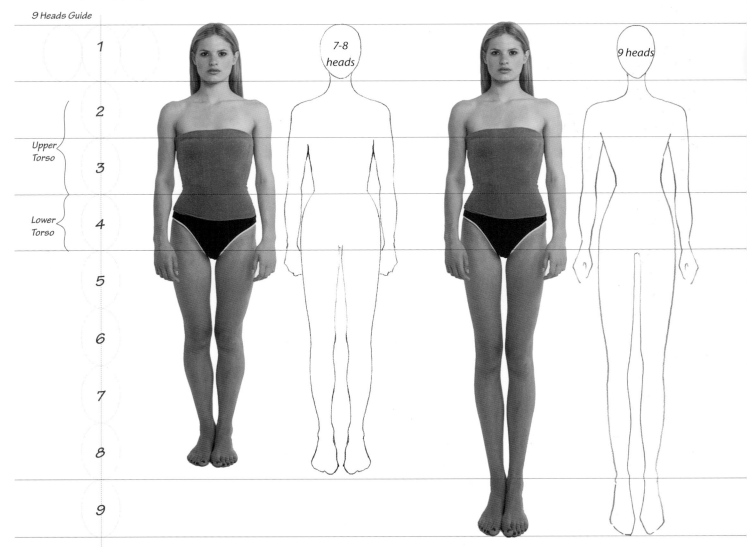

9 Heads Guide

1
2
Upper Torso
3
Lower Torso
4
5
6
7
8
9

C/F
V/B

7-8 heads

9 heads

Figure 4.1:

*The **Female Figure** measures **seven** to **eight** heads*

Figure 4.2:

*The **Fashion Figure** measures **nine heads** or more (model's legs have been stretched using Photoshop)*

2. Nine Heads Template

The basic **Nine Heads template** is presented as a front facing, symmetrical fashion figure, measured in head lengths and widths, and is drawn here using simple shapes, ovals and triangles. The *Nine Heads template* is an excellent starting point for drawing all fashion poses. It is presented here as a guideline for body proportions.

Note: In some instances, computer software has been used to present clarity of line, but it is expected that you would typically be sketching by hand.

The guidelines and body shapes are a rough guide to get you started, and help and encourage you to develop your own style of illustration.

 Exercise 1:

Roughly divide the drawing paper into nine head lengths as follows (you do not have to be too precise) (Fig. 4.3 and 4.4):

a. Draw ten, horizontal lines - each line roughly one **head length** apart.

b. Number the sections 1 to 9.

c. Draw the intermediate lines for the shoulder and the hip (dashed).

d. Name the lines.

e. Draw a vertical line - this forms the **Vertical Balance Line (V/B)** and the **Centre Front Line (C/F)** of the body.

Draw the *Oval and Triangle Fashion Figure* (Fig. 4.4) as follows:

a. Draw the head as an oval to fit section one.

b. Draw the neck from the oval to the shoulder line.

c. Draw the upper torso as a large inverted triangle: The shoulder is approximately two head widths across.

d. Draw the lower torso as two smaller triangles: Waist (point) to hip, and hip to crotch - the hip is approximately one and three quarters head widths.

e. Draw each arm as two elongated ovals:
Upper oval - shoulder to elbow.
Lower oval - elbow to wrist.

f. Draw the hands as diamond shapes - three quarters of a head in length.

g. Draw each leg as two elongated ovals:
• Upper oval - hip to knee.
• Lower oval - knee to ankle.

h. Draw the feet as diamond shapes - one head length.

i. Name your drawing **Template 1.** This is your basic **nine heads** template that you will flesh out in the next chapter and develop as you work through the chapters.

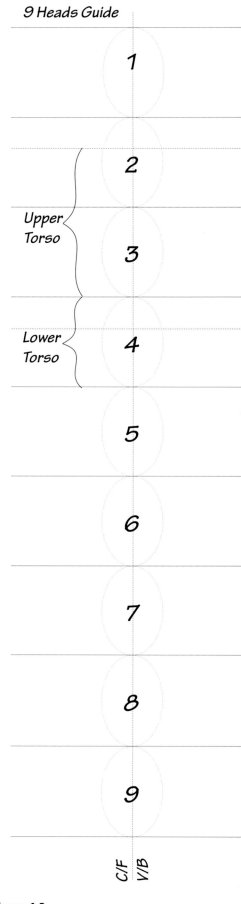

9 Heads Guide

1

2

Upper Torso

3

Lower Torso

4

5

6

7

8

9

C/F V/B

Figure 4.3:

*The drawing paper is divided into **nine heads***

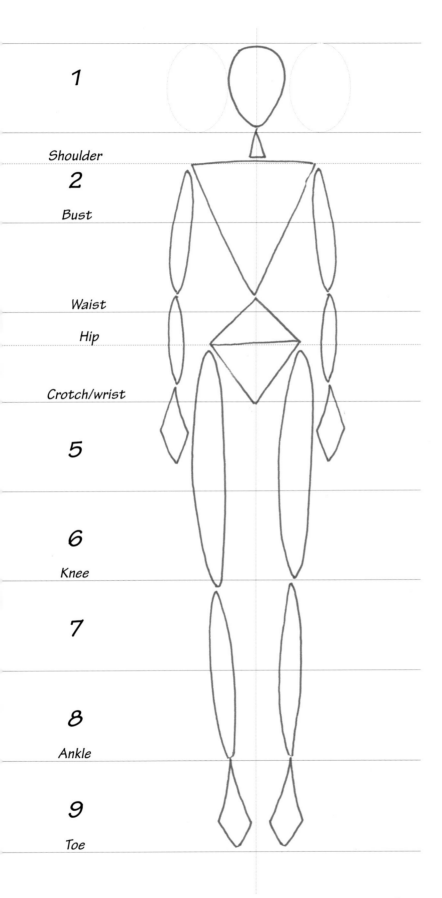

1

Shoulder

2

Bust

Waist

Hip

Crotch/wrist

5

6

Knee

7

8

Ankle

9

Toe

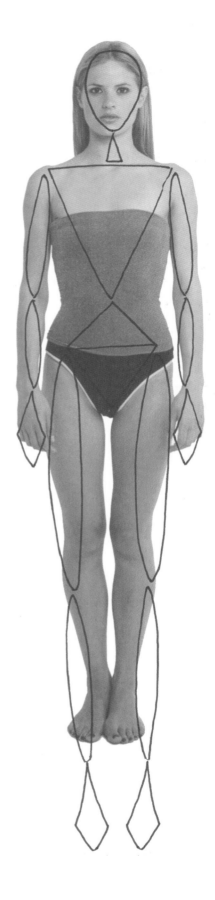

Figure 4.4: Template 1 (figure matrix)

*The **Nine Heads** template is drawn using the measurement of head
lengths and widths, and as ovals and triangles/basic shapes*

Figure 4.5:

*Demonstrates how the human form is subdivided using the oval
and triangle technique and how the legs are elongated for a
fashion drawing*

3. Balance and Movement

Vertical Balance Line (V/B)

To add **life** to the basic fashion pose it is imperative to understand how the body balances. The **vertical balance line** (V/B) is an extremely useful guideline to ensure a figure drawing is well balanced and never appears to be falling over. The V/B line drops vertically from the pit of the neck to the ground. It never bends - it hangs like a plumb line.

Exercise 2:

To understand this clearly, check your own vertical balance line by using a full length mirror (Fig. 4.6):
• Stand with your weight evenly balanced between both feet - your shoulders, waist and hips will naturally be level. Visualise the vertical balance line dropping from the **pit of your neck directly to the ground.** With this evenly balanced pose, the v/b line falls through the centre of your body to the ground equidistant from each foot.

V/B Line and High Hip

Transfer your body weight onto one leg as per Figure 4.7. The V/B line now lies from the pit of the neck dropping vertically to the leg bearing the weight. Your shoulders and waist take on opposing angles - there is now *movement* and *life* in your pose.

The leg taking all the weight is called the **weight bearing leg (1) or load bearing leg.** This leg which is bearing all the weight is straight. Your other leg, which is carrying little or no weight, is called the **balance leg (2).**

Note:
• The **vertical balance line (3)** drops directly through the w/b leg.
• The hip and shoulder **(4 & 5)** are on opposite angles; the hip **(4)** is higher and called the **High Hip.**

Change your weight to the opposite leg and see how the angles reverse to become a mirror image (Fig. 4.8). The vertical balance line now drops directly through the opposite leg.
• Move your balance leg and observe how you can place it in many positions and still stand comfortably on the w/b leg.
• Notice how you can move your arms to different positions and that the vertical balance line from the pit of the neck remains over the w/b leg.

Body Movement

Analyse this selection of poses (Fig. 4.9) demonstrating how the V/B line responds to movement.

Note:
• In all relaxed poses the V/B line drops from the pit of the neck to the point where the most body weight lies.
• The shoulders naturally slant on an **opposite plane** to the waist and hips.
• High hip and shoulder slant poses give your fashion poses a more dynamic appearance.

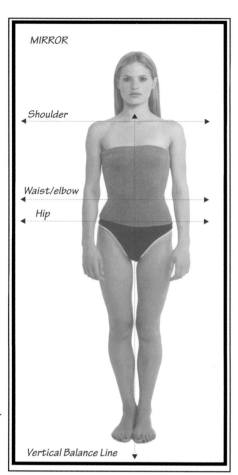

Figure 4.6:

Basic Standing Pose - *weight evenly balanced between both feet, the shoulders, hips and waist are level*

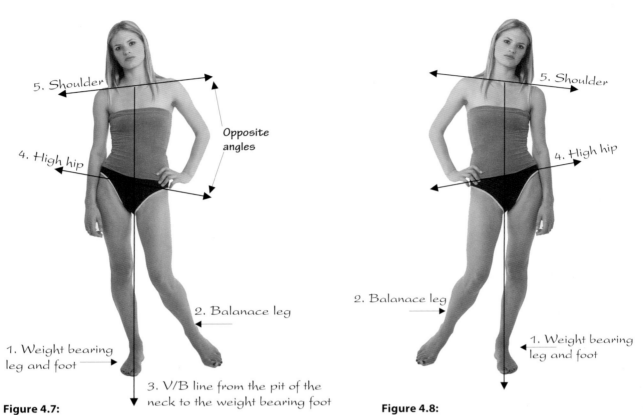

5. Shoulder

Opposite angles

4. High hip

2. Balanace leg

1. Weight bearing leg and foot

3. V/B line from the pit of the neck to the weight bearing foot

5. Shoulder

4. High hip

2. Balanace leg

1. Weight bearing leg and foot

Figure 4.7:

The V/B line passes through the weight bearing leg

Figure 4.8:

The V/B line now passes through the opposite leg which has become the weight bearing leg

Figure 4.9:

These poses demonstrate the movement of body weight from one leg to the other, how the vertical balance line from the pit of the neck always drops to the point bearing most weight and how the shoulders and hips naturally take on opposite angles to each other

4. Body Perspective

Understanding body perspective will also help you draw the correct proportions of the figure in various poses. In this section we look at the **Arc Figure,** the movement of arms and legs and the **Centre Front Line** (Fig. 4.10 to 4.12).

The Arc Figure

As the arms and legs of the front facing figure move sideways on an arc, their length remains constant. The arc figure demonstrates this movement (Fig. 4.10). In contrast when the arms and legs of the model/figure are bent and move towards or away from us they appear foreshortened (Fig. 4.11). Check out Leonardo da Vinci 'Vitruvian Man' circa 1490.

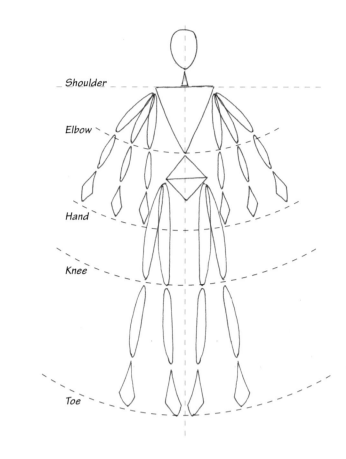

Figure 4.10:

Arc Figure - the arms and legs remain the same length as they follow an arc

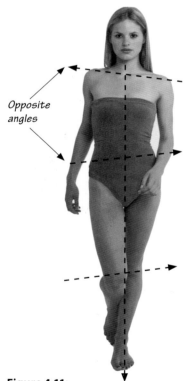

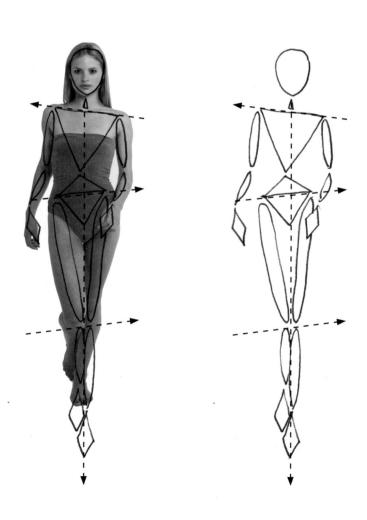

Figure 4.11:

As the model walks towards us with arms swinging, the one leg and the arms are foreshortened. Note the angled lines indicating the shoulders, hips and knees

Centre Front Line (C/F)

The **centre front line** (C/F) is another extremely useful guideline, which will help you draw the body and clothing in perspective as the model moves into her fashion poses. In this front facing basic pose (see Template 1), the centre front line divides the model symmetrically into two equal parts (Fig. 4.6). As the model turns and moves so the C/F line follows the models supple body shape and the body is no longer symmetrical, but takes on an asymmetric perspective (Fig. 4.12).

Figure 4.6 (repeat):

In this basic front facing pose, the centre front line divides the model vertically into two equal parts

Figure 4.12:

As the model turns, the C/F line follows the models supple body shape giving an asymmetric perspective of the figure

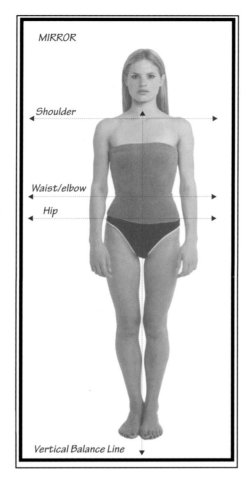

MIRROR

Shoulder

Waist/elbow

Hip

Vertical Balance Line

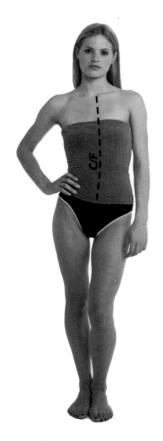

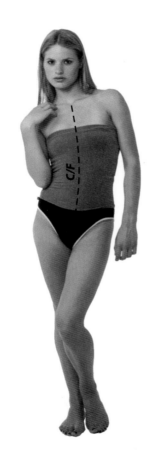

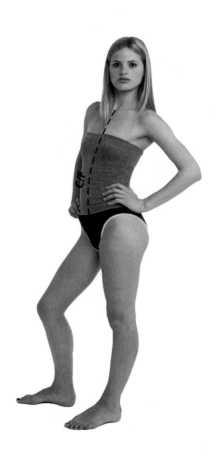

5. Fashion Poses

As the styling details of most garments are on the front, the preferred poses to display the clothing are **forward facing** or **slightly turned,** (Fig. 4.13 to 4.19). Therefore, side (profile) and back views are not drawn as frequently unless required (Fig. 4.20 to 4.22). Back views are more commonly drawn when designing wedding or evening garments as the back is often highly styled.

The key to fashion drawing is to start by perfecting a **number of standard poses** as outlined in the Figure Matrix (page 13). From this platform, a wider selection of poses can then be developed by simply varying the arm, leg and head positions. Flip the drawings horizontally and you have more variations.

Exercise 3:

The following poses are a variety of some of those most frequently used in fashion (Fig. 4.13 to 4.22). Quickly sketch them and their variations using the oval and triangle technique - note they do not have to be perfect shapes, simply capture the poses and movement.

Several of these sketches have been selected to be used as templates and developed throughout the book (Templates 1 to 7, Fashion Figure Matrix). Name the drawings as per examples and keep them protected in a folder or portfolio. They will be developed in the *Fleshing Out* chapter.

Note:

1. As the body turns, the perspective changes - you will need to slightly distort the triangle and oval shapes as can be seen in Fig. 4.20.

2. Check the figure is well balanced by using the vertical balance from the pit of the neck.

3. Check the shoulder and hip angles (opposite angles for a well balanced figure).

Exercise 4:

When you have finished drawing these poses, practise sketching poses from magazines. The model should be wearing fitted garments so that you can see the body shape.

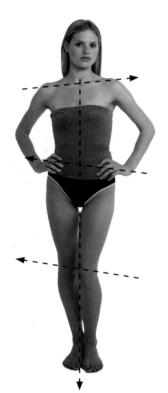
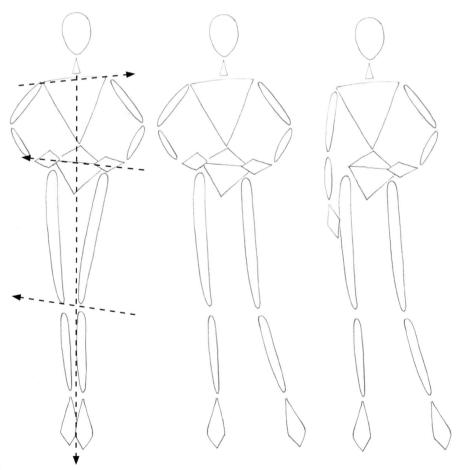

Figure 4.13: Template 2 (figure matrix)

Front facing - hands on hips, body weight rests very slightly more on one leg than the other, plus variations (pen drawing). Note the legs are even longer making a ten head figure; for the matrix figures we will revert to nine heads (pencil drawing)

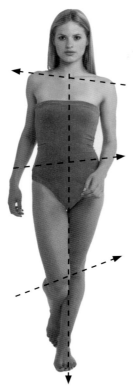

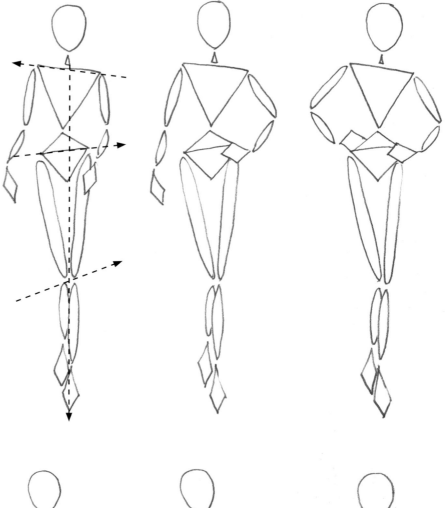

Figure 4.14: (walking)

Front facing - arms swinging, weight on one leg, leg and arms foreshortened, typical, strutting down the fashion runway type pose, plus variations (pencil drawing)

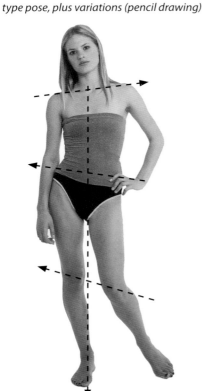

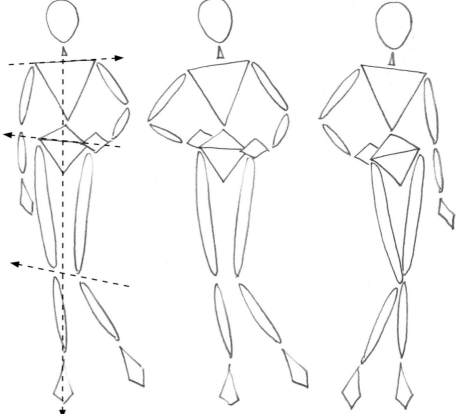

Figure 4.15: (high hip)

Front facing - weight on load bearing leg, balance leg slightly angled, angled shoulders and high hips, head tilted, typical end of runway type pose, plus variations

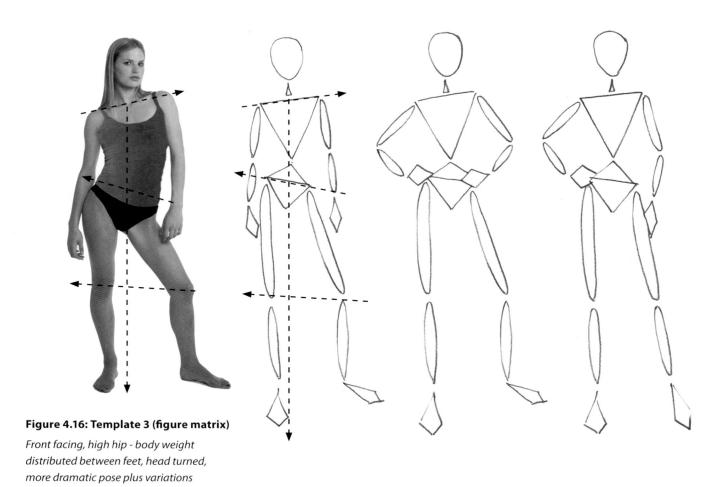

Figure 4.16: Template 3 (figure matrix)

Front facing, high hip - body weight distributed between feet, head turned, more dramatic pose plus variations

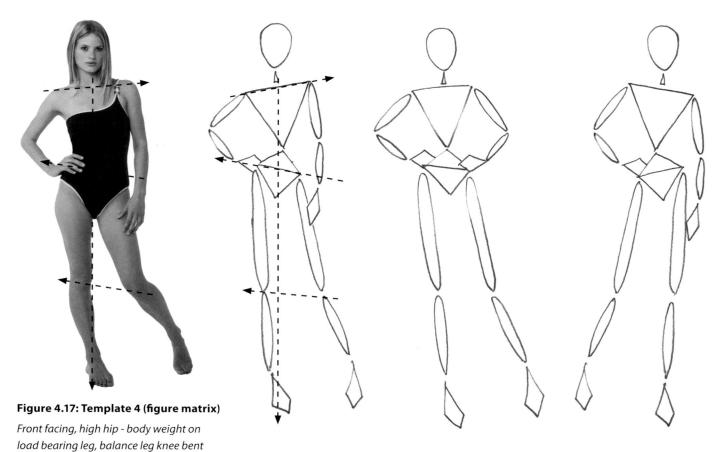

Figure 4.17: Template 4 (figure matrix)

Front facing, high hip - body weight on load bearing leg, balance leg knee bent inwards, cute pose, plus variations

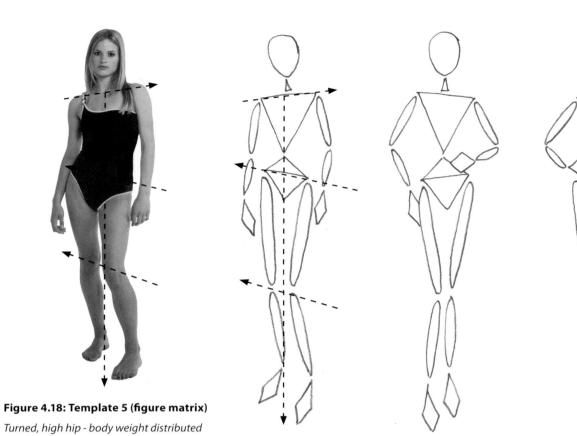

Figure 4.18: Template 5 (figure matrix)

Turned, high hip - body weight distributed between feet, angled shoulders, slightly quirky pose, plus variations

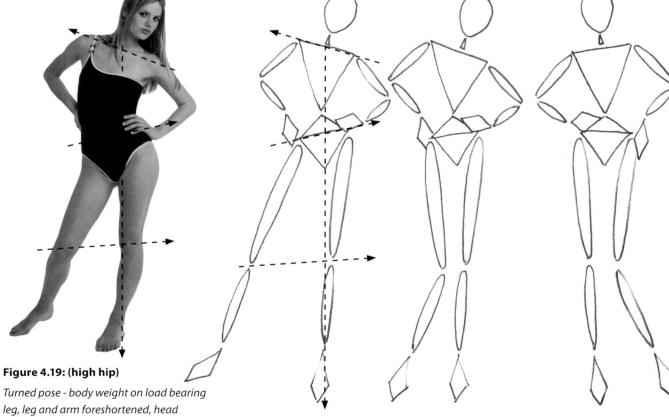

Figure 4.19: (high hip)

Turned pose - body weight on load bearing leg, leg and arm foreshortened, head turned opposite to body and tilted

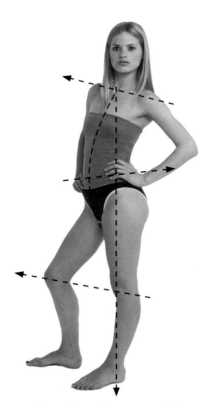

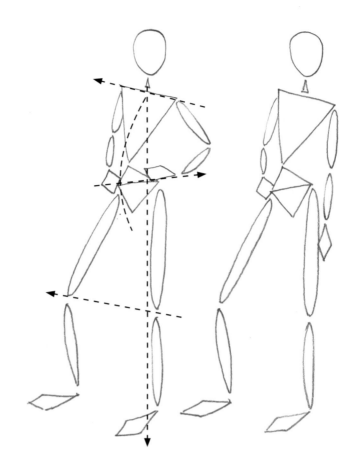

Figure 4.20: Template 6 (figure matrix)

Side pose - hip thrust forward accentuating the model's supple body, the arm furthest away is foreshortened, body weight on load bearing foot (foreground), interesting side pose and variation

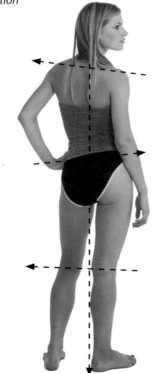

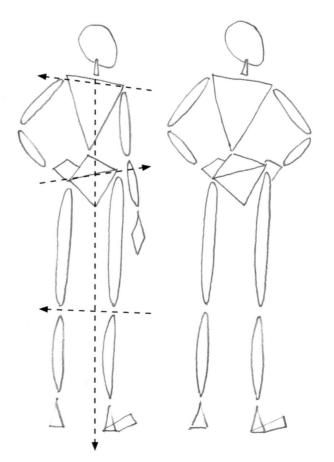

Figure 4.21: Template 7 (figure matrix)

Back pose - head in profile, an interesting asymmetrical back view and variation

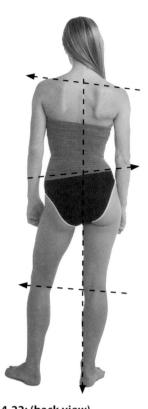
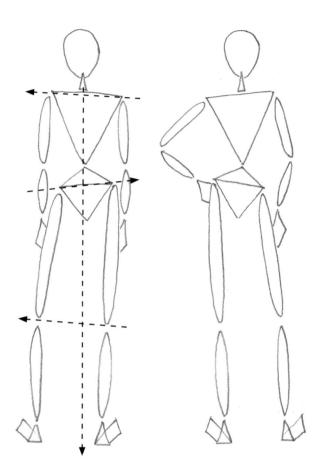

Figure 4.22: (back view)

*Back view - body weight more on one
leg than the other, high hip and angled
shoulders make this an interesting back
pose rather than a symmetrical back view
and variation*

Drawing Tips:

• The female fashion figure drawing measures ***nine heads*** or more**.**

• The fashion figure must be balanced - check the ***Vertical Balance Line (v/b)***
and the ***Centre Front Line (c/f).***

• High hip poses, with angled shoulders express more movement and give
'life' to fashion figures (croquis).

• Torso tilt - depends on how much body weight is being carried by the
supporting leg

These basic oval and triangle templates, 1 to 7, form the basis of the Figure
Matrix. The next chapter, *Fleshing Out,* will explain how to add body shape
to these very basic figure drawings. These fleshed out 'bodies' will give you
a range of fashion poses on which to design clothing and use in fashion
presentations.

Scribble and Curved Line ('S' Curve) Technique - Linda Jones

 Exercise 5, Scribbles:

This is an excellent technique for loosening up your approach to fashion figure drawing and helping to create more movement in your body poses. It is best done with a soft pencil lead such as a 4B/6B and plenty of layout paper (Zeta).

No ruled lines or erasers are needed – this is an experimental approach that allows for a drawing to develop as much for what does not work as to what does.

1a. Draw a frame – this creates a discipline for the size and proportion of your figure.

1b. Draw a straight line down the centre of the frame.

1c. Look at the line and visualise the proportions of the body, from the top of the head to the toes (the *Nine Heads* guidelines can be used as a reference, fig.4.3 and 4.4).

2a. Map in the proportions with lines and experiment with the mapping – it can take a bit of practise before the proportions become consistent.

2b. Visualising the body's silhouette, from the top of the head start to scribble the form of the body. Keep the scribble loose and be prepared to do this exercise many times.

3a. When you feel that your drawing is becoming consistent, you can add in the arms – remember the elbow sits at approximately the waist line and the hand size is ¾ the size of the head.

3b. Experiment with outlining the form using the layout paper (this drawing can now be overlaid and the line drawing developed).

4a, b, c. To create body movement, simply angle the shoulder and hip lines.

1a, b, c.

2a, b.

3a, b.

4a.

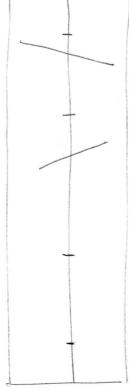

4b.

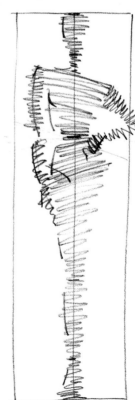

4c.

Exercise 6, Curved Line ('S' Curve) Technique:

1. To experiment further with figure movement, try the curved line method, which allows a more random development of pose. It is often called the 'S' curve when fully developed for the whole figure

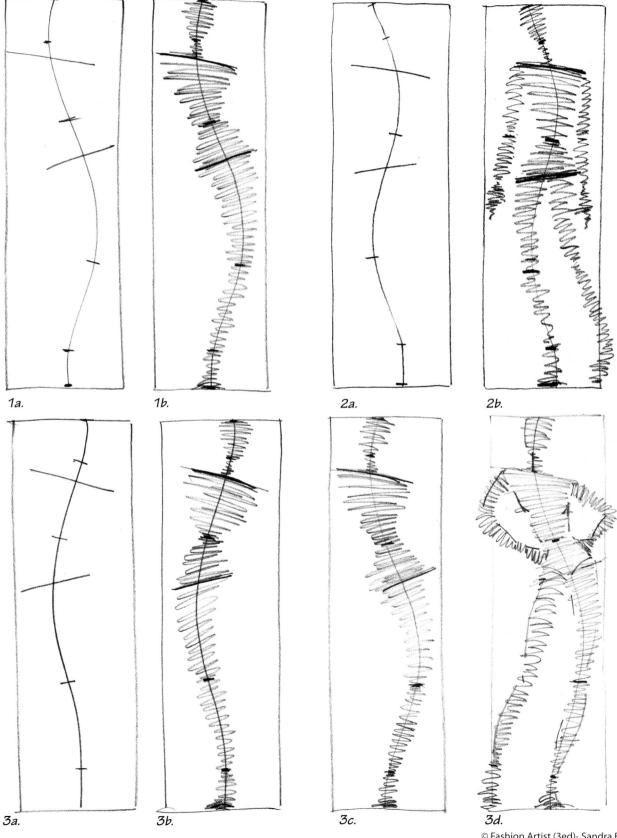

1a. 1b. 2a. 2b.

3a. 3b. 3c. 3d.

5

Fleshing Out

Fashion illustrations aim to achieve an **impression of reality** in a **stylized** or **exaggerated way** not illustrate every precise small detail as the camera portrays. The objective is to capture an overall look, with no unnecessary details cluttering the drawings. For example, fashion designers such as John Galliano, and illustrators such as Jason Brooks, sketch using clean, simple lines.

Fleshing out or **rounding out** are the terms used for adding body shape to create a fashion figure or fashion template. The following exercises will demonstrate how to flesh out your basic oval and triangle matrix templates, 1 to 7, from the previous chapter. Each template is overlaid with semi-transparent paper and used as a guide for tracing over. After the *Faces, Hands and Feet* chapter, your fleshed out templates will then be developed in the *Figure Templates* chapter.

Illustration by Jason Brooks (edited with Photoshop, now holding rose)

Art Box

- Your oval and triangle templates 1-7 from the previous chapter
- Drawing media, 2B Graphite pencil, fine liners, etc.
- A3 (14x17) semi-transparent paper
- Portfolio/Folder

1. Eleven Body Parts

The fashion figure drawing can be broken down into eleven very simple basic body parts or shapes (Fig. 5.1).

Exercise 1:

Draw these individual body parts to familiarise yourself with the shape and components of the figure as it will help you flesh out your oval and triangle figure templates.

1. **Head:** Egg-shape
2. **Neck**: Cylinder shape
3. **Shoulders**: Smooth wedge or coat hanger shape
4. **Upper torso**: Like a tapered box from the underarm positions to a small waist.
5. **Lower torso**: Shorter tapered box narrower at the waist to wider at the hip line and to the top of the thighs
6. **Thigh to knee:** A tapered cylinder
7. **Lower leg:** A shaped cylinder tapered both ends (note the knee and calf muscle, inside and outside leg shaping)
8. **Foot:** Elongated diamond shape, with slightly more definition for the toes and ankles
9. **Upper arm:** Narrow tapered cylinder
10. **Lower arm:** A shaped cylinder tapered both ends
11. **Hand:** Diamond reshaped to indicate the fingers.

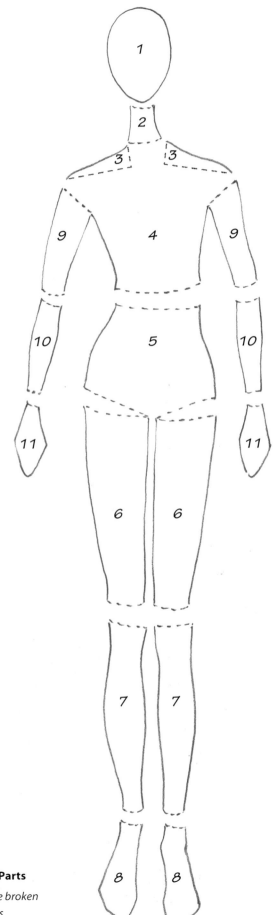

Figure 5.1: Eleven Basic Body Parts

The fashion figure drawing can be broken down into eleven basic body parts

2. Fleshing Out Template 1

Exercise 2:

This exercise (Fig. 5.2. a - d) demonstrates how to flesh out your basic oval and triangle figure, **template 1 (figure matrix),** which was drawn in the *Oval and Triangle Technique* chapter. As you flesh out your template, bear in mind the eleven body parts that you drew in the previous section.

1. Overlay your template 1 with semi-transparent paper.

2. Using a fine liner or graphite pencil, smoothly trace over your oval and triangle template 1 as you flesh out the body shape.

3. Work from top to bottom, and side to side as you draw, e.g. one shoulder then the other.

a. Head: Redraw the oval as an egg shape with the narrower end forming the chin.

b. Neck: Draw a smooth cylinder shape.

c. Shoulder: Continue a smooth line from the neck making a wedge/coat hanger shape, curve gently over the shoulder edge.

d. Upper torso and lower torso: From the underarm position (just above bust line), taper to the waist and out to the hip and top of the thigh (lower torso).

e. Thigh to knee: From the thigh taper to the knee; draw the inside leg from the crutch tapering to the knee.

f. Lower leg: From the knee, the outer edge of the leg curves out to the wider calf muscle and tapers to a narrow ankle; from the knee, the inside leg indents then curves out for the calf muscle before tapering to a narrow ankle.

g. Feet: Refine the diamond as example.

h. Upper arm: Draw the narrow tapered cylinder from the shoulder to the elbow joint, and from the underarm to the elbow.

i. Lower arm: Draw the shaped cylinder from elbow joint to wrist, gently identifying the arm muscles.

j. Hand: Continue from the wrist and refine the diamond as per example.

Exercise 3:

Now draw the other figures (Fig. 5.2. a) using similar techniques where applicable, and by following the drawn examples. (See also Exercise 4 for extra guidance)

Note: You will need to retrace your figure several times, continually improving your last sketch, until you have fleshed out figure templates that you are satisfied with. With practice drawing the figure will become easier.

1

Shoulder

2

Bust

Upper Torso

Waist
High hip
Hip

Lower Torso

Crotch/wrist

5

6

Knee

7

8

Ankle

9

Toe

Figure 5.2a, b,c and d: Template 1 (figure matrix - left to right)

Fleshed out, basic fashion figure showing the original oval and triangle template; plus basic side, three quarter and back views

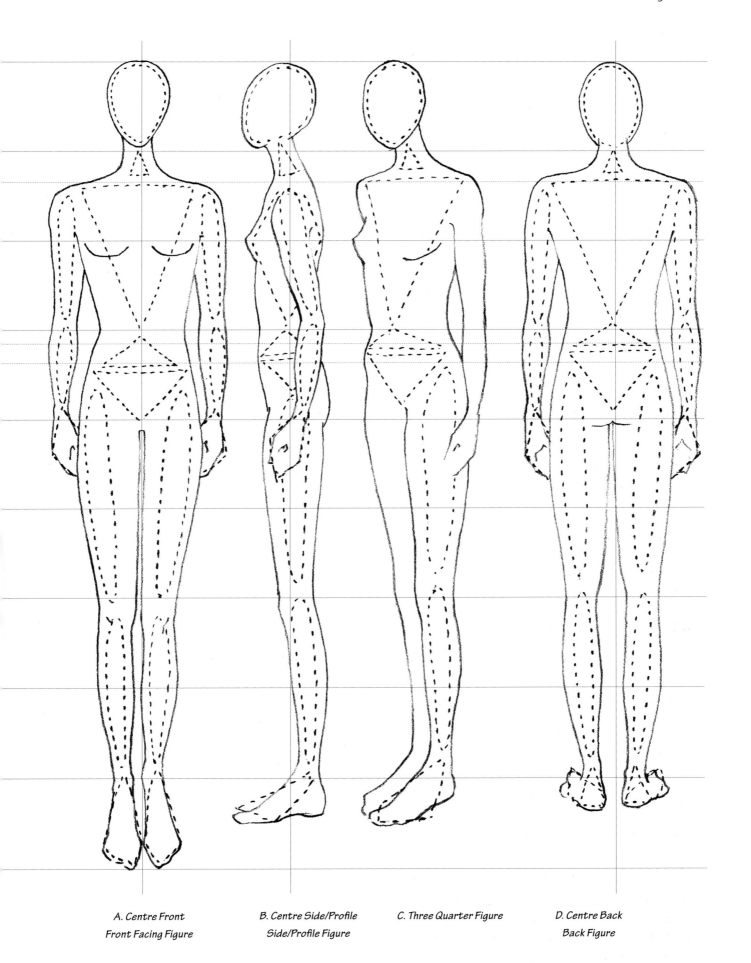

A. Centre Front
Front Facing Figure

B. Centre Side/Profile
Side/Profile Figure

C. Three Quarter Figure

D. Centre Back
Back Figure

3. Fleshing Out Templates 2-7

 Exercise 4:

This section presents the fleshed out (figure matrix) templates 2 to 7 (Fig. 5.3 to 5.8). Draw each of the figures using the previous technique for template 1.

Note:

- Figures 5.3 to 5.8 show a fleshed out body line over the oval and triangle templates, which are indicated as dotted lines.
- Your drawing does not have to be an exact copy of these but, as you work through the exercises you will start to develop your own style of figure drawing.
- All measurements and shapes are industry standard guidelines - they do not have to be strictly adhered to.
- Adjust your drawing as many times as necessary; move the paper up, down, sideways and correct lines, improve the shapes (slim down the figure, reshape muscles), retrace until you have a fleshed out line drawing that you are happy with.
- At this stage or later you might decide to elongate your fashion figure to ten heads or more by adding length to the legs.

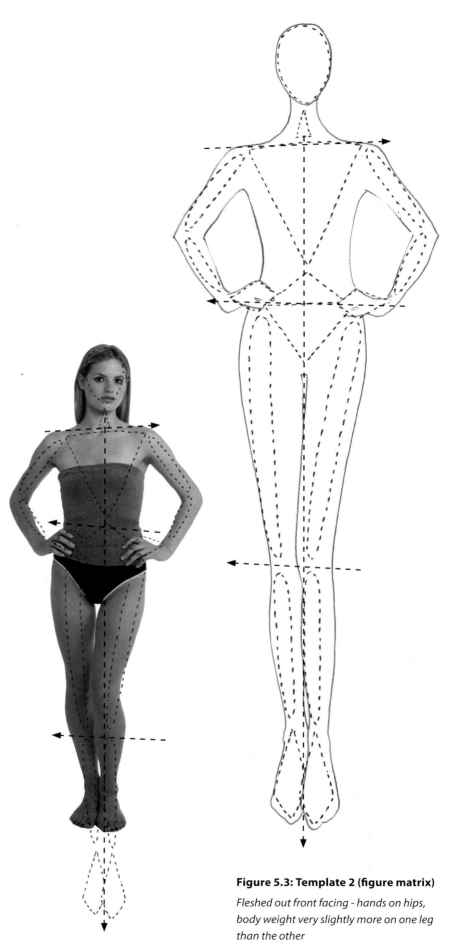

Figure 5.3: Template 2 (figure matrix)

Fleshed out front facing - hands on hips, body weight very slightly more on one leg than the other

Gallery of Fashion Bodies

Take a look at the following gallery of stylised fashion artworks by illustrators and designers from around the world. Note the various styles of illustration and how the artists' portray the body. Their understanding of the body and the female form is such that they have been able to present their own personal signature style - this comes with practise.

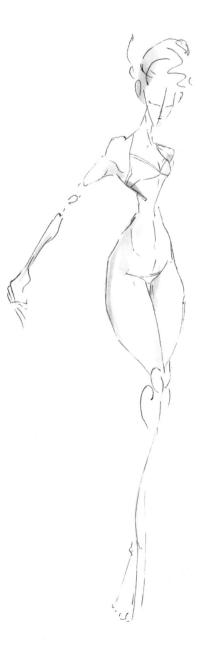
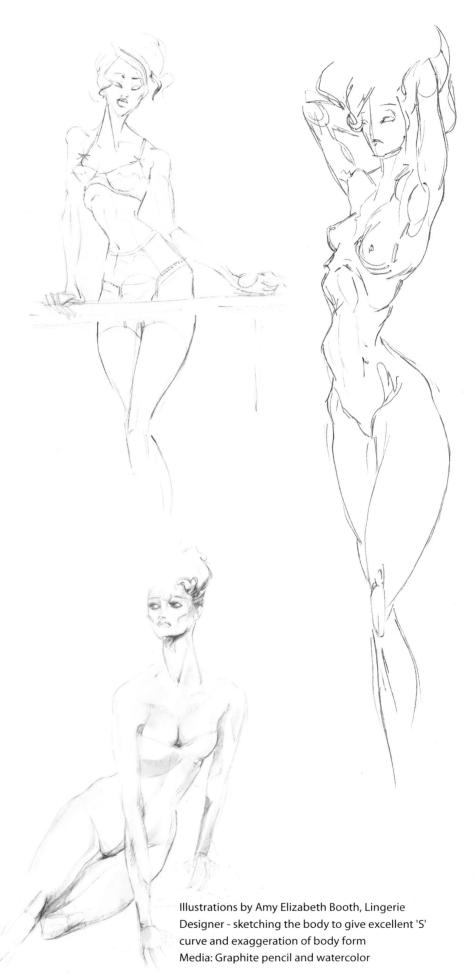

Illustrations by Amy Elizabeth Booth, Lingerie Designer - sketching the body to give excellent 'S' curve and exaggeration of body form
Media: Graphite pencil and watercolor

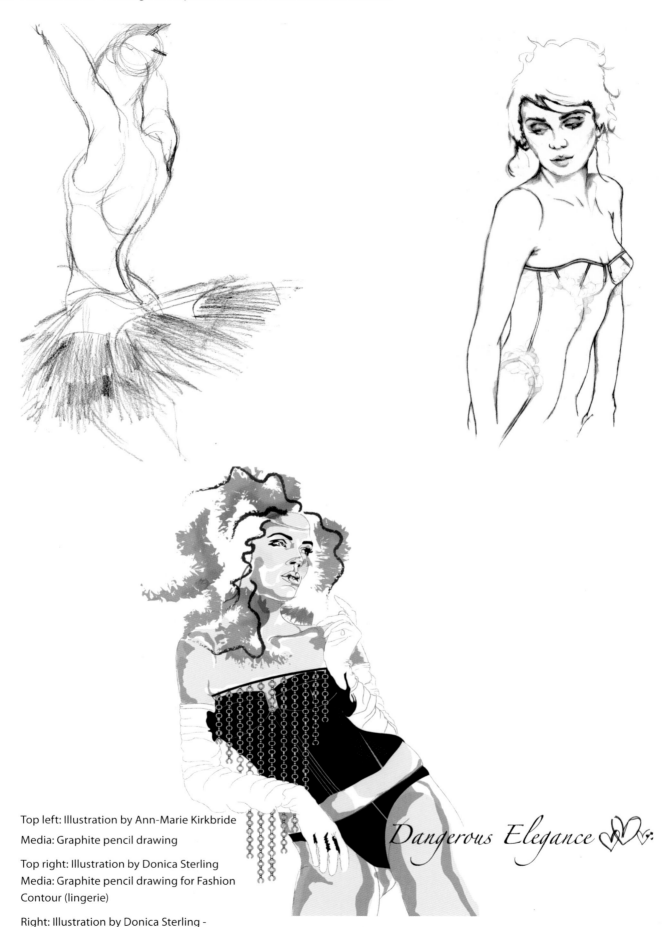

Top left: Illustration by Ann-Marie Kirkbride
Media: Graphite pencil drawing

Top right: Illustration by Donica Sterling
Media: Graphite pencil drawing for Fashion
Contour (lingerie)

Right: Illustration by Donica Sterling -
Media: Pen, edited in Photoshop to add
color and specific image effects

Dangerous Elegance

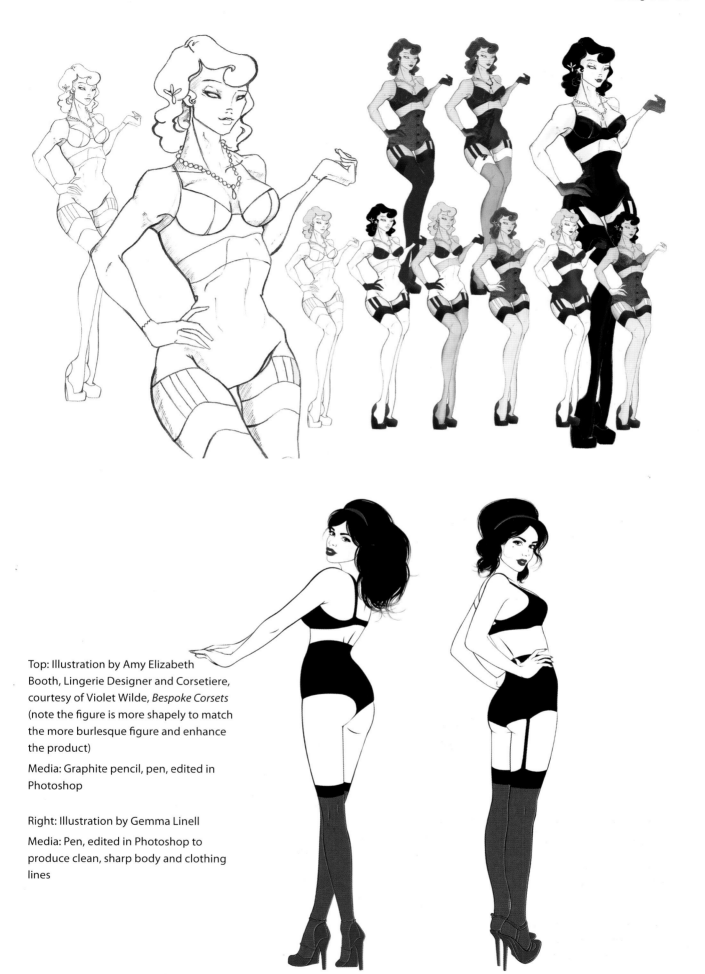

Top: Illustration by Amy Elizabeth Booth, Lingerie Designer and Corsetiere, courtesy of Violet Wilde, *Bespoke Corsets* (note the figure is more shapely to match the more burlesque figure and enhance the product)

Media: Graphite pencil, pen, edited in Photoshop

Right: Illustration by Gemma Linell

Media: Pen, edited in Photoshop to produce clean, sharp body and clothing lines

© Fashion Artist (3ed)- Sandra Burke

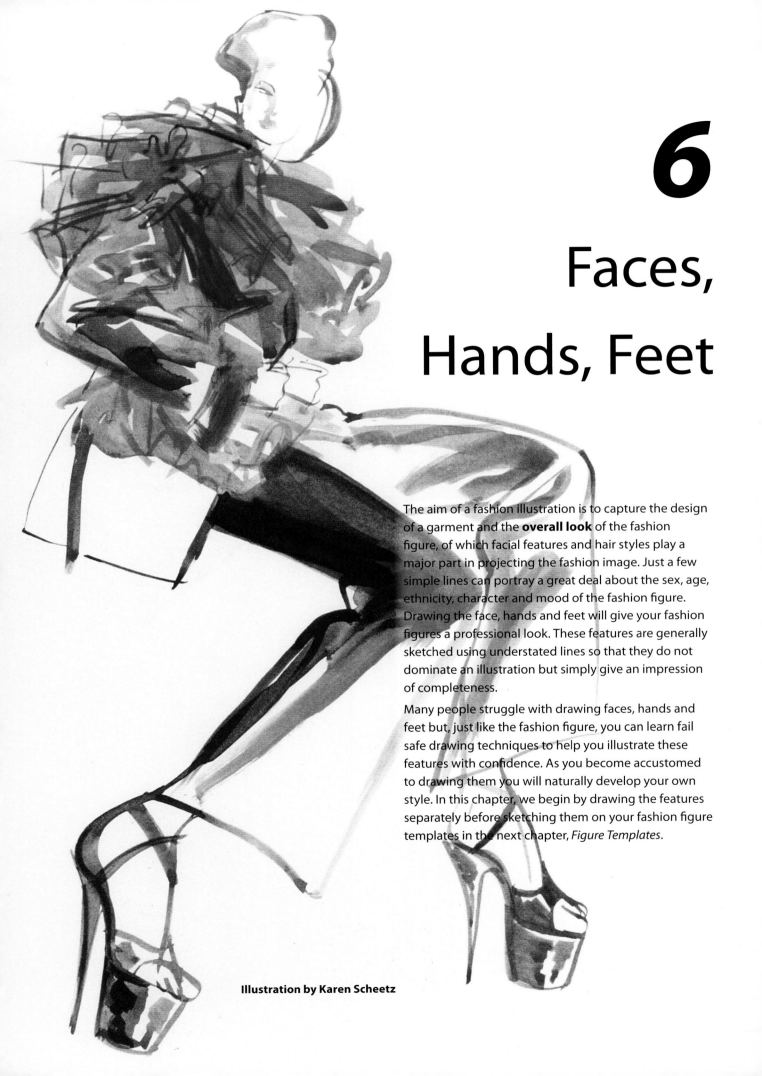

6
Faces, Hands, Feet

The aim of a fashion illustration is to capture the design of a garment and the **overall look** of the fashion figure, of which facial features and hair styles play a major part in projecting the fashion image. Just a few simple lines can portray a great deal about the sex, age, ethnicity, character and mood of the fashion figure. Drawing the face, hands and feet will give your fashion figures a professional look. These features are generally sketched using understated lines so that they do not dominate an illustration but simply give an impression of completeness.

Many people struggle with drawing faces, hands and feet but, just like the fashion figure, you can learn fail safe drawing techniques to help you illustrate these features with confidence. As you become accustomed to drawing them you will naturally develop your own style. In this chapter, we begin by drawing the features separately before sketching them on your fashion figure templates in the next chapter, *Figure Templates*.

Illustration by Karen Scheetz

Art Box

• Drawing media, 2B Graphite pencil, fine liners, etc.
• A3 (14x17 inch) semi-transparent paper
• Full length mirror
• Fashion magazines, internet resources
• Portfolio/Folder

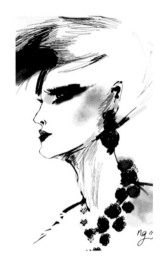

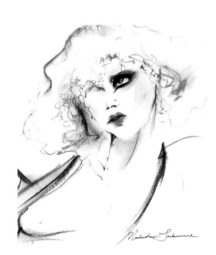

1. Faces, Hands and Feet

These features can be drawn using various line thickness, and even just an impression of a line to produce an array of different expressions, styles and characters. Observe the line work and shading techniques these designers and illustrators have used to express the fashion face, hands and feet.

Fashion faces, hands and shoes: Top left to right: Nadeesha Godamunne (two illustrations), Amy Elizabeth Booth; below Montana Forbes (two illustrations), Lucy Upsher.

Note the different line effects and shading techniques used to produce these stylised images, hand and/or digitally produced.

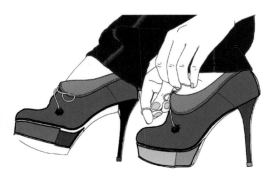

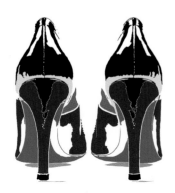

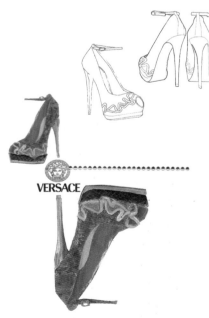

2. Drawing the Face: Front

Drawing the face can be a daunting prospect when learning to fashion illustrate - one small line in the wrong place could ruin the artwork. Fortunately, there are a number of easy solutions to this problem, as demonstrated in the following exercises. Just as you used guidelines, basic shapes and templates to draw the fashion figure, so a similar approach can be used when drawing the face.

The following exercises will guide you progressively though the techniques used to draw the face from the front view, turned perspective and profile.

 Exercise 1: Drawing the Face Front On

First, note how the front view of the human face shows all the features symmetrically (Fig. 6.1). Draw the front view of the face following the instructions below and the step-by-step example opposite (Fig 6.2).

a. Head and guidelines: Draw an egg shaped head and the guidelines for the centre front (c/f), eyes and mouth (divide the head in half to indicate the eye line; divide the lower section in half to indicate the top lip/mouth line).

b. Eyes: Draw as slender almond shapes over the eye guideline – allow an eye's width between the eyes and half an eye's width at the sides.

Note: Reshape the lower half of the face now or later, or even leave it as the basic egg shape. (Reshape depending on the style and end result you wish to achieve.)

c. Eyelids: Draw lightly as a curved line above the top of each eye.

d. Eyeball: Draw an incomplete circle/ball shape in each eye - drawing perfectly round shapes would make the eyes look like they were staring.

e. Eyebrow and eyelashes:
Eyebrow - draw a part curved line above each eye. (This could be drawn longer and fuller if preferred.)

Eyelashes - draw the top edge of the eyes/almonds slightly thicker and extend the lines slightly if you wish. Rarely will you need to draw individual lashes as this gives too much focus on the eyes.

f. Mouth: Top lip - touching the mouth guideline, draw an extended **'M'**. **Bottom lip** - draw a smaller 'm'. **Mouth opening** - indicate faintly.

g. Nose: Draw two tiny, understated curved shapes either side of the C/F line above the mouth.

h. Ears and hair: Ears - draw the ears from just above the eye guideline to finish around the nose guideline/top of lips. **Hairline** - on the C/F line, approximately a sixth down from the top, draw a curved line towards the ears. **Hair:** Draw the outline of the hair.

i. Redraw and hairstyle: Overlay with semi transparent paper and retrace the complete face, leaving out the guidelines, but adding the rest of the hairstyle and neck. Hairstyles whether long or short, straight or curly are defined by drawing a soft outline shape. Then several strands of hair are drawn together to emphasise the style lines.

Note: Remember these are guidelines to quickly get you started and to help you develop your own fashion faces in your own style.

For example some illustrators might sketch the eyes very large and rounder, place the nostrils and mouth a little lower, draw really full pouty lips, sketch a more pointy chin. There are no hard and fast rules. You must develop your own style that works for you.

Drawing Tips:
- If you want to draw a perfectly symmetrical face fold the drawing paper down the centre front line, draw one side of the face and trace through for the other.
- Never over work the details of the face as it moves the focal point of the drawing directly to the face instead of the clothing. If you make a mistake and need to erase, do so carefully, otherwise redraw.

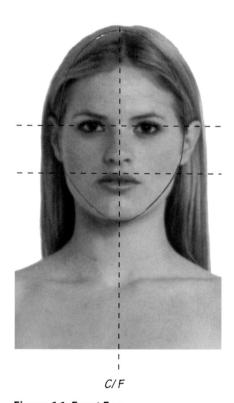

C/F

Figure 6.1: Front Face

The front view of the model's face displays all the features symmetrically

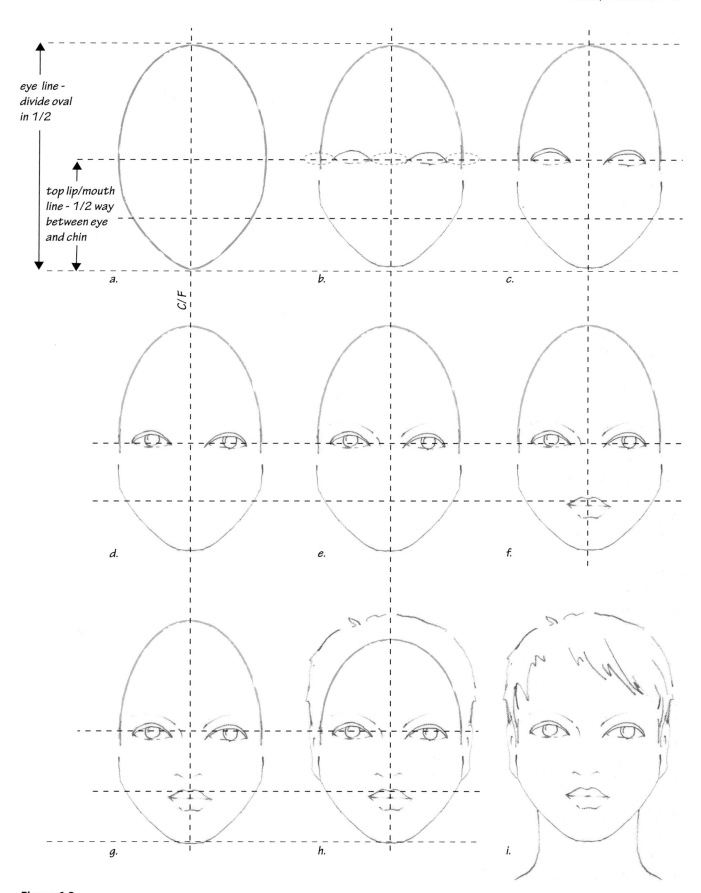

eye line - divide oval in 1/2

top lip/mouth line - 1/2 way between eye and chin

C/F

a.

b.

c.

d.

e.

f.

g.

h.

i.

Figure 6.2:

Face: *Front view showing step-by-step development*

Face sketch by Linda Jones

3. Drawing the Face: Turned

As the head turns the C/F line of the face turns and the outline of the face and the features no longer appear symmetrical (Fig. 6.3 and 6.4). The far cheekbone becomes more defined, and the features that are further away look slightly smaller than those closer. To help you understand this perspective study your own face in the mirror.

 Exercise 2: Drawing the Face Turned (3/4 Perspective)

Draw the turned view of the face following the instructions below and the step-by-step example opposite (Fig 6.5).

a. Head and guidelines: Draw an egg shaped head and the guidelines as before (Fig 6.2a).

b. Head turned: Redraw the head rotated/turned to give a 3/4 perspective; the chin (pointed end of the egg shape), will move to one side of the C/F.

c. Head and C/F: Draw in the new C/F line.

d. Eyes (eyelids and eyeballs)**:** Draw the eyes - the eye furthest away is smaller in width than the one nearest to you. There is approximately a 3/4 eye width between them to allow for the nose, and a small space between the furthest eye and the far side of the face.

e. Eyebrows and lashes: Eyebrows - draw the brows lightly as curved lines above the top of each eye, the furthest brow is drawn shorter. **Eyelashes** - if you prefer, draw a thicker line along the top edge of the eye extending at the outer edges.

f. Mouth: The lips (M) are drawn shorter on the far side as they disappear from view.

g. Nose: Draw soft lines indicating the length and shape of the nose and nostril on the far side of the C/F and, on the near side, draw a small curved shape for the other nostril.

h. Face shape, hairline, neck and ears: Face - on the far side, reshape the face from the eyebrow to the eye and out to the prominent cheekbone curving down towards the mouth and chin; continue up to the jaw bone.

Extend the back of the head, draw the **hairline** on the C/F line, approximately a sixth down from the top, draw a curved line towards the forehead and ear.

Ears - draw the ear just above the eye and mouth guidelines.

i. Redraw and hairstyle: Overlay with semi transparent paper and retrace the complete face, leaving out the guidelines, but adding the hairstyle and a slim, elegant neck.

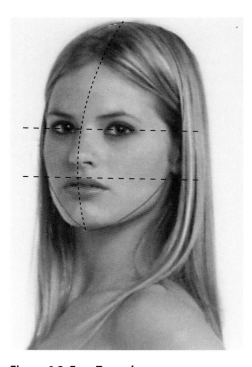

Figure 6.3: Face Turned

As the model begins to turn her face the appearance of her features are no longer symmetrical; notice her jawbone and cheekbone become more prominent

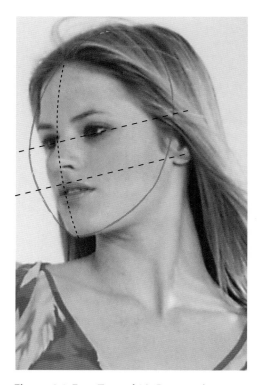

Figure 6.4: Face Turned 3/4 Perspective

As the model turns her face to a 3/4 perspective the appearance of her features are no longer symmetrical; her chin is now more prominent

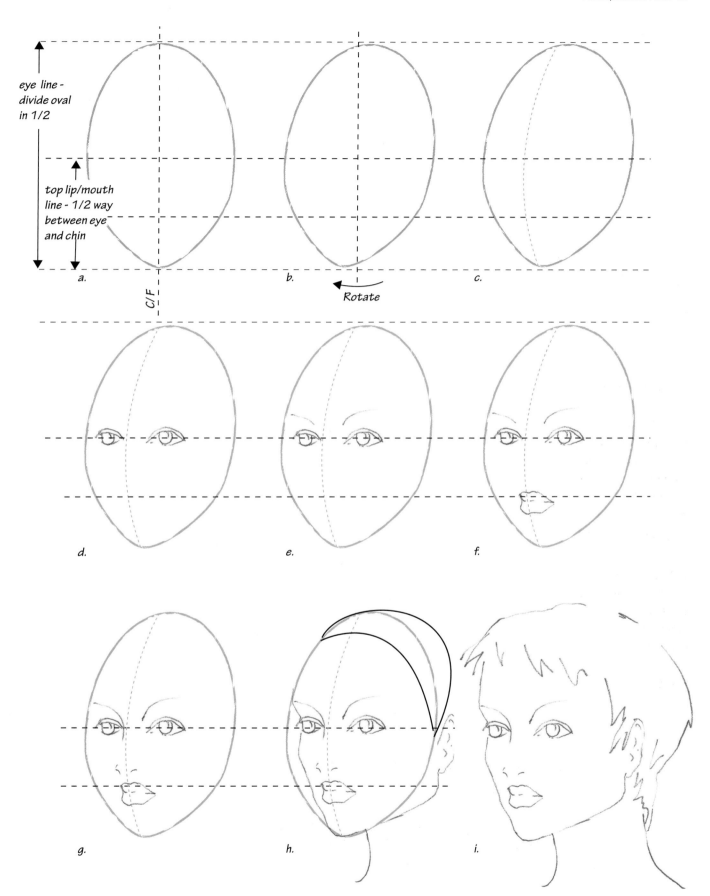

eye line - divide oval in 1/2

top lip/mouth line - 1/2 way between eye and chin

a.

C/F

b.

Rotate

c.

d.

e.

f.

g.

h.

i.

Figure 6.5:

Face: Turned or 3/4 perspective view - *showing step-by-step development*

Face sketch by Linda Jones

4. Drawing the Face: Profile

With the view of the head in profile, the drawing guidelines remain the same but the shapes of the features are distinctly different (Fig. 6.6).

 Exercise 3: Drawing the Face in Profile

Draw the profile view of the face following the instructions below and the step-by-step example opposite (Fig 6.7).

a. Head and guidelines:

• Draw an egg shaped head and the guidelines as before (Fig 6.2a).

• Draw vertical lines to divide the left and right side of the oval in half again; this is the position for the one side of the eye and the ear guideline.

b. Eye: Draw the eye, eyelid, brow and lashes.

c. Nose: To help you draw the front profile of the face, box around the one side of the oval. Draw the nose line protruding outside of the oval/box; draw the nostril.

d. Forehead, mouth and chin: From the top of the head, draw a gentle curved line down and in towards the eye and out again, forming the profile nose shape. From the nose curve in and out to form the pouting lips and prominent chin.

e. Ear: Draw the ear (edge on the guideline, between the eye and mouth guidelines.

f. Back of head and neck: To help you draw the back of the head and neck, box around the right side of the oval extending it to form the centre back line of the head. From the top of the head draw a curved line towards the c/b rectangle; continue down to form the back neck and finish with the angled front line of the neck.

g. Hair: Draw in the hairline.

j. Redraw and hairstyle: Overlay with semi transparent paper and retrace the complete face, leaving out the guidelines, but adding the hairstyle.

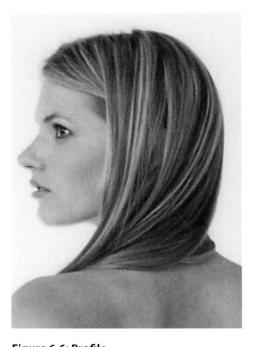

Figure 6.6: Profile

As the model turns her face to a profile view so the appearance of her features are a different shape; only one ear and eye can be seen; the forehead, nose, chin and jawbone become more prominent

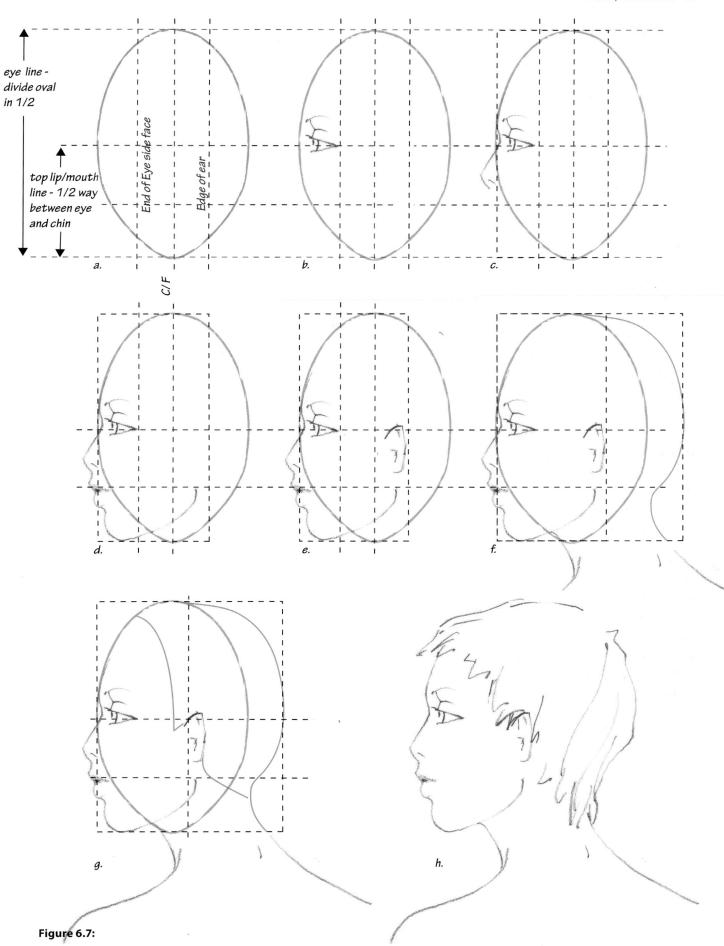

eye line - divide oval in 1/2

top lip/mouth line - 1/2 way between eye and chin

End of Eye side face

Edge of ear

C/F

a.

b.

c.

d.

e.

f.

g.

h.

Figure 6.7:

Face: Profile view - showing step-by-step development

Face sketch by Linda Jones

5. Gallery of Fashion Faces

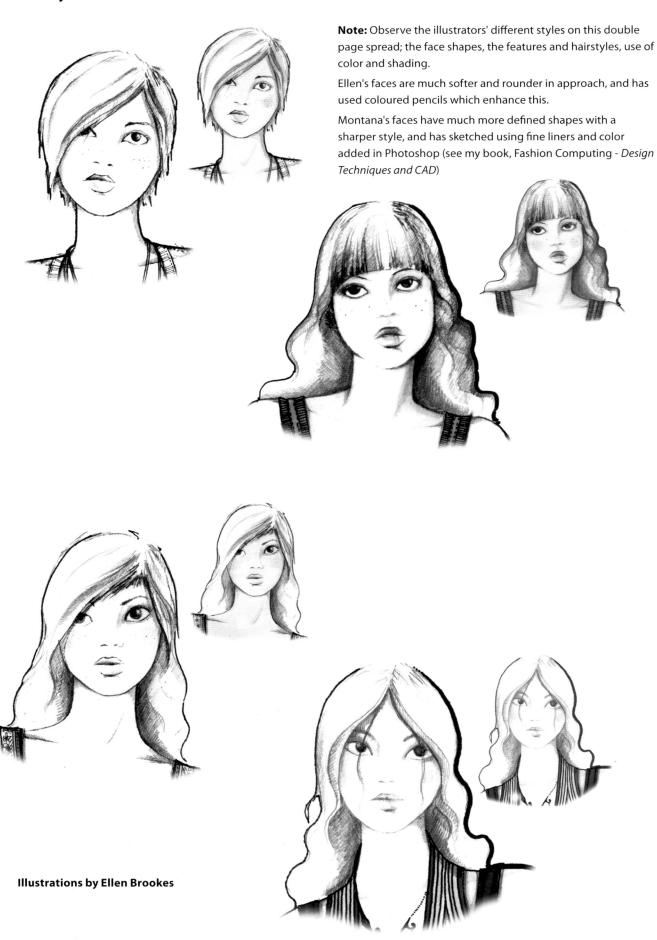

Note: Observe the illustrators' different styles on this double page spread; the face shapes, the features and hairstyles, use of color and shading.

Ellen's faces are much softer and rounder in approach, and has used coloured pencils which enhance this.

Montana's faces have much more defined shapes with a sharper style, and has sketched using fine liners and color added in Photoshop (see my book, Fashion Computing - *Design Techniques and CAD*)

Illustrations by Ellen Brookes

Illustrations by Montana Forbes

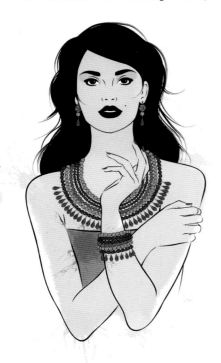

Left and below, illustrations by Gemma Linnell

Photos of model (hands and feet) - Christian Blanken runway show LFW

Hands and feet sketches by Linda Jones

5. Hands

Female fashion hands are presented as slender, elegant and understated. An outstretched hand is approximately 0.75 of a head depth. A common mistake is the tendency to draw them too small (see *Oval and Triangle Technique* chapter).

 Exercise 4: Trace Your Hand

To familiarise yourself with the shape and 'bendy bits' of the hand; fingers, knuckles and finger joints, complete the following exercises.

a. (Fig 6.8a): Place your hand flat on the drawing paper and, using a fine liner or graphite pencil:
- Draw around your hand beginning and ending at your wrist.
- Draw sweeping curved lines over the joints and knuckle positions to familiarise yourself with the points where they bend.

b. (Fig 6.9a): Place your hand flat on the paper, extend your forefinger and thumb, clench the other fingers under your palm. Draw around your hand.

c. (Fig 6.8b and 6.9b): To make your sketches look more like *'fashion' drawing hands*, overlay with semi-transparent paper and redraw the shapes slightly narrower while smoothing the lines and making the hands slender and more elegant.

Draw around your hand

Fashion sketch hand - cleaner lines

Figure 6.8a and b:

Draw around your outstretched hand, then redraw more elegantly for the fashion hand

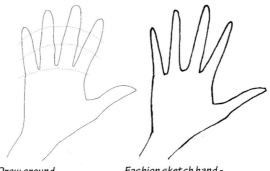

Draw around your hand

Fashion sketch hand - cleaner lines

Figure 6.9a and b:

Draw around your hand (forefinger and thumb extended, three fingers clenched), redraw more elegantly for the fashion hand

6. Drawing Fashion Hands

The following photographs show some of the most popular hand positions for fashion illustration. When learning to draw the hands, you could start by sketching them very simply by drawing them partly hidden, for example, in trouser pockets, or by the sides of the body.

Exercise 5:

Practise sketching hands by following the photos and the drawn examples Fig. 6.10 to 6.12. and the example on the facing page.

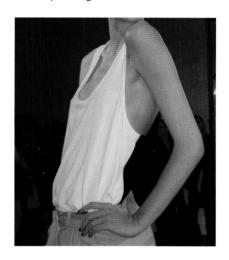
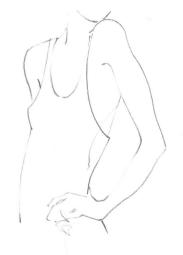

Figure 6.10:

The fingers of the model's hand are drawn grouped together with a few simple lines and the thumb extended.

Figure 6.11:

With hands in pockets, just a few simple lines indicate the thumbs and shape of the hands.

Figure 6.12:

The hands fall each side of the model in a relaxed position and are drawn using a simple shape and a few lines to define the fingers and thumbs

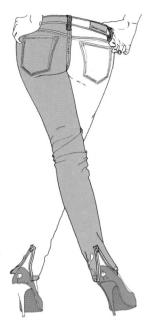

Illustration by Montana Forbes
Media: Graphite pencil, pen and color edited using Photoshop

Feet sketches by Linda Jones

7. Feet and Shoes

Although fashion figures are rarely drawn without shoes, learning to draw the bare foot will help you understand the perspective and shape of the foot and consequently make it easier to draw footwear. Like the hand, the female fashion foot is drawn **long** and **slender**. It is approximately the same depth as the head (see the *Oval and Triangle Technique* chapter).

Note: The higher the heel of the shoe, the longer the front view of the foot appears. The rough guidelines are drawn to initially outline the foot's shape and note how they are then developed and redrawn.

These photographs (Fig. 6.13 to 6.16) present typical positions of the foot.

 Exercise 6:

Practise sketching feet by following the photos and the drawn examples Fig. 6.13 to 6.16, front, side, turned and side back views.

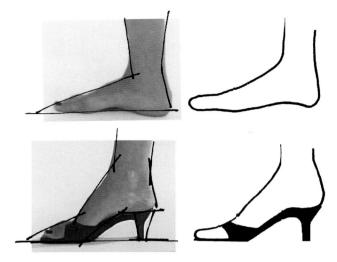

Figure 6.13: *Side foot with and without shoe - drawn more slender for the fashion foot, the higher the heel, the higher the instep*

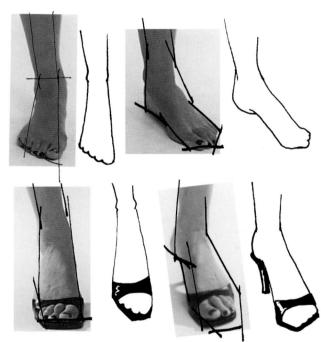

Figure 6.14, and 6.15: *Front and turned bare foot - the fashion foot is drawn long and slender; front and slightly turned foot with shoe - the fashion foot is drawn long and slender, the higher the heel, the longer the foot appears*

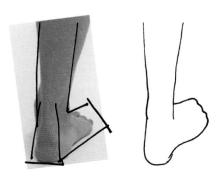

Figure 6.16: *Back foot, 3/4 view without shoes*

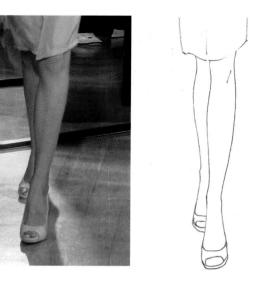

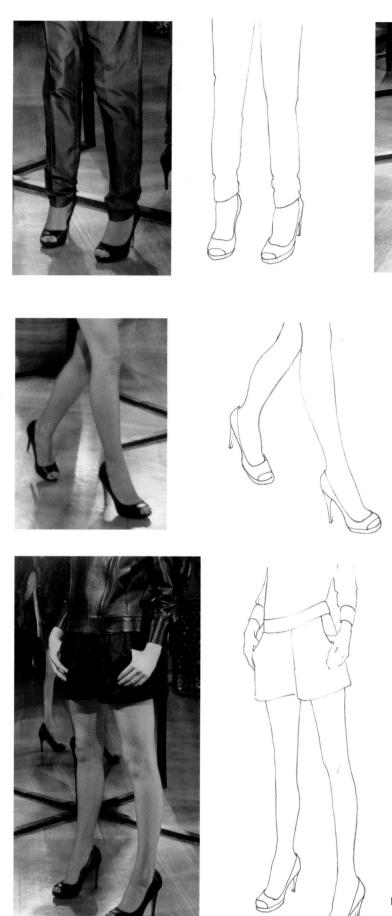

Figure 6.17 - 6.20: Static, walking and posed views

Feet slightly turned/3/4 perspective and walking views

8. Gallery of Fashion Faces, Hands and Feet

Take a look at the following gallery of illustrations from several designers and illustrators worldwide. Note the different styles, techniques, and media used to draw the face, hair, hands and feet. As you master the basic fashion drawing techniques, like these professionals, you will naturally develop your own style of illustration.

Illustrations by Stuart McKenzie
Media: Pen drawing, edited in Photoshop

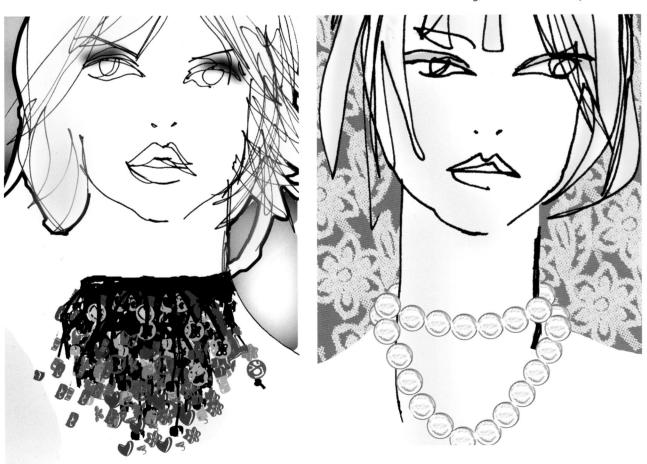

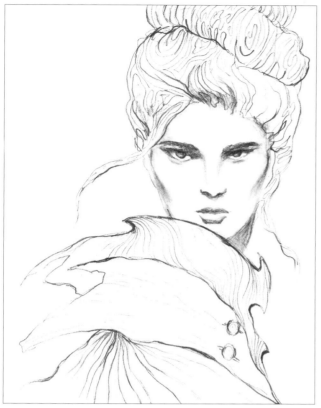

Illustration by Laura Krusemark
Media: Graphite pencil

Illustration by Nadeesha Godamunne
Media: Pen drawing, watercolor, edited in Photoshop

Illustration by Sarah Beetson
Media: Pen drawing, acrylics, edited in Photoshop

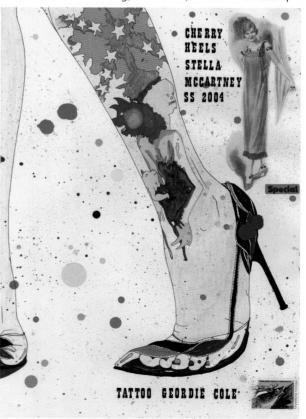

Illustration by Sarah Beetson
Media: Pen drawing, acrylics, edited in Photoshop

Fashion Figure Templates

To give your fashion figure templates a more professional look you need to sketch the facial features, hands and feet, the techniques of which were covered in the previous chapter, *Faces, Hands, Feet*. In this chapter, we now complete the fashion figure templates 2-7. In the next chapter, *Clothing Design*, your fashion figures will then be further developed by adding clothing.

Illustration courtesy **of PROMOSTYL Paris,** International Trend Forecasting Agency from their Womens Summer Trends book

Art Box

- Your fashion templates 2 to 7 from the *Fleshing Out* chapter
- Drawing media, 2B Graphite pencil, fine liners, etc.
- A3 (14x17 inch) semi-transparent paper
- Full length mirror to observe yourself in various poses to understand body balance, movement, shoulder and waist angles, etc.
- Fashion images of the fashion model
- Portfolio to keep work protected

1. Fashion Figure Matrix Templates: Faces, Hands, Feet

 Exercise 1:

Using semi-transparent paper, overlay each of your fleshed out templates and complete your fashion figure by drawing the face, hands and feet (Fig. 7.1 to 7.6). Follow these sketches as examples and redraw your own fashion templates until you are happy with your style and figure.

Drawing Tips:

- If using a fine liner, use the appropriate size, for example 01 for small scale details like the face.

- When drawing a small scale fashion figure, you must be careful not to draw the facial features too heavily as the detail could make the face appear too bold and overpowering.

- By using semi-transparent paper it is easy to improve a line, or correct the proportion and shape of the figure each time you redraw.

For a more dynamic pose you might also sketch:

- The fingers - longer and slender
- The neck - longer and angled
- The hips thrusting further forward
- A narrower waist

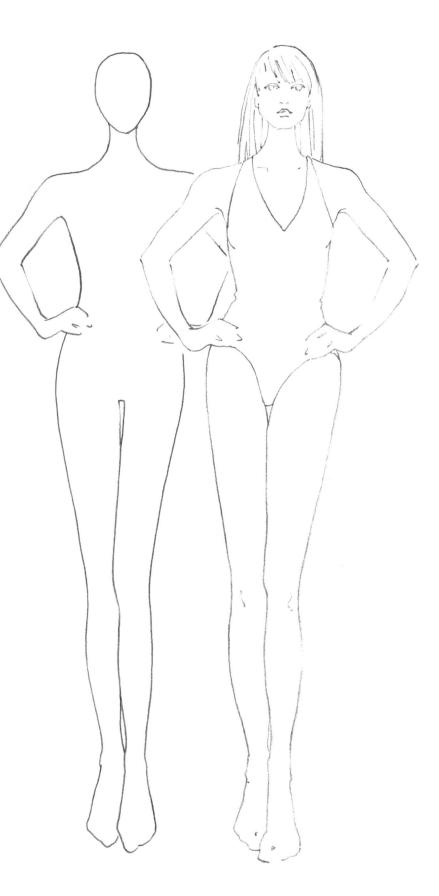

Figure 7.1: Template 2 (fashion matrix)

Fleshed out front facing - hands on hips, body weight very slightly more on one leg than the other

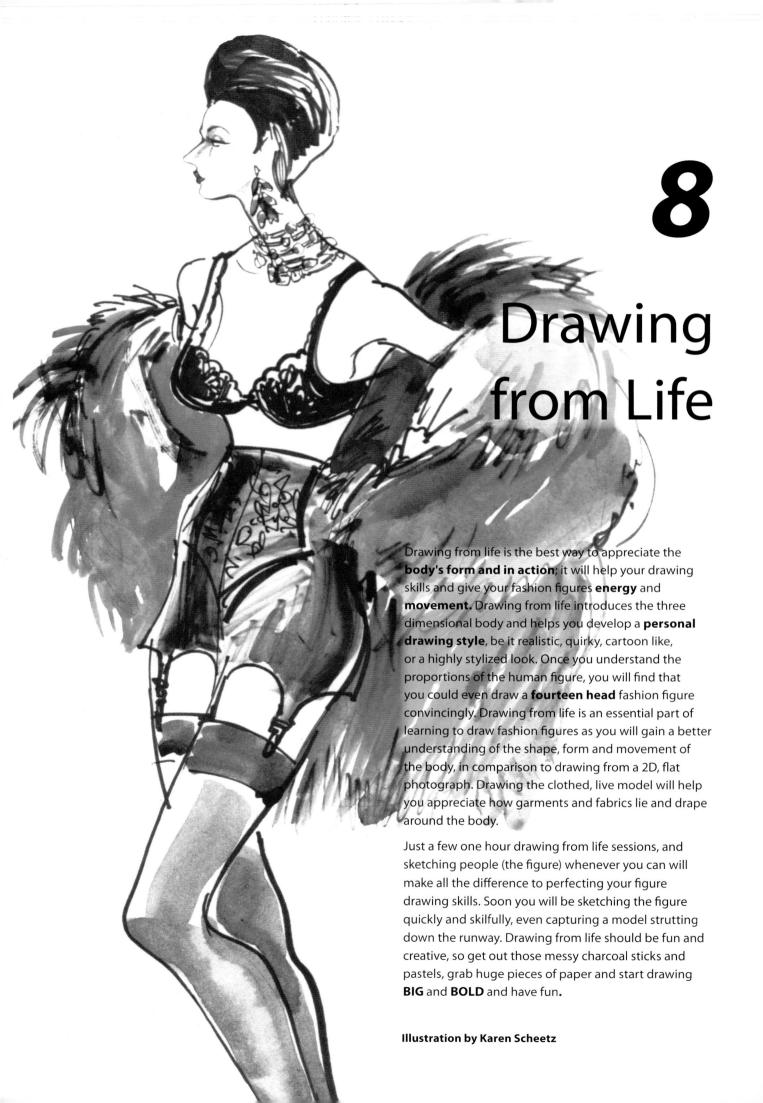

8

Drawing from Life

Drawing from life is the best way to appreciate the **body's form and in action**; it will help your drawing skills and give your fashion figures **energy** and **movement.** Drawing from life introduces the three dimensional body and helps you develop a **personal drawing style**, be it realistic, quirky, cartoon like, or a highly stylized look. Once you understand the proportions of the human figure, you will find that you could even draw a **fourteen head** fashion figure convincingly. Drawing from life is an essential part of learning to draw fashion figures as you will gain a better understanding of the shape, form and movement of the body, in comparison to drawing from a 2D, flat photograph. Drawing the clothed, live model will help you appreciate how garments and fabrics lie and drape around the body.

Just a few one hour drawing from life sessions, and sketching people (the figure) whenever you can will make all the difference to perfecting your figure drawing skills. Soon you will be sketching the figure quickly and skilfully, even capturing a model strutting down the runway. Drawing from life should be fun and creative, so get out those messy charcoal sticks and pastels, grab huge pieces of paper and start drawing **BIG** and **BOLD** and have fun**.**

Illustration by Karen Scheetz

Art Box

- A2 (18 x 24 inch) inexpensive paper - lots of waste: semi-transparent, wrapping paper, newsprint, wallpaper, etc. Use quality paper for your portfolio
- Charcoal sticks or pencils and any of the following: Colored pastels sticks/ pencils, wax crayons, markers (thick nib), thick brushes if working with inks, etc.
- Fixative Spray - for charcoal and pastels
- Easel or a raised drawing board
- Putty eraser - to lighten media and effects

1. The Studio

The venue you use for your drawing from life sessions:

- Must have adequate lighting to clearly observe how light falls on the model's body, creating highlights and shadows.
- Should allow you enough space to work on large sheets of paper (A2/18 x 24 inch)
- Might become very messy when using dusty charcoals and pastels; you might need to cover the floor with paper; it is also advisable to wear old gear.

Preferably work at an easel or use a large drawing board - to produce your best work you need a comfortable drawing position. You also need to be able to stand back from your work periodically and check your drawing for its overall impression.

The media listed in this art box has been selected to encourage a bold approach to drawing, this means looking at the figure as a whole leaving out intricate details. For drawings that are not to be used for presentation you can use a cheap hair spray to temporarily fix the media (charcoals/pastels) - this is not recommended for finished artwork as it is not a permanent fix and might discolor the paper.

Figure 8.1 and 8.2, below left to right: Drawing from life at Central St Martins - *Student works at an easel; note that by exaggerating the legs they have become the focus*

Drawing from life class at UEL - *With huge sheets of paper attached to the wall and using large paint brushes the students are encouraged to let go of their inhibitions and capture the model by painting with large bold brush strokes*

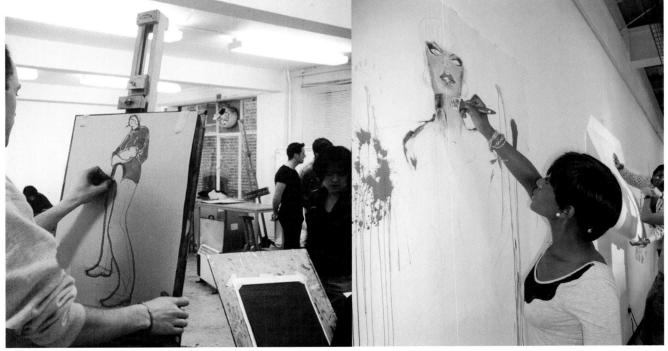

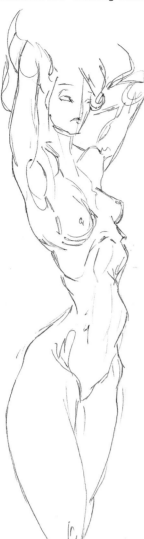

2. The Model

Female and male fashion figures are generally drawn as young and slender; this is in line with how the fashion industry typically promotes clothing. If your models do not fit this *'perfect'* description it is not a problem as it is good experience and practise to draw people of all age groups and with different figure shapes. Later, you could alter your sketches to make them more like a fashion figure.

Drawing people in action is also good practise. If fashion reporters or illustrators are sketching the latest fashion trends at fashion shows they only have a few seconds to sketch the models strutting down the catwalk.

Initially, in your drawing from life sessions, the model should either be wearing fitted garments so that you can concentrate on the shape and stance of the body, or posing nude. As you become more proficient drawing the figure in different poses, you can progress to drawing the model wearing various styles of clothing; this will help you to understand how a garment fits on and around the body, how it hangs, drapes and creases. Costume designers would especially benefit if the model is dressed in a uniform, period costume or as a specific character.

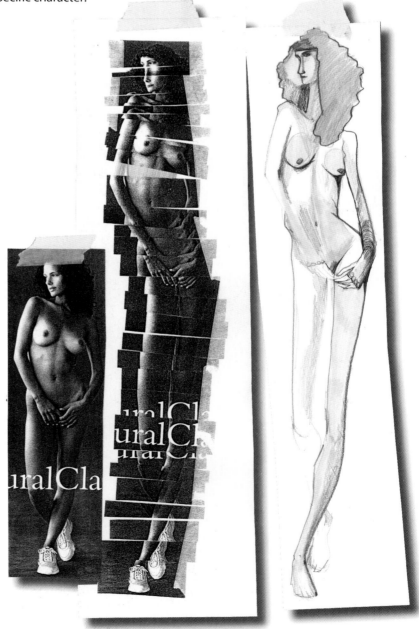

Figure 8.3, above: Life drawing by Amy Elizabeth Booth

Media: *Graphite pencil*

Line sketch capturing the movement of the body ('S' Curve) and the incredible shape and form of the model's body

Figure 8.4, right: Life drawing by Nadeesha Godamunne

Media: *Graphite pencil and water color*

 ### Exercise 1: Cut and Lengthen

Try this exercise yourself (Fig.8.4)

A magazine tear of the naked model is copied several times then cut into strips and selected sections are retaped into position lengthening various parts of the body. It is then sketched using graphite pencil and a watercolor. This is an excellent exercise for experimentation to understand how various parts of the human form can be exaggerated and still work as a whole.

3. Capturing The Poses

In your 'fashion' **drawing from life** classes, I suggest you start with the model in similar poses to those outlined in the figure matrix (page 13 and the exercise on the next page and Fig. 8.7); then move on to action poses. The emphasis should be on capturing the pose and body shape quickly, not necessarily drawing intricate details. (In contrast, in a traditional **life drawing art class** the nude model holds a pose for 30 minutes to an hour and the artist is expected to draw more explicit sketches.)

Exercise 2: Here are some suggestions for the drawing exercises:
• Warm up exercise - start by drawing a sequence of quick poses where the model holds the pose for only 30 seconds to a minute, allowing just enough time for you to capture the overall figure pose in basic shapes. This is a great exercise for releasing inhibitions as there is no time to get bogged down with any details.
• Move to two minute poses; this will give you enough time to flesh out the body.
• Progress to longer poses of five to 20 minutes giving you time to sketch in more detail - look at shading the figure, the shadows, the highlights, and begin to define or soften lines.

Figure 8.5, right: Life drawing by Amy Elizabeth Booth
Media: *Graphite pencil*
Sketch captures the movement of the body in a walking pose

Figure 8.6, below: Life drawings by Jean Oppermann
Media: *Pen and ink washes*
These action sketches of the **'body in motion'** *take about three to ten mins each; an excellent exercise to loosen up. By using a very liquid media using bold brush or pen strokes, you can capture the form and action of the pose and the clothing as it moves and drapes on and around the body in action*

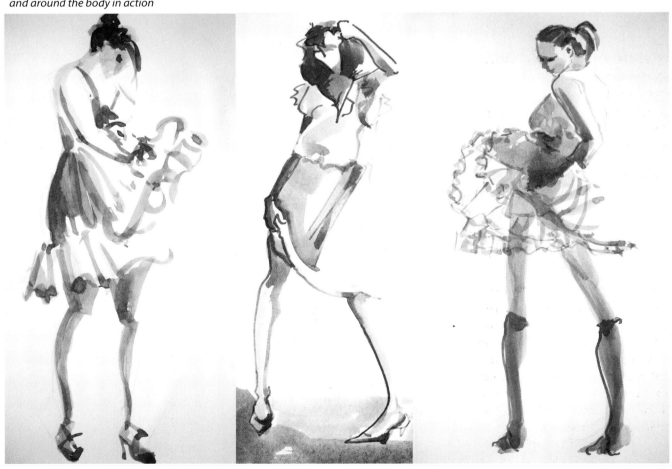

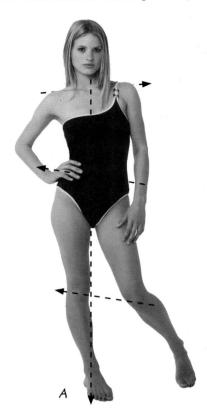

A

Figure 8.7, a - e, right and below: Drawing the model from life

4. Drawing Techniques

See *Oval and Triangle Technique , and Fleshing Out* chapters. The OT technique is an excellent way to get started when drawing from life; elongate the legs just as you have done previously. The idea is to capture the pose quickly and simply and then develop the drawing in more detail if you need to. Do not worry about making mistakes, just relax, you should be having fun while loosening up your drawing style and understanding more about the body.

 Exercise 3: Drawing the model - Fig. 8.7 a to e:

A. First analyse the pose from head to foot - note the angles of the shoulders, waist and hips.

B. Using a charcoal or a dark pastel stick divide your paper into head depths and draw in some rough guidelines across the page to help you establish the figure proportions.

C. Draw the head/oval; note the weight bearing foot, mark in the v/b line from the pit of the neck; draw the shoulder, hip and knee angles, then capture the overall pose using triangles, ovals and basic shapes.

D. Observe the model; flesh over your basic sketch from head down.

Note: You do not need to use the overlay technique here; drawing on top of the guidelines is fine as these are rough drawings.

Lines can be smudged with your fingers if too dominant or distracting to the eye. Tweak your drawing to suit the desired effect you want; you do not need to draw every line exact.

E. You can use your life drawing as a template for your fashion drawings; trace over, scale down until you are happy with the result.

Paper divided into 9

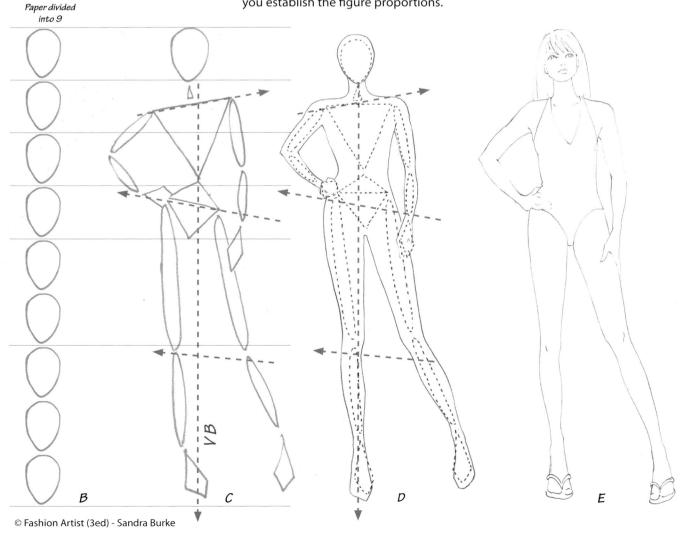

B C D E

A

B

C

Exercise 4: Shading Your Figures

You can shade your drawing from life figures by applying tonal definition to give depth, volume and form, and to gain a 3D effect (Fig. 8.8 a, b, c):

A. Observe the figure you are sketching and identify the three main tones and where you will add them to your life drawing - dark, medium and light - these give the 3D effect.

Tones: Dark tones appear further away than light tones; dark tones appear on inward curves, higher areas are lighter.

B. Start drawing the dark tones. As you sketch gradually use less depth of shading so that the media is lighter. You will start to see depth and shape on your figure.

You could also use a lighter pastel.

C. Take a white pastel and sketch the lighter areas if you need to. Go over the figure, retouching if necessary; be careful not to overwork the shading - less is best.

The Face: If any more detail is required, add only the minimum to give an impression of the features, for example, lightly shading should be enough.

Figure 8.8 a, b, c: Illustration by Karen Scheetz

Media: Charcoal is used to create a softer looking drawing.

Note the use of strong, dark and soft smudged lines creating shadows and highlights; and the use of a rust coloured pastel for added detail.

5. Creative Exercises

Exercise 5: Creativity and Innovation

Frequent sketching of everyday poses and experimenting with different media will enhance your creativity and innovative thinking, whilst improving your fashion drawing and illustration skills. Try these fun exercises:

- **Semi-blind sketching:** Keep your eyes focused on the model; draw from the head down; only look at the drawing paper to relocate a point, e.g. from an outline to centre front – do not rush the sketch.
- **Opposite hand:** Draw with the opposite hand to what you would normally use.
- **Boot polish:** Cover finger with dark boot/shoe polish/ paint and create bold figures in movement.
- **Continuous line:** Draw figures using one continuous line, never breaking until the figure is complete (just like peeling an apple in one go!).
- **Flat charcoal:** Take the flat side of a charcoal stick and draw the complete figure.
- **Vary the scale:** Draw figures large scale to thumbnail size.
- **Media and paper:** Experiment with all media and paper - leave your comfort zone.

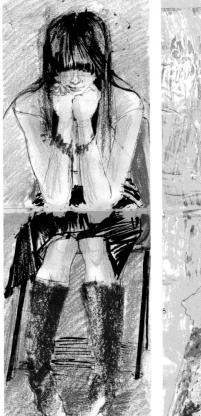

Figure 8.9a, b, c, below: Sketches by Nadeesha Godamunne
Media: *Brush and ink*
These impressions of the model have been captured quickly using bold strokes and splashes of color to give just an impression of the body in pose

Figure 8.9a, b, above: Sketches by Ann-Marie Kirkbride
Media: *Marker and wax crayon; girl seated*
Media: *Felt pen, emulsion and acrylic; girl standing*

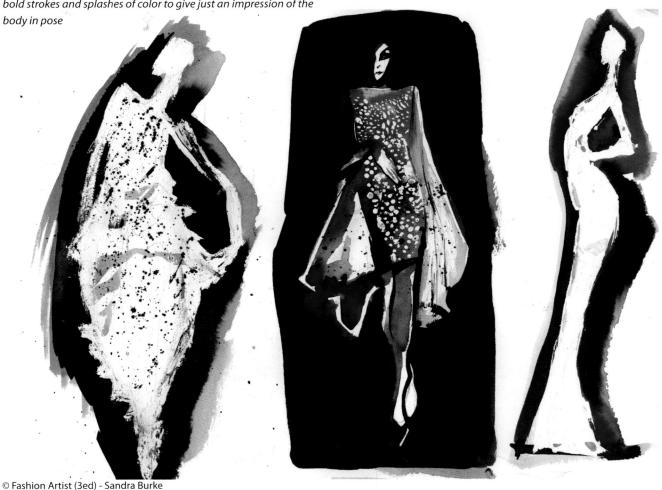

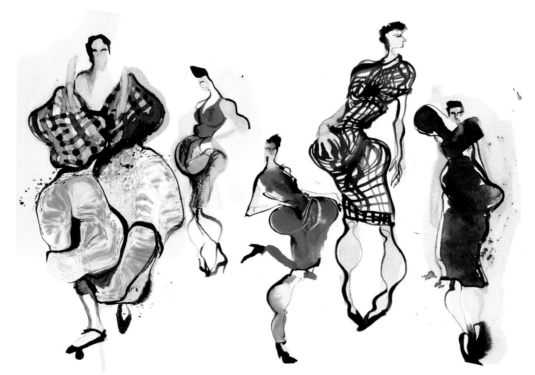

Figure 8.10 and 8.11, above and below: Sketches by Nadeesha Godamunne

Media: *Mixed media from acrylics to wax, graphite, charcoal, watercolor and watercolor pencils*

Nadeesha's approach to this series of action sketches and fashion poses is one of having fun and being creative and experimental with the model's poses and the media. These sketches of the model have been captured quickly using a mix of bold strokes and splashes of color and strong line.

The sketches above have taken on a cartoon like quality, whereas, the sketches below are excellent as fashion poses to display the clothing more accurately.

6. Life Drawings as Fashion Templates

Once you have completed a number of 'fashion drawing from life' sketches, select the ones you feel are most suitable as fashion poses to display your designs and redraw them for your fashion figure templates. Do this by tracing over the figures, correcting and enhancing lines, and perfecting the pose as you proceed from head to toe. Oversized sketches can be scaled down by using a large format photocopier, scanner, digital camera/iPad (edit in Photoshop, etc.) or scale manually.

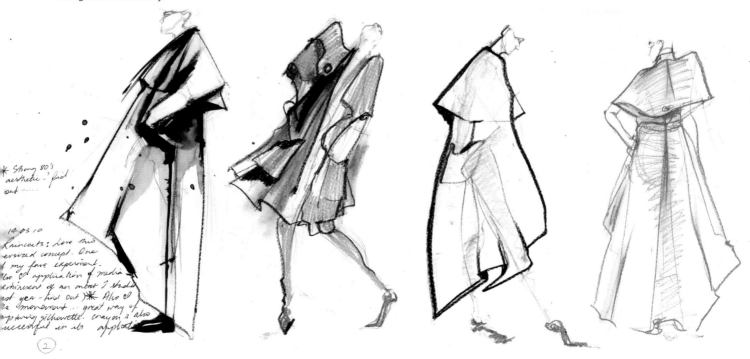

6. Gallery of Drawing from Life Fashion Figures

Take a look at the following gallery of stylised fashion artworks from illustrators and designers around the world. Note the various styles of illustration, how they portray the body, and their use of media. Their understanding of the body is such that they are able to exaggerate certain parts of the figure or pose and make the artwork both dynamic and convincing.

Illustrations by Amy Elizabeth Booth

Media: *Graphite pencil, pen and watercolor pencil wash*

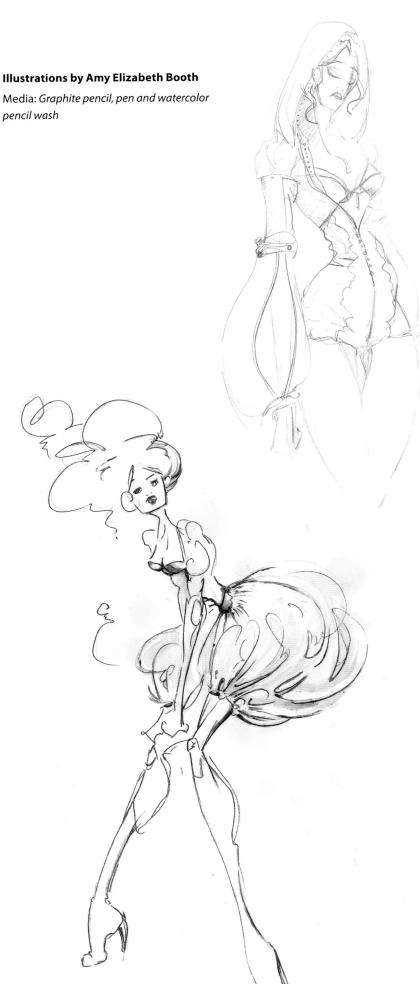

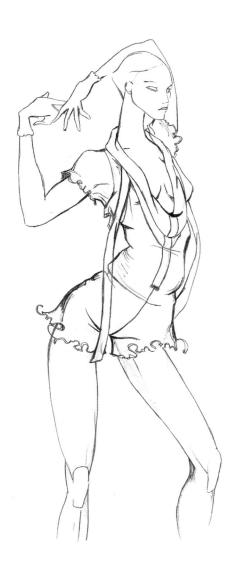

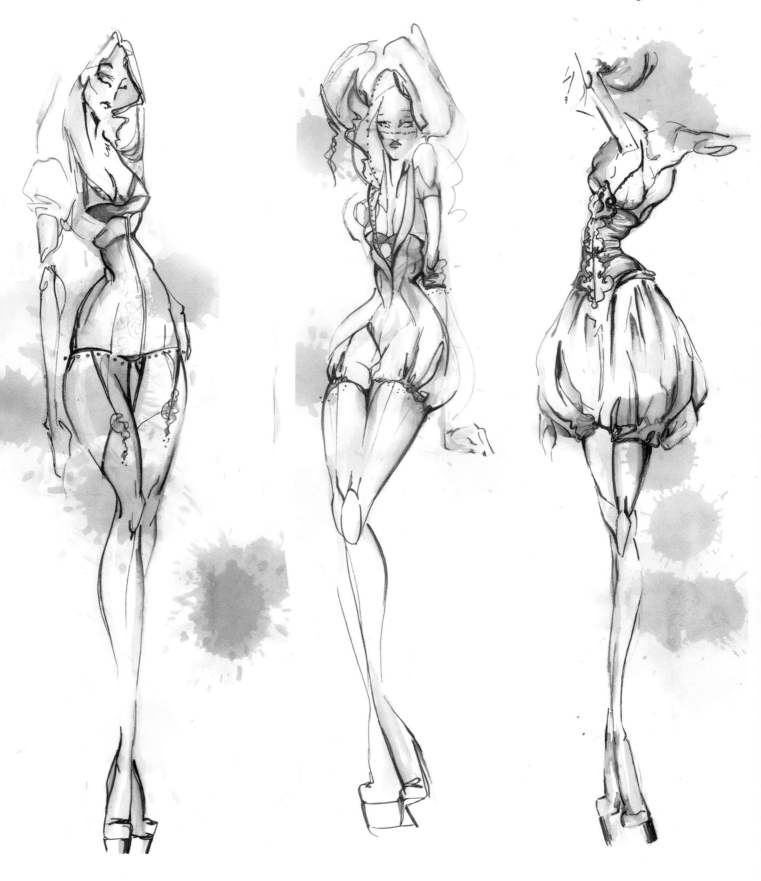

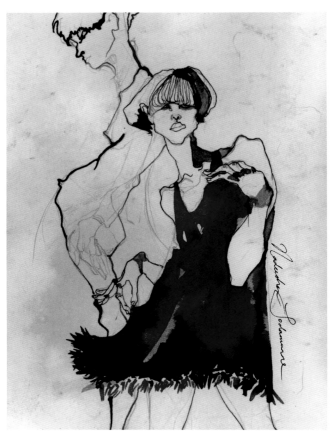

Illustration by Nadeesha Godamunne

Media: *Pen and watercolor*

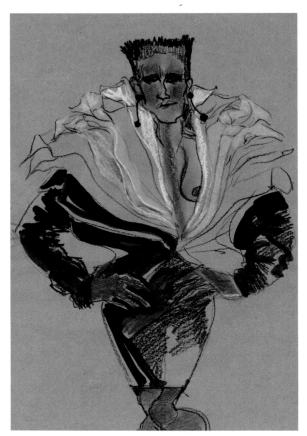

Illustration by Nadeesha Godamunne

Media: *Water soluble pastels*

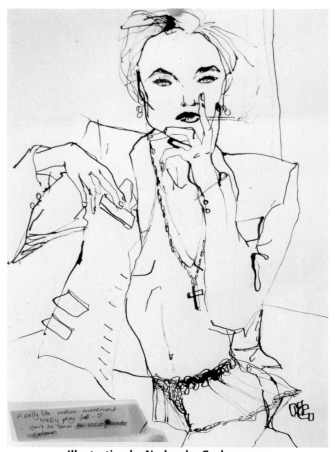

Illustration by Nadeesha Godamunne

Media: *Pen and ink*

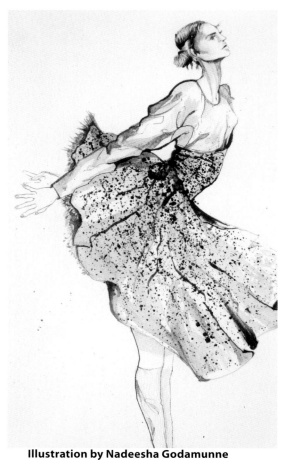

Illustration by Nadeesha Godamunne

Media: *Inks, pen and brush strokes*

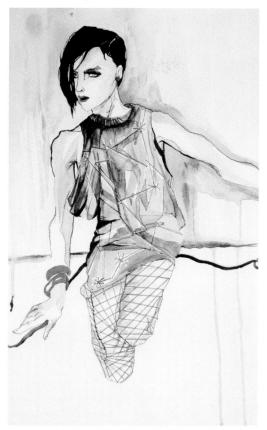

Illustration by Nadeesha Godamunne

Media: *Watercolor*

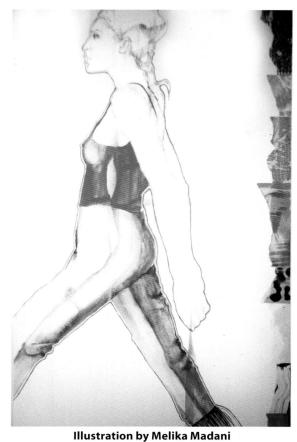

Illustration by Melika Madani

Media: *Ink, water soluble pastels and collage*

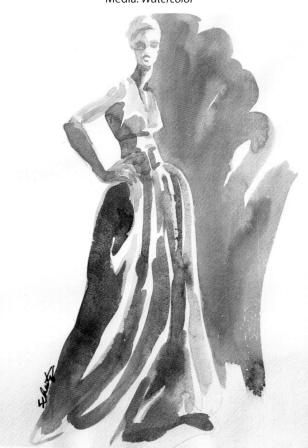

Illustration by Karen Scheetz

Media: *Watercolor*

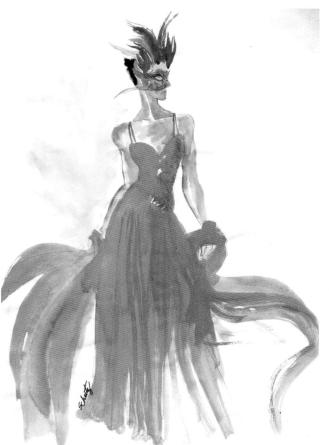

Illustration by Karen Scheetz

Media: *Watercolor*

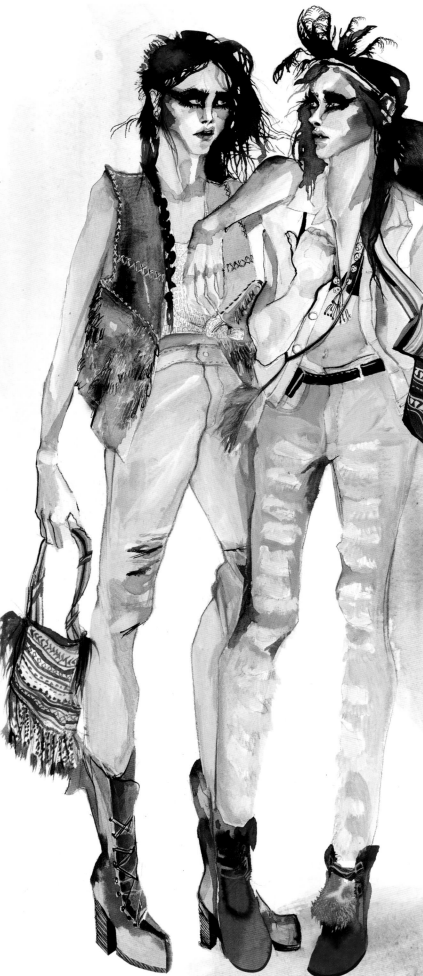

9

Clothing Design

A competent fashion designer requires the skill to sketch clothing designs ranging from a simple tee shirt to an extravagant **Haute Couture** creation. This includes drawing clothing as:

• Flats and technical drawings
• Designs on the fashion figure body/croquis.

Flats, also referred to as **working drawings,** and **technical** and **specification drawings** in the production process, are an explicit drawing of a garment design. They are drawn to scale, showing construction lines and styling details. Fashion companies use flats as their primary visual source to communicate and liaise with the design team, buyers, clients, pattern makers and sample machinists, and for production, marketing and merchandising purposes. It is, therefore, essential that you are not only able to present your work on the fashion figure but are also competent in drawing flats.

Fashion designs drawn on a figure are used in design presentations where a more flamboyant style of illustration is required to increase visual impact, for example, marketing, trend forecasting and styling.

This chapter will explain how to sketch clothing as flats, specs and technical drawings and on the fashion figure using your fashion figure templates. Your *'clothed'* templates will then be rendered in the *Fabric Rendering* chapter.

Illustration by Nadeesha Godamunne

Art Box

• Your templates 2 to 7, *figure templates* chapter
• Drawing media, 2B Graphite pencil, fine liners, etc.
• Ruler, french curves (optional)
• A3 (14x17 inch) semi-transparent paper
• A3 (14x17 inch) Cartridge paper /preferred paper
• Fashion mags/resource folders/portfolio

1. Figure Templates for Specs

 Exercise 1:

When drawing flats for clothing production (specs/specification drawings) the **industry standard body** is front or back facing with normal body proportions **(seven to eight heads)**. Your fleshed out Template 1, from the *Fleshing Out* chapter, is ideal for front and back views, but you need to **redraw** it with normal length legs as per the human form (Fig. 9.1). Note that the head and feet of the back view are reshaped as per example. Name this new figure, **Template 1 Basic Body.**

Draw the style lines on your clothing template as per Fig. 9.1. These style lines correspond to the dress form and are the fit and construction lines from which clothing patterns and garments are made. They will help you draw the correct fit, proportions and details for your designs.

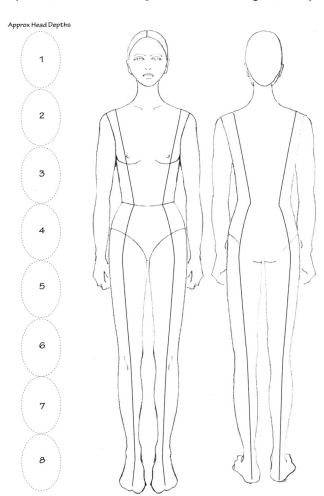

Approx Head Depths

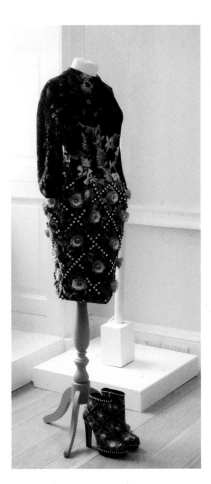

Figure 9.1 (above): **Template 1 Basic Body** (production/spec example)

Template 1, front and back view redrawn with normal leg proportions. Use as a clothing template for flat drawings for production purposes. See Fig.9.2 (larger copy) and trace or draw your own hand drawn basic figure template.

Right: *The dress form/mannequin),* Mary Katrantzou Ready-To-Wear Collection, London Fashion Week

Approx Head Depths

Key Lines and Lengths

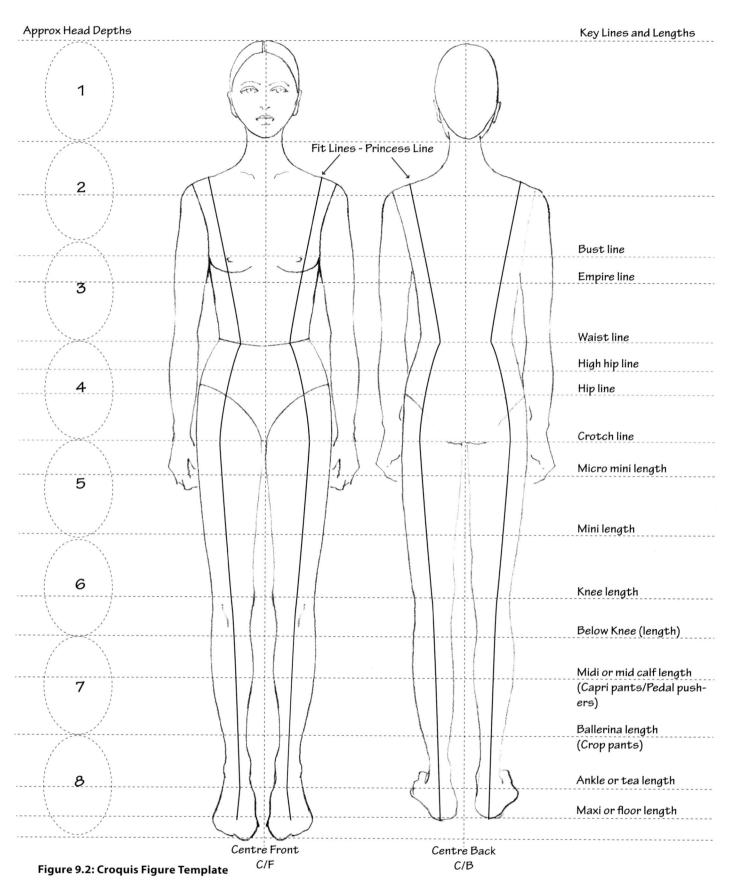

Fit Lines - Princess Line

1

2

3

4

5

6

7

8

Bust line

Empire line

Waist line

High hip line

Hip line

Crotch line

Micro mini length

Mini length

Knee length

Below Knee (length)

Midi or mid calf length
(Capri pants/Pedal push-
ers)

Ballerina length
(Crop pants)

Ankle or tea length

Maxi or floor length

Centre Front
C/F

Centre Back
C/B

Figure 9.2: Croquis Figure Template

Shows the front and back views of a body with average proportions (7.5 - 8 heads depth).
Note: Every manufacturer produces fashion apparel/garments for a particular target
market and, therefore, will have developed specifications (technical drawings) of their own
in regard to their customer figure type. Consequently there is no one standard - template.

Croquis Template: Linda Jones

2. Flats/Technical Drawings

The next two sections present various styles of clothing drawn as flats from various international fashion designers and fashion companies. The flats are both hand drawn and computer generated.

• These flats are the starting point for specification (technical) drawings for production purposes and can also be used in design presentations. From these styles you can start to develop your own designs by changing the styling lines, shape and fit lines.

 Exercise 2:

Practise drawing the following basic silhouettes and style details on the next three pages. Use **Template 1 Basic** as your guide for achieving the correct clothing proportions.

Once you have completed these flats, practise drawing variations using your resource files as reference.
• When drawing a garment start with the silhouette, followed by the details.
• To achieve the correct proportions start drawing from the top down.
• When drawing manually, a ruler and french curves will help you draw more accurately.

• As in the previous drawing exercises, overlay with semi transparent paper and redraw until you are happy with your sketch.

See also:
• *Fashion Design Series*, **Fashion Designer** - *Concept to Collection,* the *Silhouettes, Styles, Details* and the *Design Development* chapters for more key styles and designs.
• **Fashion Computing** - *Design Techniques and CAD* , which shows you how to draw your designs using the most popular drawing software, Illustrator and CorelDRAW.
• **fashionbooks.info** website *and* Facebook

Dresses

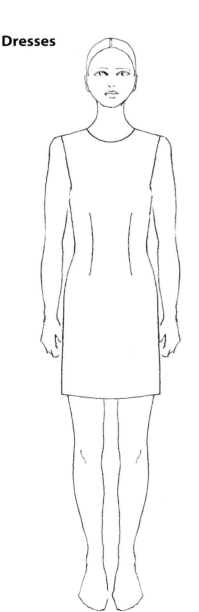

a. Sheath Dress

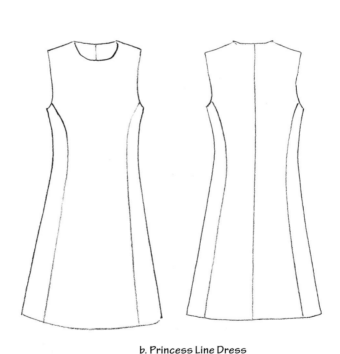

b. Princess Line Dress

Figure 9.3a, b: Template 1 Basic used as the guideline for proportions for basic dress silhouettes

a. Sheath dress has darts for a smooth fit

b. Princess Line dress - front view and back view - side front and side back seam lines produce the fit and flare of the style, back zip

Tops and Skirts

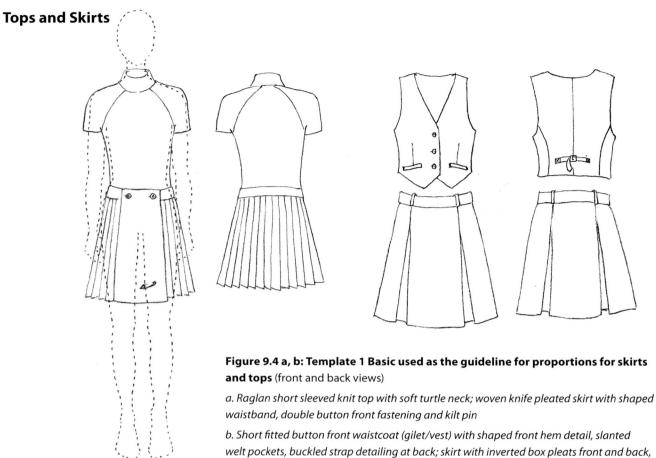

Figure 9.4 a, b: Template 1 Basic used as the guideline for proportions for skirts and tops (front and back views)

a. Raglan short sleeved knit top with soft turtle neck; woven knife pleated skirt with shaped waistband, double button front fastening and kilt pin

b. Short fitted button front waistcoat (gilet/vest) with shaped front hem detail, slanted welt pockets, buckled strap detailing at back; skirt with inverted box pleats front and back, waistband with belt loops

Tops, Shirts and Pants

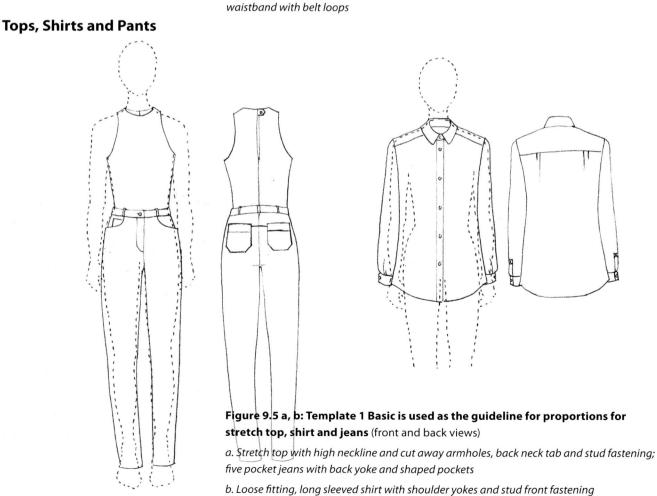

Figure 9.5 a, b: Template 1 Basic is used as the guideline for proportions for stretch top, shirt and jeans (front and back views)

a. Stretch top with high neckline and cut away armholes, back neck tab and stud fastening; five pocket jeans with back yoke and shaped pockets

b. Loose fitting, long sleeved shirt with shoulder yokes and stud front fastening

Jackets

The centre front line is a very helpful and important guideline when drawing single-breasted and double-breasted jackets, especially when drawing; the angle of the collar 'roll' line, the positions of the button and buttonholes, and the amount of wrap over allowed.

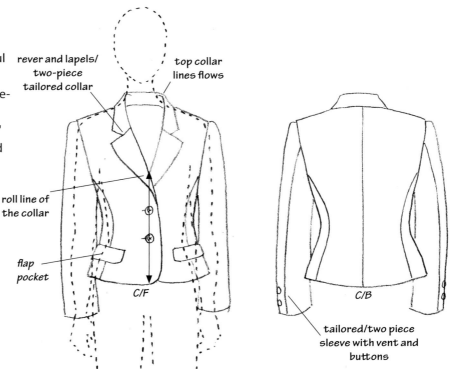

Figure 9.6: Template 1 Basic is used as the guideline for jacket proportions (front and back views)

Short single breasted, fitted tailored jacket with notched (tailored) collar and lapels, and flap pockets

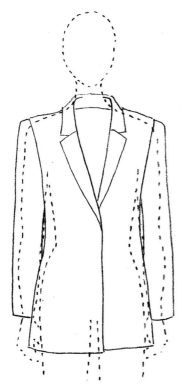

The silhouette of the jacket is sketched first, followed by the collar and lapels, darts, then the pocket details

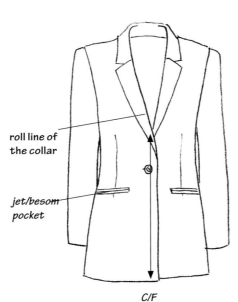

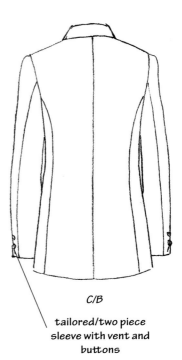

Figure 9.7: Template 1 Basic is used as the guideline for jacket proportions (front and back views)

Long length single breasted, tailored jacket with notched (tailored) collar and lapels, single button fastening, and jet pockets

3. Gallery of Flats and Technical Drawings

Take a look at the following gallery of flats and technical drawings (also called spec/working drawings) from a number of designers (Fig. 9.8 to 9.12). Note the various styles of illustration and methods of presenting them. Depending on your design brief, this will determine to some extent the required style of drawing, the technical accuracy, and if back views are necessary.

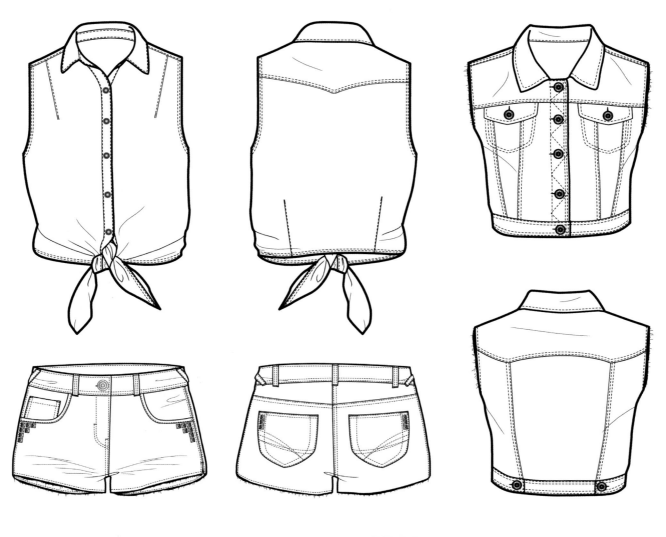

Figure 9.8: Flats from Spring/Summer Collection, Denim and Cotton Story by Fashion Designer Cherona Blacksell

This collection of flats has been initially drawn by hand and edited digitally in Illustrator. The drawing style of the flats would be excellent for presentation purposes.

Exploded section of decorative studs and stitching on pockets

Above:

Tie front sleeveless shirt with stud front fastening, back yoke and topstitching details/twin needle

'5' pocket denim shorts with frayed hems and decorative studs on pockets, and side angled belt loops

Denim gilet/waistcoat with frayed armhole detail, metal button front fastening, double stitching/twin needle details, back yoke and buttoned tabs

Opposite:

Denim jacket with zipped pocket detail, metal button front fastening, double stitching details, back yoke and buttoned tabs

Collarless, cropped denim jacket with side front pocket detail in panels, metal button front fastening, double stitching details, back yoke and panels, and buttoned cuffs and tabs

Skinny, '5' pocket denim jeans with double belt loops, decorative and double stitching details and turnups

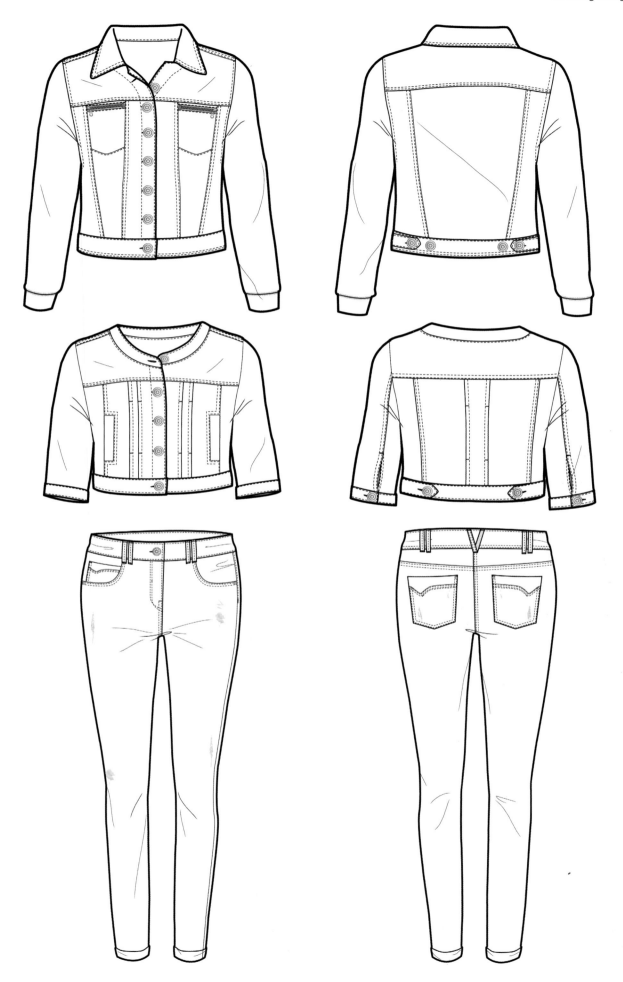

4. Clothed Fashion Figure (Figure Matrix)

Designing clothing can be a chicken and egg situation - which comes first, the fabric or the garment design?

Typically designers will work to a design brief and might find it is the **fabric**, a **theme** or **mood** that inspires the design. From this initial concept, the clothing designs are developed as a series of rough sketches before producing a final design (see this Fashion Series, **Fashion Designer**, *for more detail on the Design Process*).

For this exercise, a range of fabrics has been chosen (Fig. 9.13); the clothing has been designed based on these fabrics and forms a cohesive, capsule collection, which could also form part of a larger collection. You can sketch the same designs on your fashion figure templates or you can choose your own fabrics and designs.

The fabrics are based around the theme of *'The Wild and The Natural'* and include:

Plains:
• Crepe, stretch crepe, silk chiffon, silk tulle, silk organza
• Stretch velvet
• Quilted waterproof nylon, shiny coating
• Wool
• Black leather
• Jersey knit (grey)
• Faux fur

Prints:
• Bold floral
• Leopard print and snake print
 Colors:
• Black, grey, silver, prints (blues and yellow, and reds and yellows on black ground)

Exercise 3: Drawing the Clothed Fashion Figure/Croquis
A small collection of garments has been drawn to demonstrate examples of clothing on the figure templates 2 to 7. Using your templates from the *Fashion Figure Templates* chapter, copy the clothing onto your templates 2 to 7 (Fig. 9.14 to 9.19), or sketch your own.

• Redraw using the overlay technique until you are happy with your fashion figures and styling.
• Trace over your clothed fashion templates onto your preferred art paper. Note: Semi-transparent paper is best used for tracing, rough sketches and design development (see the *Art Kit* chapter).
• If the paper you have chosen to use does not allow you to see the image by using the overlay technique you will have to do a graphite tracing or use a lightbox (see the *Art Kit* chapter).

Figure 9.13: Fabrics
Fabrics chosen for the following garment designs as part of a collection, top to bottom, left to right: crepe, silk chiffon, jersey knit (grey), leather, floral print on chiffon and crepe, leopard print, quilted waterproof nylon

Drawing Tips:

When you draw clothing on a fashion figure consider:
• The pose should be appropriate for the style of garment so that it shows the design to its best advantage. This is usually a front view, but a back or side view might also be required.
• Think of the body like a coat hanger, providing the shape on which a garment will hang and drape around it. The designs should not appear flat, like that of paper clothing on a paper doll. If the fabric in the design is soft, for example, silk, chiffon or muslin, it will drape softly and fall around the body in a fluid way. If the fabric is firm, such as a heavy cotton, denim or satin, it will hold its shape and, depending on the styling, might stand out from the body.

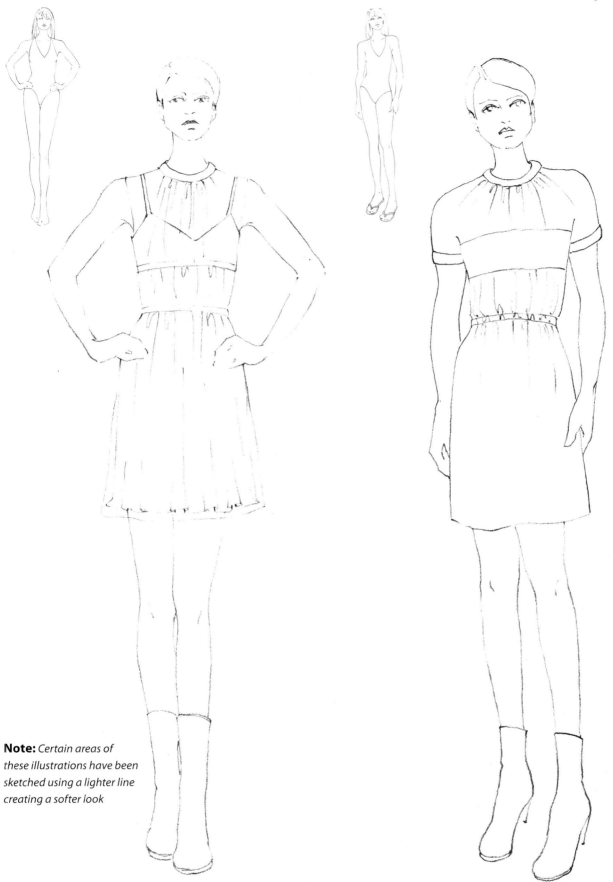

Note: *Certain areas of these illustrations have been sketched using a lighter line creating a softer look*

Figure 9.14: Template 2 (fashion matrix):

Sleeveless printed silk georgette top and skirt, each with silk chiffon overlay detail

Figure 9.15: Template 5 (fashion matrix):

Dress of silk chiffon and crepe

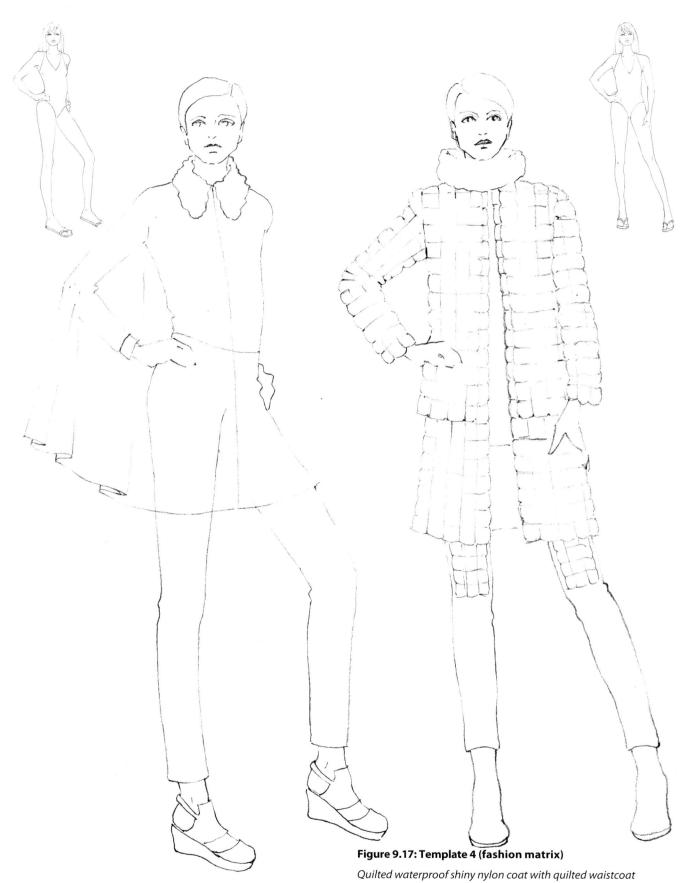

Figure 9.16: Template 6 (fashion matrix)

Printed silk long sleeved shirt

Printed stretch velvet jeans

Printed sheer silk organza cape with faux fur collar

Figure 9.17: Template 4 (fashion matrix)

Quilted waterproof shiny nylon coat with quilted waistcoat

Leopard print faux fur snood/collar

Jersey knit long sleeved top with digital screen print

Stretch crepe and shiny nylon slim pants with quilted top front panels and zipped inside leg at ankle

Ankle Boots

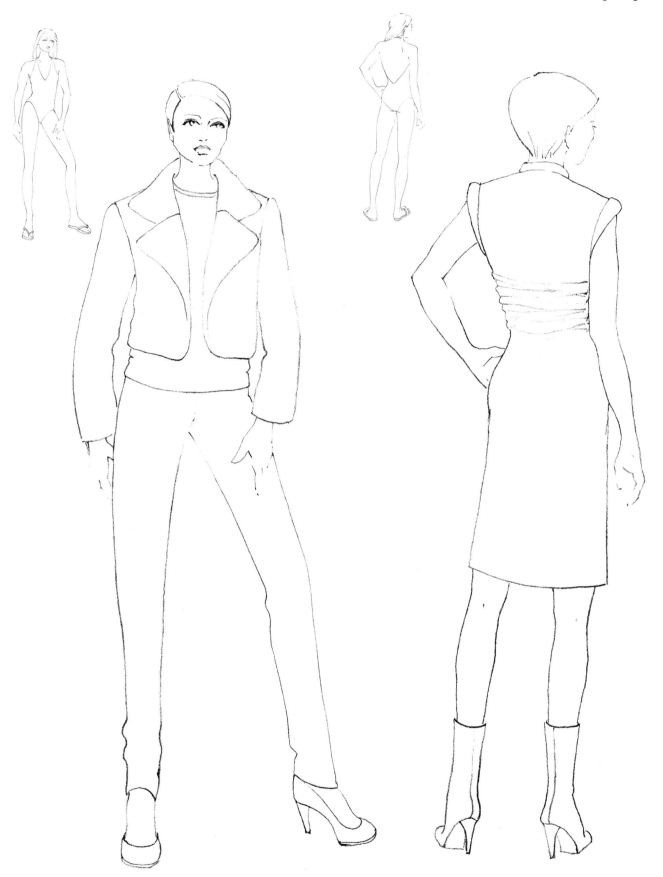

Figure 9.18: Template 3 (fashion matrix)

Leopard print faux fur zipped front bomber jacket

Jersey knit sleeveless top with digital screen print

Slim wool pants (extra long leg length)

Figure 9.19: Template 7 (fashion matrix)

Fitted leather dress with capped padded sleeve and high waist detail

Leopard print or plain faux fur ankle boots

5. Gallery of Clothed Fashion Figures and Flats

Take a look at the following gallery of clothed fashion figures from a number of designers around the world. Note the various styles of illustration, the use of line, its thickness and the drawing techniques to sketch clothing - gathers, seams, pocket, collar details, etc. Depending on your design brief or project, this will determine to some extent the style of your own work.

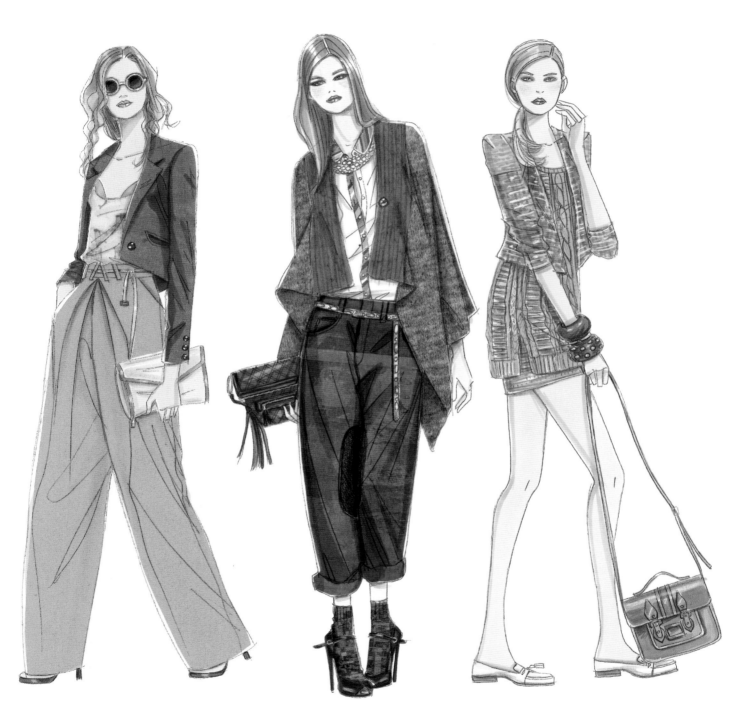

Illustration courtesy **of PROMOSTYL Paris,** International Trend Forecasting Agency from their Womens Summer Trends book

These womenswear illustrations have been created by hand with some digital editing (fabrics) in Photoshop

Note the styles of clothing and how they have been drawn, and the way the clothing hangs, falls and/or drapes on the body

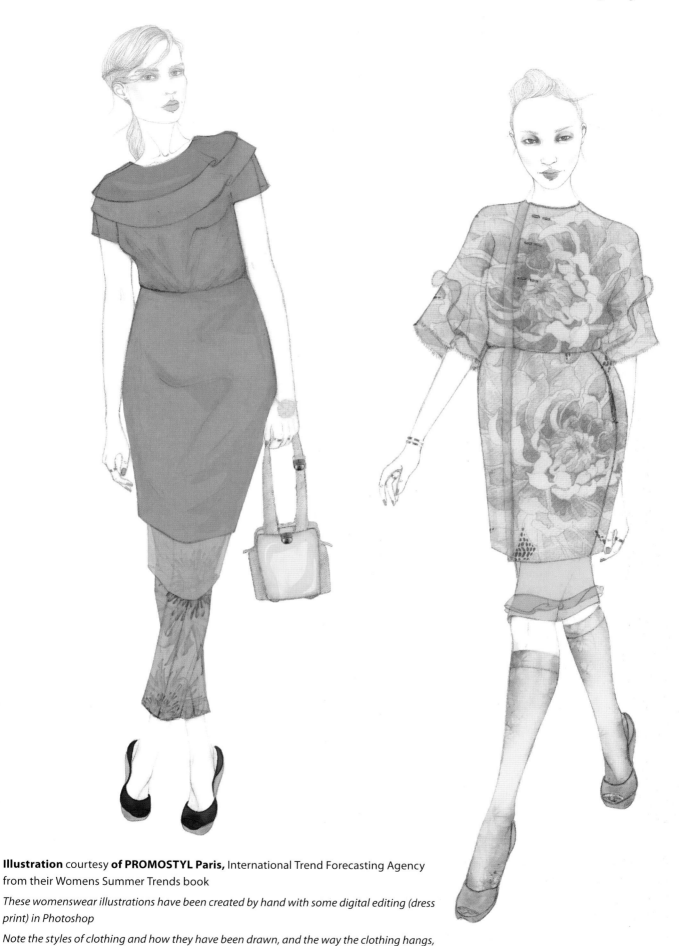

Illustration courtesy **of PROMOSTYL Paris,** International Trend Forecasting Agency from their Womens Summer Trends book

These womenswear illustrations have been created by hand with some digital editing (dress print) in Photoshop

Note the styles of clothing and how they have been drawn, and the way the clothing hangs, falls and/or drapes on the body

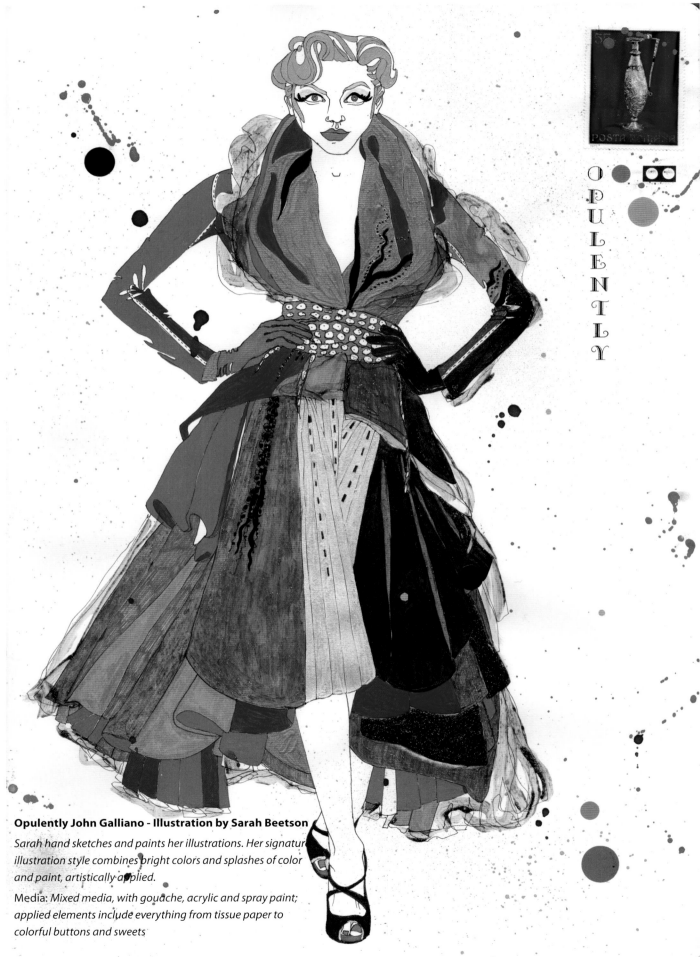

OPULENTLY

Opulently John Galliano - Illustration by Sarah Beetson

Sarah hand sketches and paints her illustrations. Her signature illustration style combines bright colors and splashes of color and paint, artistically applied.

Media: *Mixed media, with gouache, acrylic and spray paint; applied elements include everything from tissue paper to colorful buttons and sweets*

Line art illustration by Jonathan Kyle Farmer

Outfits feature padded sections, binding details and rib trims.

Illustration by Bindi Learmont

Silk chiffon and silk A-line dress; branded fabric bag

Illustration by Bindi Learmont

Top with wrap skirt with tie belt and fringed, beaded hem detail

Illustrations by Lucy Upsher

Natures Acrobat - presentation boards of her collection and a hand illustrated illustration.

Womenswear designer and illustrator Lucy Upsher says, *'The majority of my illustrations are a mixture of pencil drawings collage fabrics or Photoshop rendered print then often drawn into again. The flats are mostly all CAD but I do also do them by hand drawn depending on the brief.'*

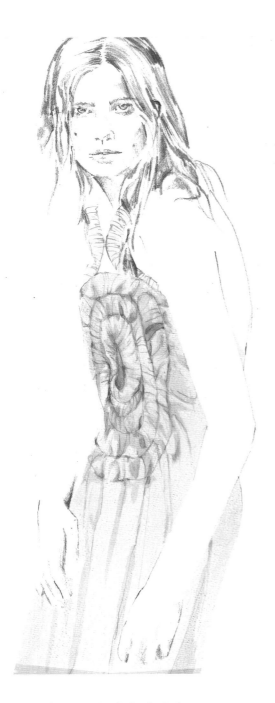

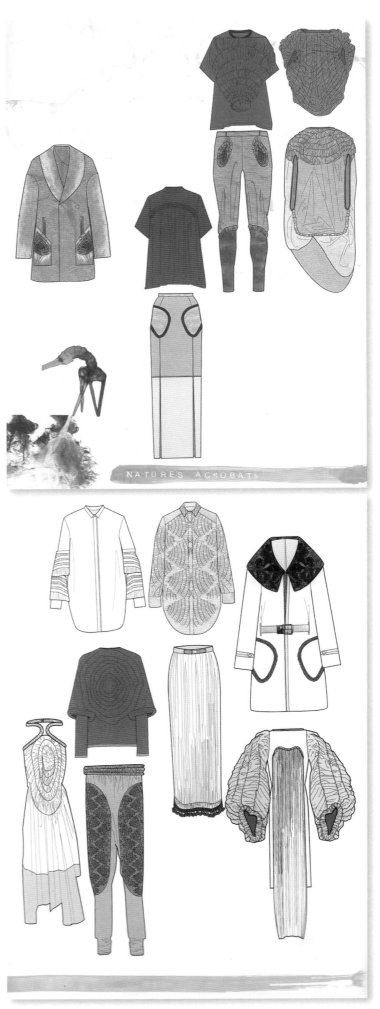

NATURES ACROBATs

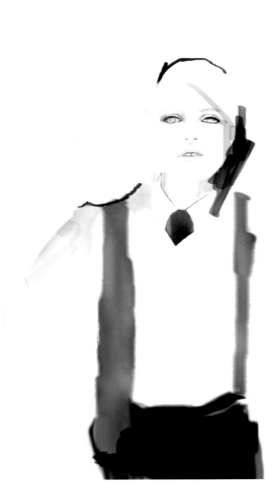

Illustrations by Yiunam Leung

'I try to capture the essence of the colours, and the concept, imagining the flow of the design and try to capture that in my illustration. My work is a mix of hand and Photoshop.

The face is very important for my style of illustration. This is where I start and spend the longest on, maybe 3-4 hours just on one eye, building up layers and shadows. The rest I try to keep simple using brush strokes etc. like a Chinese painting. I always relate the clothes to the brush strokes. When watching the shows I imagine how I can translate the designs into an illustration. This is important, because many people can illustrate a photo from a catwalk; it might look nice but not very original. It is how you visualise the clothes and how you translate them that is important.

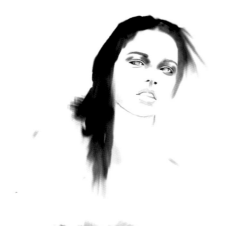

Concluding Comments

- The ability to draw clothing as flat, working drawings is just as important as drawing clothing on the fashion figure. In fact, some fashion companies only work with flats and specs.
- Perfect your drawings of back views as well as front as they are often required in presentations and are always required for production specification work.

In the next chapter, we will look at fabric rendering (illustrating or representing) fabrics onto your clothed templates 2 to 7. This will give your templates a more 'finished' look and then you will be ready for the *Fashion Presentations* chapter.

© Fashion Artist (3ed)- Sandra Burke

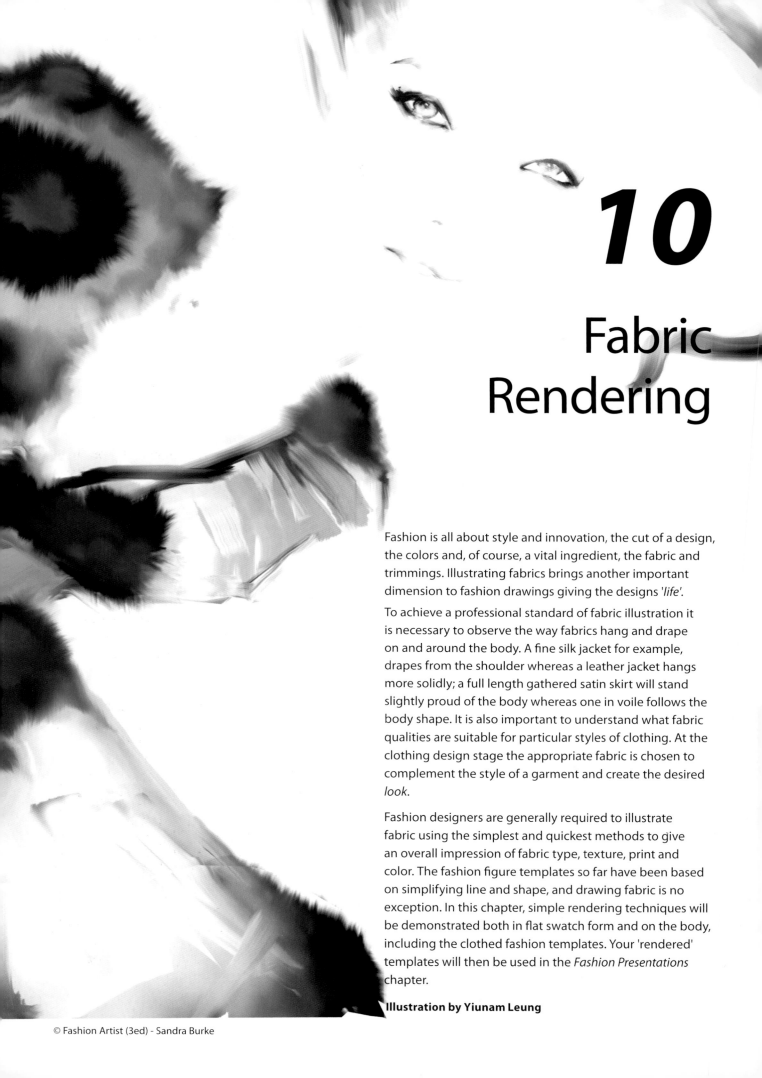

10

Fabric Rendering

Fashion is all about style and innovation, the cut of a design, the colors and, of course, a vital ingredient, the fabric and trimmings. Illustrating fabrics brings another important dimension to fashion drawings giving the designs 'life'.

To achieve a professional standard of fabric illustration it is necessary to observe the way fabrics hang and drape on and around the body. A fine silk jacket for example, drapes from the shoulder whereas a leather jacket hangs more solidly; a full length gathered satin skirt will stand slightly proud of the body whereas one in voile follows the body shape. It is also important to understand what fabric qualities are suitable for particular styles of clothing. At the clothing design stage the appropriate fabric is chosen to complement the style of a garment and create the desired *look*.

Fashion designers are generally required to illustrate fabric using the simplest and quickest methods to give an overall impression of fabric type, texture, print and color. The fashion figure templates so far have been based on simplifying line and shape, and drawing fabric is no exception. In this chapter, simple rendering techniques will be demonstrated both in flat swatch form and on the body, including the clothed fashion templates. Your 'rendered' templates will then be used in the *Fashion Presentations* chapter.

Illustration by Yiunam Leung

Art Box

- Your clothed templates 2 to 7 and art box from previous chapter
- Coloring media (your preference): Markers (flesh/hair color, etc.), pastels (suggest water soluble and fixative if not using water), colored pencils (suggest water soluble), gouache, acrylics, inks, etc. and brushes
- Silver/white roller ball (use over dark colors for outline, highlight)
- Adhesive and double-sided tape, putty rubber (for pastels)
- Selection of fabric swatches, scissors/pinking shears
- Sketchbook/folder/plastic sleeves for fabric swatches
- Portfolio

1. Fabrics Swatches

Fabric swatches are an important component of your design data. Collect small samples of fabric to use as references for your fashion drawings and as sources of inspiration for future designs. Fabric stores, and some fabric wholesalers, will often cut small swatches from their rolls of material. An ideal size for swatches is approximately 5 x 5 cm (2 x 2 inches). Take note of the feel and handle of the fabrics on the piece, as this will help you understand the drape when you start to render them on the figure. Other sources for fabric swatches are dress makers, clothing factories and charity shops.

Consider these fabric types:
- Natural, man-made, knits, wovens, nonwoven
- Soft, feminine, sensual fabrics - sheers, silks, silky handle, satins, lace, tulle, organza
- Wools, tweeds, worsteds, denims
- Surface interest patterns, weaves
- Shiny and matt fabrics - satin, leather and suede effects
- Prints - stripes, plaids, checks, florals, animal, geometrics
- Novelty fabrics - velvet, sequins, beading and embroidery
- Knits and stretch - plain, cable stitch, jersey

See *Fashion Designer* in this series, *Color and Fabric* chapter

Keep fabric swatches grouped in a **sketch book** or alongside appropriate design ideas (photo below), or**:**
- File in a fabric resource folder
- Keep in small plastic bags, per fabric group
- Place in a 'slide holder' plastic sleeve
- Attach to a card and place in a plastic sleeve (photo below)

Note relevant details such as fabric quality and fibre content, price and width, name of supplier. This information will be especially important later if you wish to purchase some of the fabric.

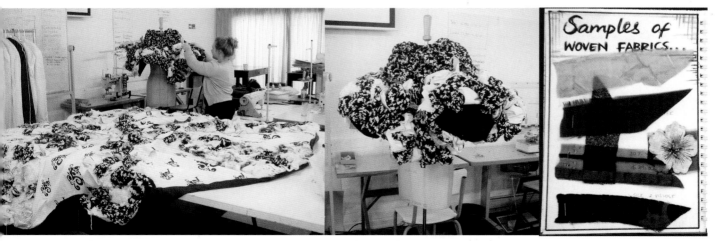

Above left to right: Designer, Judy Nell, *modelling on the stand the fabric she has created from her innovative stitching and appliqué techniques. When choosing the fabrics for her collection, she considered the stiffness of the fabric, the way it pleated and stood out from the body rather than draping around the body in soft folds.*

Fabric swatches grouped as part of a design/collection, courtesy Priyha Vasan

2. Media and Fabric Rendering Techniques

Exercise 1:

Experiment with your media to perfect your fabric rendering skills:

• Using the same quality art paper you will use for your rendered figures, check that the media is compatible, for example, paint will not adhere to wax; too much water on cartridge paper causes it to wrinkle (alternatively use watercolor paper).

Marker pens and fine liners are an effective and quick method to illustrate fabric, hence many fashion companies use this medium. Markers give a slightly flat finish, but the illustration can be enhanced using mixed media; **colored pencils, pastels, paints,** etc.

• Some markers bleed more than others on certain paper; work according to the desired amount of bleed required or use marker paper to prevent bleeding.

• Work in the same direction and keep the line wet to prevent streaking.

• Use several coats of color or slightly darker tones to indicate density, shade, folds and gathers in a garment.

• A clear blender blends, lightens and softens edges.

• Make use of line thickness (markers often have different sized nibs in one pen).

Pastel pencils/sticks (water soluble)**:**

• Vary the pressure on the pastel to make light or dark lines of different thickness.

• Build up tone by adding layers of color.

• Smudge with fingers or use a pastel stump to soften the pastel.

• Add highlights and shine using a white or light pastel.

• Use fixative to stop the soft dusty media from spreading.

Colored pencils (water soluble):

• Use dry or wet - apply color pencil onto the art paper and work into it with a slightly wet brush.

• Build up layers to intensify color.

Acrylic:

• Use a little water for an opaque finish, or more for a watercolor effect.

• Quality acrylics can be air brushed.

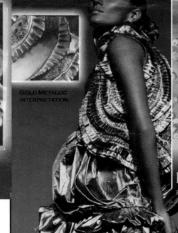

GOLD METALLIC INTERPRETATION

SEQUIN INTERPRETATION

Gouache:
- Similar to watercolor but is mixed with white pigment and extender to make it opaque.
- Use a little water for an opaque finish, or more for a watercolor effect.
- Dries to a slightly different color, so test before applying to the artwork.

Watercolor:
- **Build up** to a denser color, the darkest applied last.
- **Wet on dry** - each layer is allowed to dry before another is added.
- **Wet on wet** - colors applied over each other while still wet.

Note:
- Dark tones appear further away than light tones e.g. white will stand out, use it to create shine.
- Rather than always using white paper, experiment with colored and black paper for different effects.

Figure 10.1 and 10.2, opposite top to bottom: Fabric Renderings by Laura Krusemark

Media: *Markers and water soluble color pencils (including silver and white)*

A variety of rendered fabric swatches from sequinned tulle, lace, prints and herringbone; magazine tears with fabric swatches to represent gold metallic and sequin fabrics.

Figure 10.3, right: Fashion Illustration by Karen Scheetz

Media: *Charcoal and Pastel*

Fabric: *Silk organza top with silk chiffon skirt.*

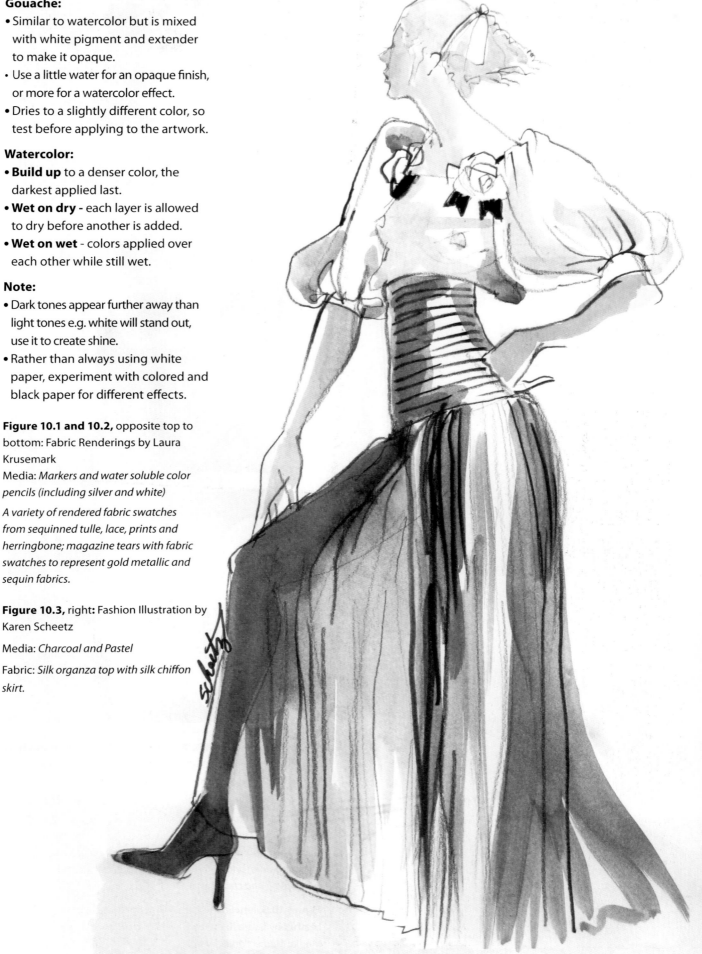

3. Rendering Templates 2-7 (Matrix)

 Exercise 3:

Illustrate the fabric examples as fabric swatches and then render your clothed fashion templates, Fig. 10.7 to 10.13 and example 10.14.

The fabrics selected for the clothed figures range from silk organza, crepe, stretch velvet, leather and faux fur etc. and form a cohesive collection in style, fabric, color and print (see *Clothing Design* chapter).

Interpret your drawings in your own style using these renderings as a guide.

Begin by rendering small swatches of the fabrics to:
• Test out the media.
• Capture the overall fabric/design.
• Reduce the scale of pattern.

Tip: observe the fabric from a distance - it will appear less detailed and easier to interpret.

Once satisfied with the fabric representation, render your clothed fashion templates (as you work you will find you naturally scale the fabric design to suit the scale of the illustration).

Fabric rendering examples:
Mixed media of acrylics, gloss gel, watercolor, pastels, colored pencils, fine liners, have been used; you can use your choice of media to achieve the different effects.

Rendering the templates:
• Apply the flesh color as flat color or shade to add depth, shape and form.
• Totally fill with media or leave some areas free of color by gradually fading to nothing.
• Add color to the hair, lips and shoes.
• Finally, overdraw and/or thicken lines, if you wish, to enhance and define the overall look.

Fabric steps:

1. Florals: Create the floral print using a combination of watercolors and colored pencil. It is best to apply the floral print on a white background as watercolors are transparent the colors are visually brighter. The background is then filled in with black watercolor. (You can also use water soluble pencils, markers and pencils - experiment until you achieve the desired look.)

2. Sheers - silk chiffon, organza: Create a very dilute wash - more concentrated watercolors will give you the look of heavier denser fabrics. To add texture to the fabric, lightly add black and/or white colored pencil for shading.

So that there is very little white background showing, add more colored pencil and/or more watercolor to the flower print. Building up these successive layers adds more depth to the image.

3. Black/padded/quilted: Mix a gloss gel with black paint (Golden Regular Gel Gloss acrylic was used here) to give an impasto effect and apply all over the garment area. While still wet, etch the shape of the padding - any fine point will do. Once dried add white highlights using white acrylic. (If you do not have gloss gel, you could also simply use white acrylic.)

4 . Leopard skin: Using watercolor and a fine round watercolor brush paint the leopard spots. For the background grey, use a combination of pastels (Faber Castell Pitt Pastels were used here as they are a little firmer than regular soft pastels) and colored pencil. The pastel allows you to blend/smudge the color all over. Use a Staedtler Fineliner marker or something similar to redefine the leopard spots.

Figure 10.7a to d: Fabric Renderings by Peter Lambe

Mixed Media as per exercises

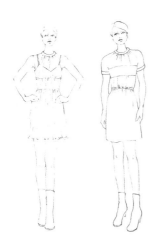

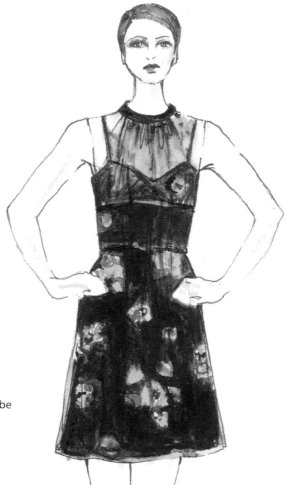

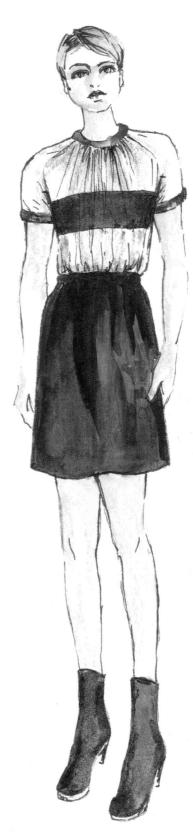

Fashion Figures - Collection:
Line drawings by Linda Jones
Fabric renderings by Peter Lambe

Figure 10.8: Template 2 (fashion matrix):

Sleeveless printed silk georgette top and skirt, each with silk chiffon overlay detail

Figure 10.9: Template 5 (fashion matrix):

Dress of silk chiffon and crepe

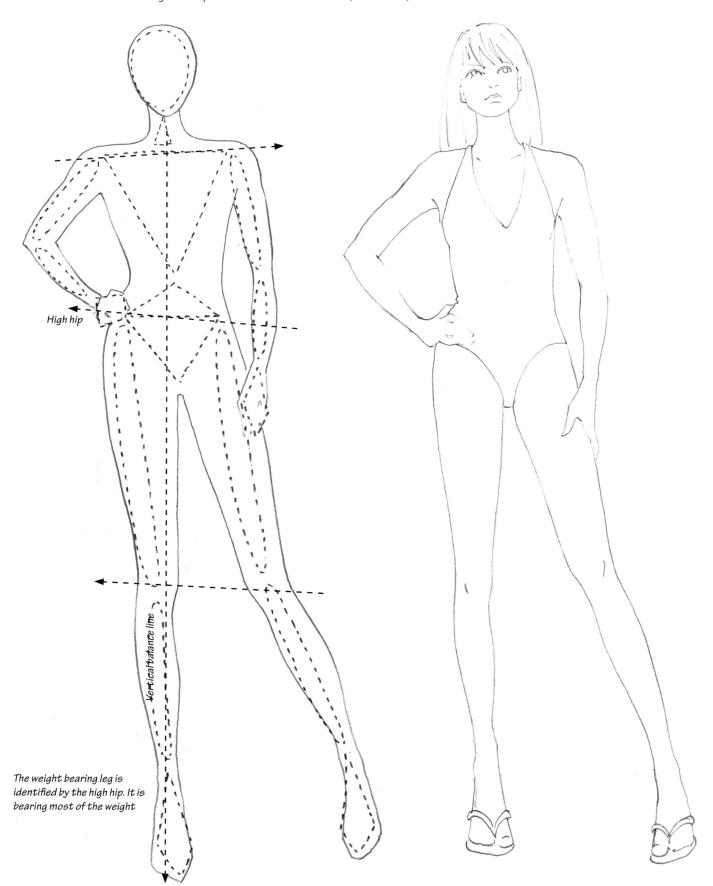

High hip

Vertical balance line

The weight bearing leg is identified by the high hip. It is bearing most of the weight

Figure 10.14a, b, c, d: Template 4 (fashion matrix)

Shows the progression from the basic oval and triangle technique, to fleshing out, clothing or dressing the model, and rendering the fabric and features of the figure. Adjustments can be made to the sketches as you progress, and until you are happy with the result.

You can use the overlay technique using semi-transparent paper, but the finished rendered sketch must be on the correct art paper that can take the media. The sketches can be sketched digitally if you have the appropriate software and tools.

© Fashion Artist (3ed) - Sandra Burke

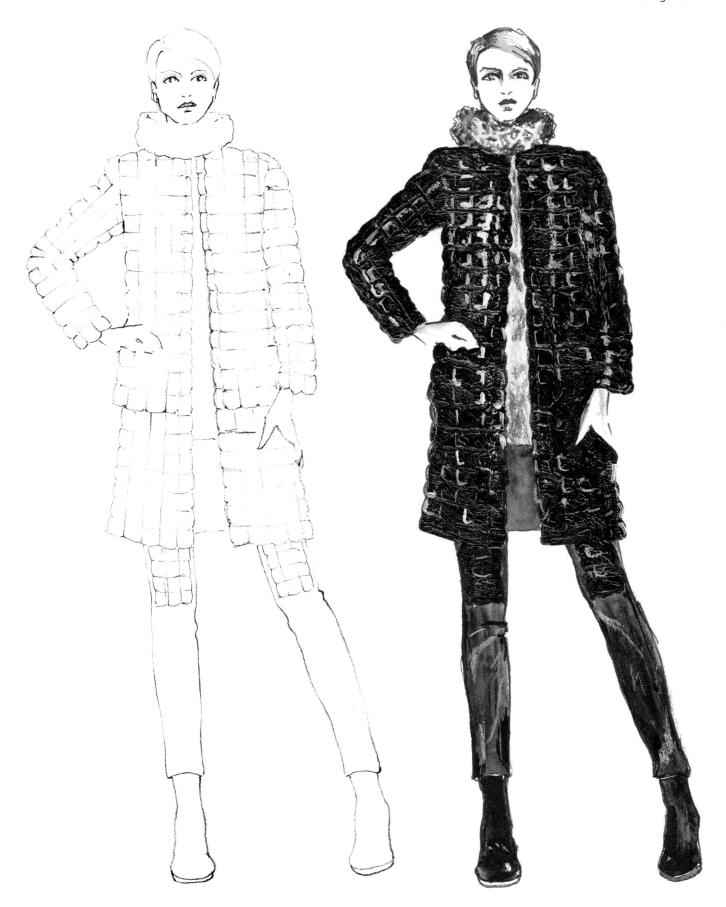

Fashion Figures - Collection:
Line drawings by Linda Jones
Fabric renderings by Peter Lambe

4. Gallery of Rendered Fashion Figures

The following artworks show fabric and clothing techniques by various designers and illustrators. Note:
• The fabrics used for the clothing.
• The media and techniques used to render the fabric.
• The poses used, how the figures are balanced, the angles of the shoulders and hips.
• The drawing of the hands, faces, shoes and the overall look of the illustration.

The presentation of fashion illustrations and all the design elements (flats, fabrics and colors, etc.) will be covered in the *Fashion Presentation* chapter.

Fabric Rendering and Illustrations by Lucy Upsher

Media: *Graphite and water soluble colored pencils, gold pencil*
Fabrics: *Printed and plain satins and silks*
Note: *Hand drawn illustrations; the use of shading, the soft and hard lines; the shadow effect anchoring the figure*

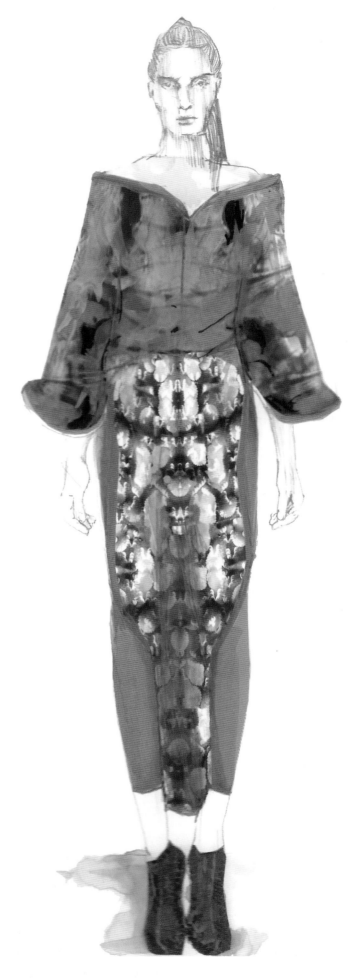

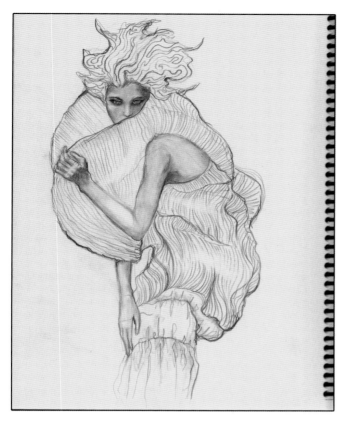

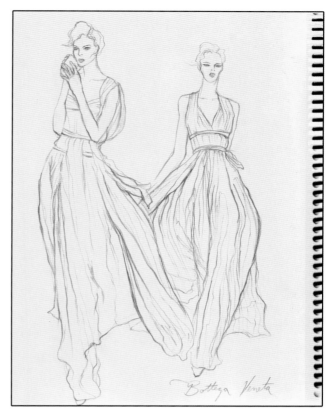

ISSEY MIYAKE

BOTTEGA VENETA

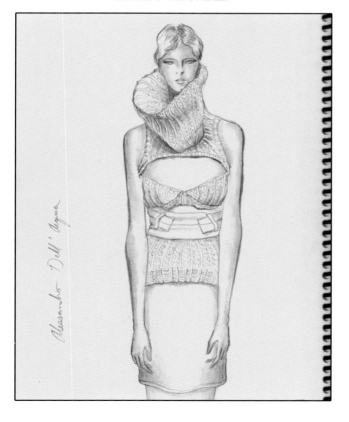

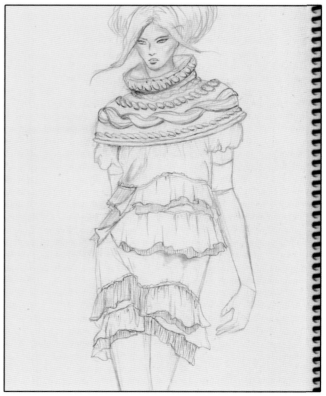

ALESSANDRO DELL' ACQUA

CLAIRE KELLER

Fabric Rendering and Illustrations by Laura Krusemark

Media: *Graphite pencil, using strong and soft lines, shading and smudging of line*

Fabrics (top to below, left to right): *Silk Taffeta, Silk Georgette, Silk Wool, Silk Wool and Georgette*

Note: *Hand drawn illustrations; the use of shading, the soft and hard lines*

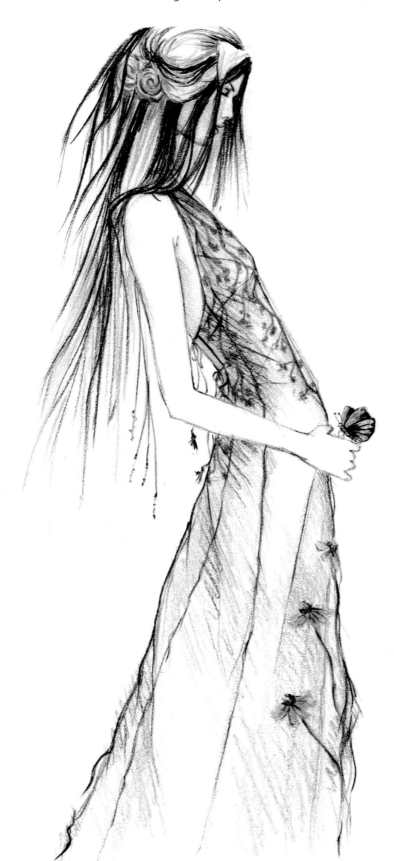

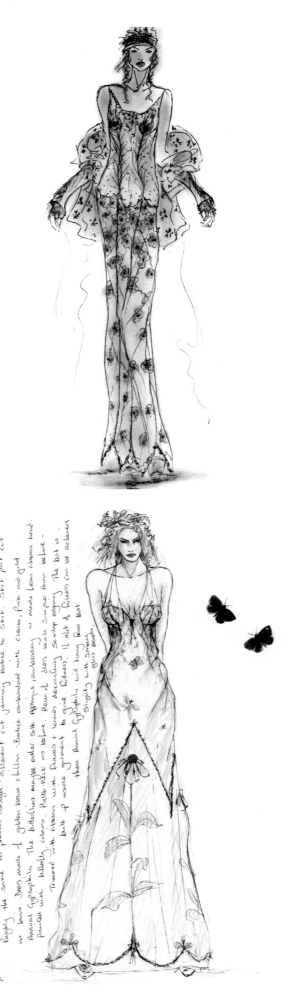

Fabric Rendering and Illustrations by Kathryn Hopkins

Media: *Graphite pencil, water soluble colored pencils.*

Fabrics: *Plain and Embroidered Silk, Silk Georgette and Silk Chiffon*

Note: *Hand drawn illustrations; the use of shading, the soft and hard lines*

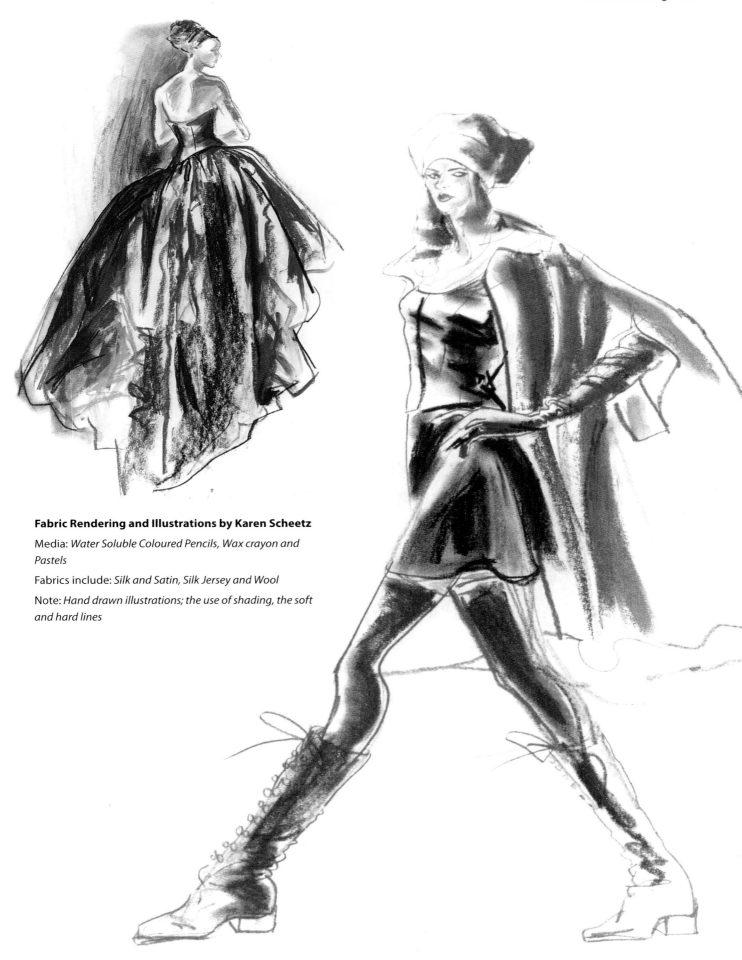

Fabric Rendering and Illustrations by Karen Scheetz

Media: *Water Soluble Coloured Pencils, Wax crayon and Pastels*

Fabrics include: *Silk and Satin, Silk Jersey and Wool*

Note: *Hand drawn illustrations; the use of shading, the soft and hard lines*

S/S Collection, LFW, Design Development Sketches with Fabric Renderings by Georgia Hardinge, Womenswear Designer

Media: Fine liners and Markers

Fabrics: *Silk, Silk Jersey, Silk Georgette, Embroidered and Embossed Silks, Plains and Prints*

Georgia showed two Spring/Summer collections in London and Paris (below), one with mono prints and plain fabrics, the second with color prints, some plains and embellished.

Georgia's fabrics for her collections are significant to her styling, *'I love wool. Even for summer I can't not use it a little. It's my medium. The wool is viscose felted wool and is the best for sculpture and it does not fray....Within the collection a couple of the pieces are always handmade from start to finish......I try to use new technology fabrics and mix the old with the new but keeping it modern and wearable.... I'm making my own fabric by burning silk satin and mixed silks and dying them. I love shrinking and stretching fabric then I can actually say I've made the outfit's entirety.....Each piece map the silhouette and curves of the female line, as geographic arrangements are constructed through the shape and form of the fabric.intricate folds and pleats; layering gives depth and a striking monochromatic palette of slate and coal punctuated with bold reds ensure the collection retains an edge.*

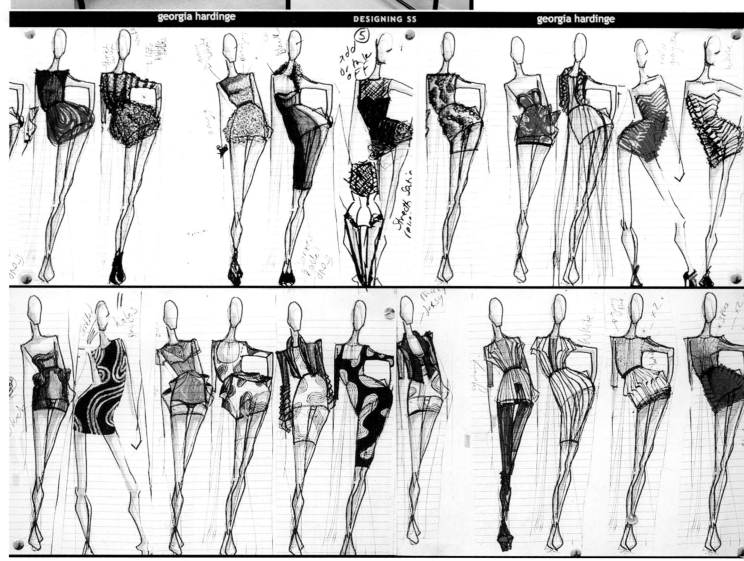

S/S Collection, LFW, and Fashion Illustrations by Holly Fulton, Womenswear Designer

Media: *Markers (the illustrations were then printed and enlarged for the stand at London Fashion Week)*

Fabrics: *Luxurious Materials - Printed and Plain, Embellished, Embroidered, Embossed, Knits, Jerseys, Cottons*

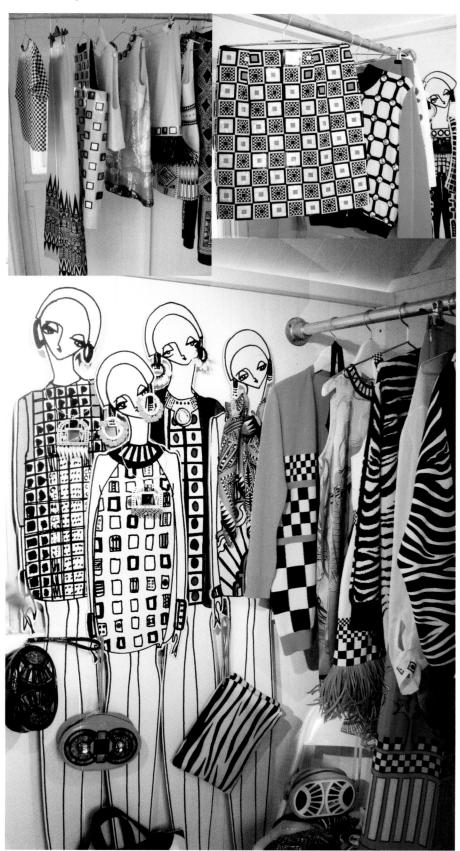

Holly's design signature includes: *'Graphic print, luxurious materials and hot accessories.'*

Three things that inspired her for this Spring/Summer collection: *'Nicholas Krushenick, Memphis design and Joan Collins on a cruise circa 1967.'*

'Holly earned a BA in Fashion from the Edinburgh College of Art in 1999. She went on to work on LANVIN's accessories team in Paris for some time before launching her own label and eventually taking it to London Fashion Week.'

Holly is also inspired by VERSACE and MOSCHINO, and very much into her prints, which she draws by hand, time consuming, but work she enjoys.

Her personality and dress reflects in her work - an optimist, a happy person, fun and powerful.

One of the women that she admires is Jeanne Moreau, *'If I could be anyone I'd be Jeanne Moreau... I'd love to dress the women of the older generation, such as Joan Collins or Angelica Huston. Someone unexpected...I love nothing more than seeing my work on a variety of women as opposed to just myself and the models....I've got a CHANEL suit, which I bought from a charity shop in Edinburgh for £100. I found it and it fits like a glove. When I wear that suit people actually treat me differently, almost with more respect. That suit makes me feel so glamorous... That's exactly how I want women to feel when they put on something I've made.'*

11
Fashion Presentations

Presentation boards are the professional method used to **visually display a design concept** in a creative, dynamic format. The concept could be for a fashion collection, a fashion mood or theme, fashion colors, fashion fabrics or fashion promotion.

Individually, sketches can look flat and uninteresting, but if all the right ingredients are grouped together in a **well planned layout,** the theme will be stronger and **commercially successful.** Just like a piece of steel, once used in conjunction with other building materials they can turn into something amazing like the *Eiffel Tower in Paris!*

Designers and illustrators use many presentation techniques to enhance their artwork. In this chapter, I discuss some of these creative techniques, ending with a presentation of the rendered fashion figures(matrix) as a capsule collection. These presentations can then be used as part of a design portfolio (see *Fashion Portfolio* chapter).

Illustration by Lidwine Grosbois

Art Box

• Your rendered fashion templates 2 to 7, and art box from the clothing chapter
• Selection of fabric swatches - described below
• A3 (14x17 inch) or A2 (18x24 inch) light weight colored card (suggest slightly heavier than your art paper to use as a background for your presentation layout)
• Knife/scalpel for cutting card
• Optional: Collage items: buttons, feathers, beads, etc.

1. Planning a Fashion Presentation

It is important to think through your presentation to ensure it is successful and dynamic. Consider the purpose and objective of the presentation. It might be for a fashion trend or forecasting board displaying directional looks, colors and fabrics; for a fashion design, a collection, a promotional drawing, an advertisement for a particular brand, magazine, film or television. Depending on the design brief, the target market, and the purpose of the presentation, a typical fashion presentation might include some or all of the following:

• The designs illustrated on the fashion figure and/or as detailed flats/working drawings.
• Fabric swatches - the fabrics used for the designs.
• Color story (palette) - the colors used for the design and color choices if required.
• Trims used.
• Photographic and inspirational images.

See also **Fashion Designer** - *Concept to Collection,* Design Presentations, and Fashion Portfolio chapters for more information.

Figure 11.1: Presentation by Rachel Williams

Fashion Mood Board Presentation displaying perfectly the essence of the collection (the mood and colors). Note the soft and sharp lines of the presentation, and the balance of the two half figures that dominate the presentation.

Media/Techniques: The figures were initially hand sketched and edited in Illustrator, and the images and layout edited in Photoshop.

2. Presentation Techniques and Formats

This section presents various professional and creative presentation techniques and formats.

These linear presentation examples, Fig. 1.1 suggest presentation formats that include the placing of; the theme or title, fabric and color swatches, fashion illustrations, flats and descriptions.

To develop a good design layout you need to consider; the grouping of similar elements, a degree of white space, and an overall harmonious balance of all the elements.

Figure 11.2: Courtesy of Penter Yip, Fashionary - *http://fashionary.org*: *Design presentation linear layout examples*

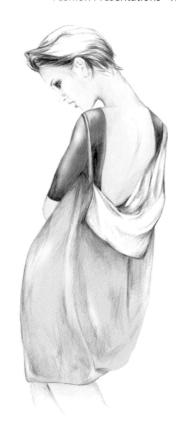

- **Theme:** The presentation should have a strong theme to capture the mood, and might need a short title. The theme, for example, might be determined by the fabrics, **Neutral Organzas;** the season, **Winter Wovens;** the style of the merchandise, **Rebirth** (Fig. 11.3.). Depending on the brief, avoid using year identification as this dates the work immediately.

- **Pose:** Choose the appropriate pose for the particular look you wish to portray e.g. a sophisticated pose for a classic mood (Fig. 11.3), a casual walking pose for summer casuals (Fig. 11.4).

- **Crop figures:** Will the figure(s) be full length? One enlarged, cropped figure in the foreground with a group of smaller full length figures in the background can work well. Only crop, if the lower part of the figure does not have important design detail (Fig. 11.3).

- **Number of figures:** The presentation might require a number of figures to illustrate the designs or mood (Fig. 11.1). The figures do not all have to be the same size - varying the scale could create greater visual impact. For example, one large scale figure in the foreground can be dynamic (Fig. 11.3).

- **Anchor the figures, sketches, images:** To prevent these looking like they are floating, a shadow effect can be used to anchor them to the page/paper (Fig. 11.3 - 11.6).

Figure 11.3: Presentations and Illustration courtesy of PROMOSTYL Paris, International Trend Forecasting Agency from their Womens Summer Trends book

The illustration has been drawn by hand and the presentation edited in Photoshop

The single sophisticated cropped figure is central to the other elements which have been placed to create balance

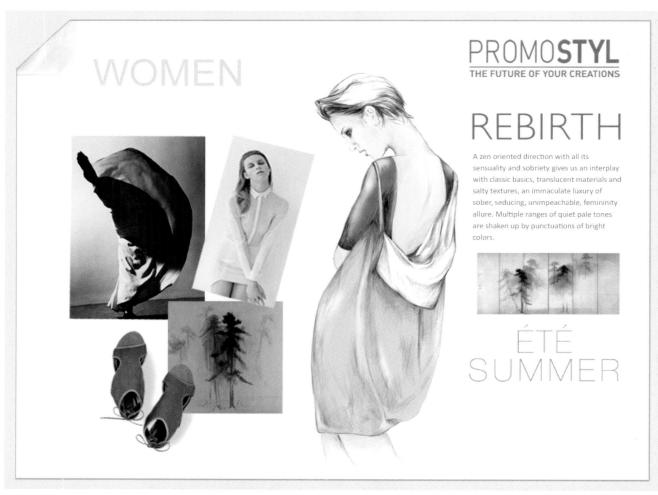

WOMEN

PROMO**STYL**
THE FUTURE OF YOUR CREATIONS

REBIRTH

A zen oriented direction with all its sensuality and sobriety gives us an interplay with classic basics, translucent materials and salty textures, an immaculate luxury of sober, seducing, unimpeachable, femininity allure. Multiple ranges of quiet pale tones are shaken up by punctuations of bright colors.

ÉTÉ
SUMMER

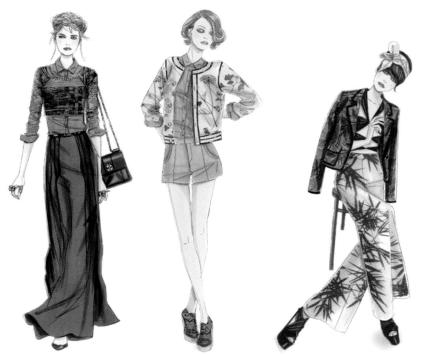

Figure 11.4 (below), 11.5, 11.6 (opposite top to bottom): Presentations and Illustrations courtesy **of PROMOSTYL Paris,** International Trend Forecasting Agency from their Womens Summer Trends book

The illustrations have been drawn by hand and also edited digitally in Photoshop

The figures are central to the other elements which have been placed to create the balance. The elements include some or all of the following; theme, descriptive text, flats, fabrics, photos and graphics

- **Text:** The style of text should match the mood of the presentation. For example, if the theme is **sophisticated, funky, fun,** the text should complement or enhance it (all Figs.). Handwriting is acceptable if it is legible and suits the presentation. You could use digital, collage or transfer lettering.

- **Descriptions:** The clothing designs, fabrics and colors might need brief descriptions (Fig.11.3 to 11.6).

- **Collage:** Collage gives a 3D dynamic impact to your presentation - use anything from photographs, digital images, magazine tears, tissue paper, clear film, foil, feathers, string, sand, etc., to capture the spirit and theme, and to enhance your presentation (Fig.11.1, 11.3 to 11.9). Once digitised they will appear flatter but will still have a 3D feel if, for example, an effect like a drop shadow is added (Fig.11.4 - 11.6).

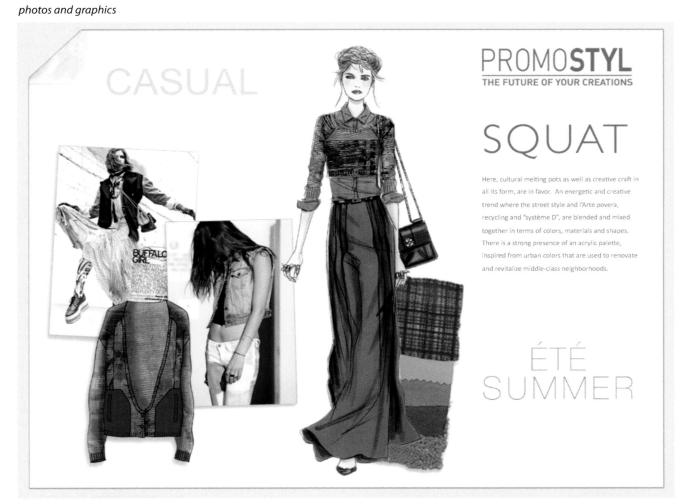

CASUAL

PROMO**STYL**
THE FUTURE OF YOUR CREATIONS

SQUAT

Here, cultural melting pots as well as creative craft in all its form, are in favor. An energetic and creative trend where the street style and l'Arte povera, recycling and "système D", are blended and mixed together in terms of colors, materials and shapes. There is a strong presence of an acrylic palette, inspired from urban colors that are used to renovate and revitalize middle-class neighborhoods.

ÉTÉ
SUMMER

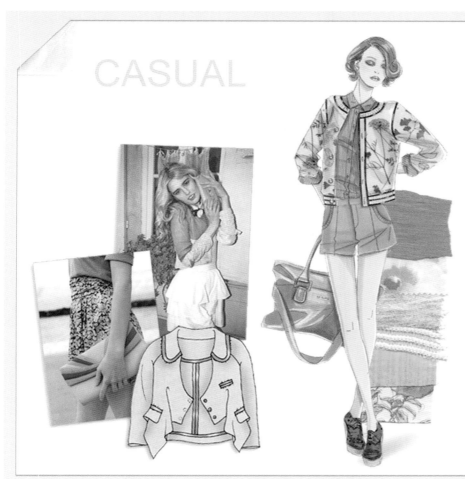

CASUAL

PROMOSTYL
THE FUTURE OF YOUR CREATIONS

SPRING

A spring theme; youthful and feminine, but without sentiment.

Here, greenery and gardens are transposed out of their context in order to take over the prints and the fabrics that sprout up like threads and become organic.

A calm and romantic silhouette, sometimes borrowed from our grandmothers' trousseau. The range displays urban and flowery shades, which give an impression of a modern and stylish atmosphere.

ÉTÉ
SUMMER

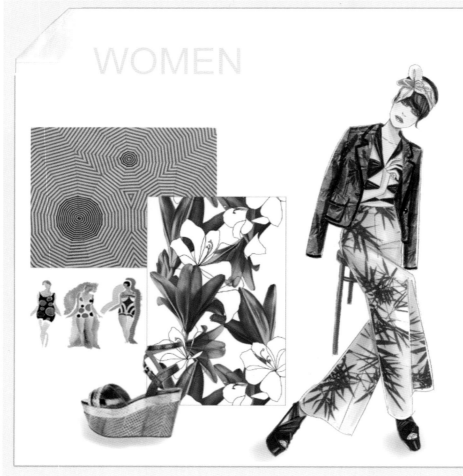

WOMEN

PROMOSTYL
THE FUTURE OF YOUR CREATIONS

PARADISIO

It's time to dare!

A true decorative elegance with it's all feminine glamour, a faultless sense of proportion and length, precision between fantasy and reason, grant a bold and realistic silhouette. Color Stories are born from the frank RGB trio coloring and combination, the blue tint, warm artistic reds and exotic jungle greens, come all together in a seductive jazzy dance of extravaganza.

ÉTÉ
SUMMER

© Fashion Artist (3ed)- Sandra Burke

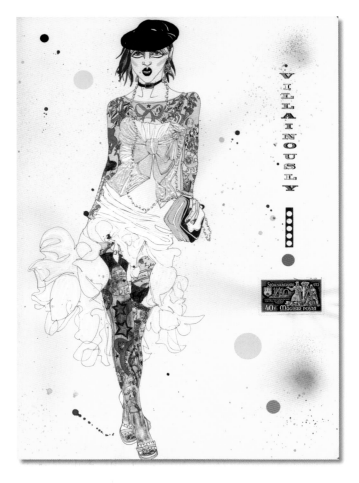

- **Fabric:** Prepare swatches to suit the presentation format by using any of these techniques 11.4 and 11.5):
- Trim the fabric swatches using double-sided tape to prevent edges fraying and adhere to the paper.
- Cut with pinking shears - this cuts a zigzag edge and stops the edges fraying.
- Scrunch in little bundles using double-sided tape.
- **Paper/Background:** Some presentations call for a colored background or with some detail, especially if no fabric or flats are being presented (Fig. 11.7 to 11.11). For a more classic and sophisticated presentation with flats and fabrics, a white ground could be perfect (Fig. 11.3 to 11.6).
- **Border:** Just as a picture is enhanced in a frame, so a design presentation can be enhanced when surrounded by a border (Fig. 11.3 to 11.6).
- **Portrait and landscape layout:** This depends on the type of board and the elements to be presented (see all Figs.). Portrait might be the preferred layout when presenting one or two full length figures, but this will also depend on the other elements to be included. Some poses call for a landscape layout; landscape is often used for menswear for individual items (jackets, shirts, pants), etc., and children's presentations, as the figures are shorter and cuter (see *Men*, and *Children* chapters).

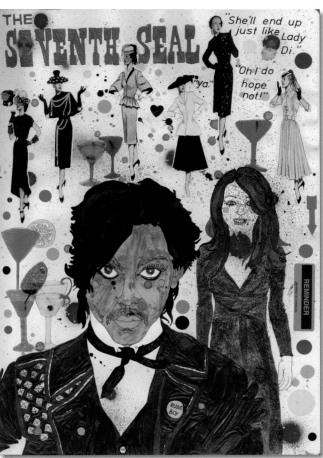

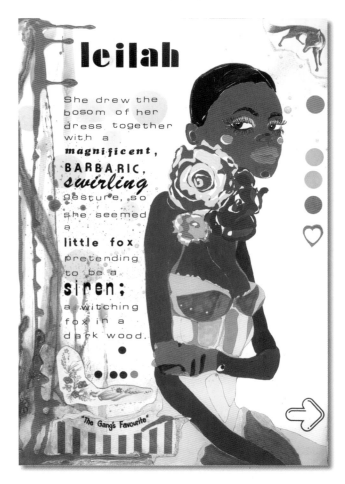

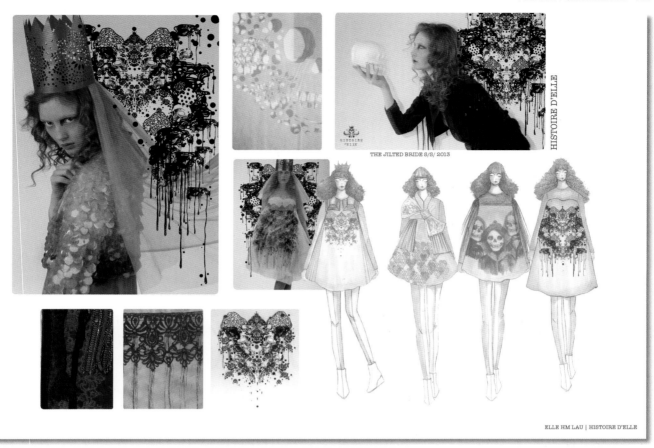

Figure 11.7 - 11.9 (opposite):
Presentations by Sarah Beetson
Hand drawn illustrations with collage and detailed backgrounds, and a small amount of digital editing

Figure 11.10 (above): Elle Hoi Ming Lau
Created by hand with a small amount of Photoshop editing. All elements; the photography, textile and clothing designs are balanced and focussed on the theme and placed on a white ground

Figure 11.11 (below): Presentation by
Jonathan Kyle Farmer (Michael Kors)
The figures (sophistication with a twist) of varying sizes display the collection perfectly; the business theme is enhance by a line drawing of the city

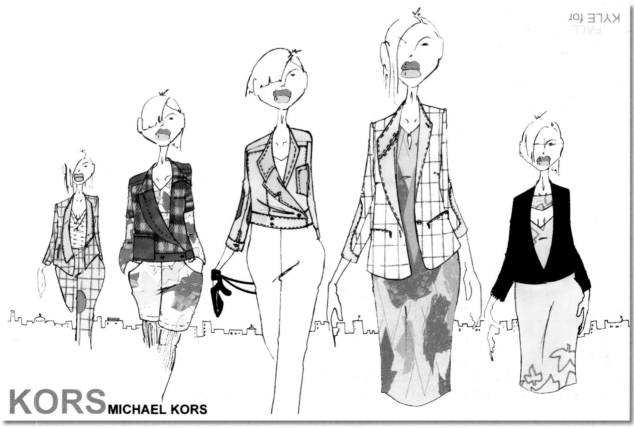

3. Digitally Generated and Enhanced Presentations

Depending on the design brief, you might create all part or all of your presentations manually or digitally. For example:

• Illustrator and CorelDRAW, are industry standard globally and excellent for creating flats and text.

Use them to create flats, text and even the complete presentation.

• Photoshop, also industry standard, is perfect for editing images and creating presentations, bringing all the design elements together on one presentation; scans of images, digitally created flats, etc.

• Print out all necessary visuals and text, cut and paste together with

your manually rendered fashion figures/designs and fabric swatches.

Once you are skilled in using digital software packages such as, Illustrator and/or CorelDRAW and Photoshop, and depending on what software is accessible to you (CAD systems, etc.), you might consider digitally generating all your fashion figures

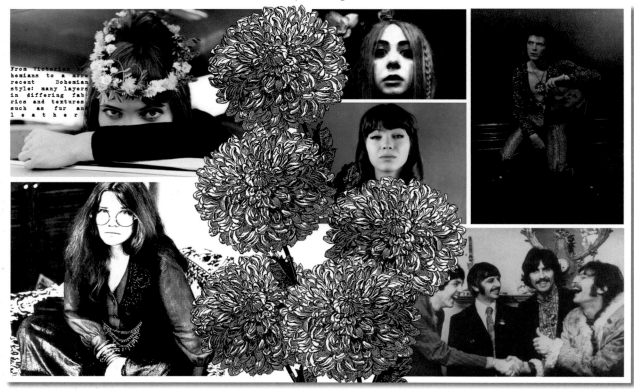

From Victorian bohemians to a more recent Bohemian style: many layers in differing fabrics and textures such as fur and leather

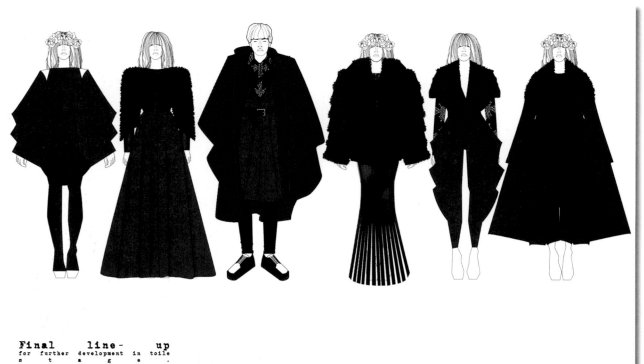

Final line-up
for further development in toile stage.

and the layout as one presentation sheet. If you need to print the presentation in large format you would probably need to use a service bureau.

For more information see my book, *Fashion Computing - Design Techniques and CAD*.

Figure 11.12a (opposite),11.12 b and 11.21c (below to bottom): Presentations by Rachel Williams

Mood Board and *Design Presentations* for **Bohemian** Collection.

Presentations include fashion figures created in Illustrator and edited in Photoshop. Scanned images and digital images from the Internet help to create and enhance the presentations.

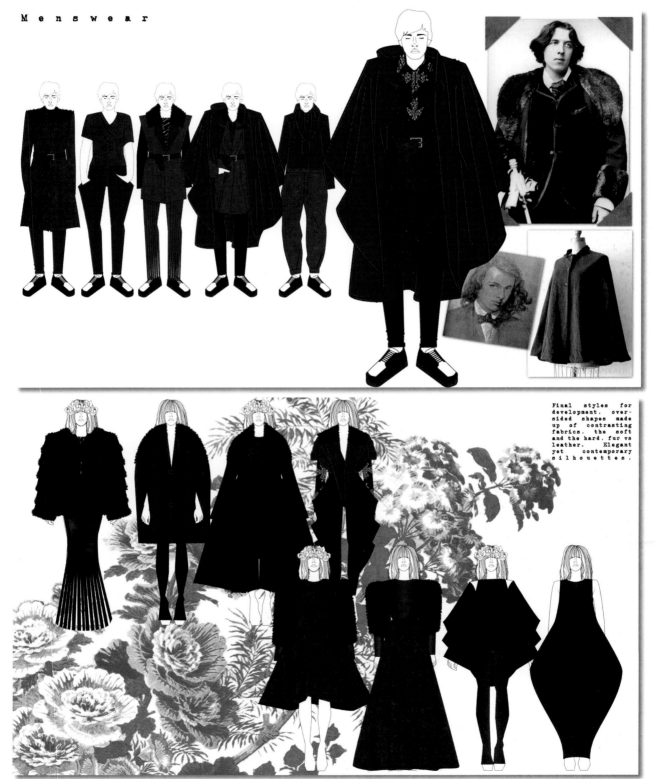

Final styles for development. over-sided shapes made up of contrasting fabrics. the soft and the hard. fur vs leather. Elegant yet contemporary silhouettes.

© Fashion Artist (3ed)- Sandra Burke

4. Fashion Design, Presentation and Production Process

The fashion design and production cycle starts with market and trend research, sampling fabric, designing and making the samples (see *Fashion Designer* book in this series, *Fashion and the Design Process* chapter).

These presentations show fashion designer, Helen Butcher, in the design stage of planning her collection; the theme, fabrics, colours, inspirational photographs and images, and sketches of her garments together with sketches of the finer details included in her final ten outfit line up.

In the next chapters we move on to drawing men and children/kids, before discussing how to display presentations and artwork in a design portfolio.

Figure 11.13a (below),11.13 b and 11.13c (opposite top to bottom): Presentations by Helen Butcher

Design Development, Design Presentation, and Mood Board for Shanghai Collection.

Presentations include fashion figures and flats created in Illustrator and edited in Photoshop. Scanned fabric, and images, and digital images from the Internet help to create and enhance the presentations.

SHANGHAI EXPRESS

SHANGHAI EXPRESS IS INSPIRED BY THE CARE FREE ATTITUDE OF THE EARLY 1930'S WITH STRAIGHT CUTS, DROPPED WAISTS AND PRINTS INFLUENCED BY THE GRAPHIC STYLE OF ART DECO. PHOTOGRAPHIC PRINTS BY ARTIST DAVID BALLINGER ARE SPLICED WITH TAILORING, MACRAME KNOTTING AND FLORAL PRINTS TO CREATE A FEMININE YET EDGY COLLECTION, EXPLORING THE IDEA OF GENDER MASHING.

FABRICS CONTRAST BETWEEN LEATHER, SILK AND MOHAIR AS THE COLLECTION INCORPORATES ELEGANT MENSWEAR PIECES OF THE ERA; COCO CHANEL OFTEN MANIPULATED MENSWEAR GARMENTS TO MAKE THEM INTO WOMENSWEAR.

A COLOUR PALETTE OF DEEP TEAL, ORCHID HUSH, QUARRY AND A RANGE OF GREYS IS OFFSET BY A RICH FUSHIA PINK AND NOTES OF REFRESHING ICE GREEN.

COLLECTION PROPOSAL

I LIKE THE COLOUR. COULD HAVE A CLIP/HARNESS TO ADD FURTHUR INTEREST?

ELEGANT BUT WITH A CASUAL APPROACH. COULD ADD ANOTHER LAYER TO THIS

NEEDS BEADING EMBELLISHMENT TO BRING THE PRINT TO LIFE

I LIKE THE CONTRAST TO THIS LOOK. NEED TO MAKE SURE TAILCOATS HAVE A MODERN TWIST AND DONT LOOK LIKE A 1930'S REPLICA.

TRANSLUCENT LAYERS COULD MAKE JACKET SLEEVELESS SO JUMPER CAN FIT UNDERNEATH

ADD BUTTON FLY TO TROUSERS. ADD A CROPPED JACKET TO COMPLETE OUTFIT

HIGH WAISTED 7/8 TROUSERS. COULD PAIR WITH TAILCOAT SHIRT FOR MORE FORMAL LOOK

ADD LONG CARDIGAN OVER A DRESS?

JUMPER DRESS UNDER SHEER TAILOCAT?

HELEN BUTCHER

SHANGHAI EXPRESS: DESIGN SELECTION

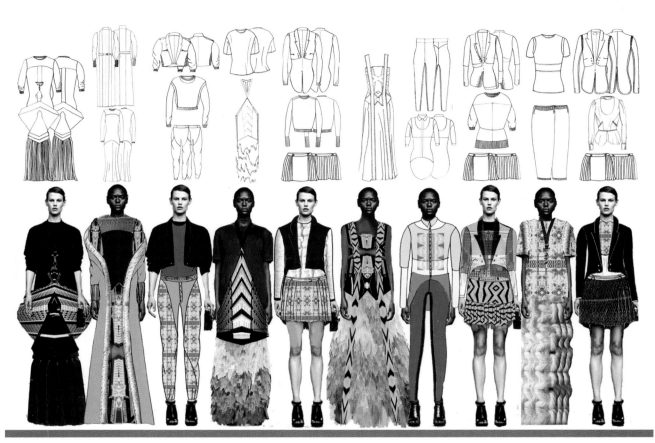

TEN OUTFIT LINE UP

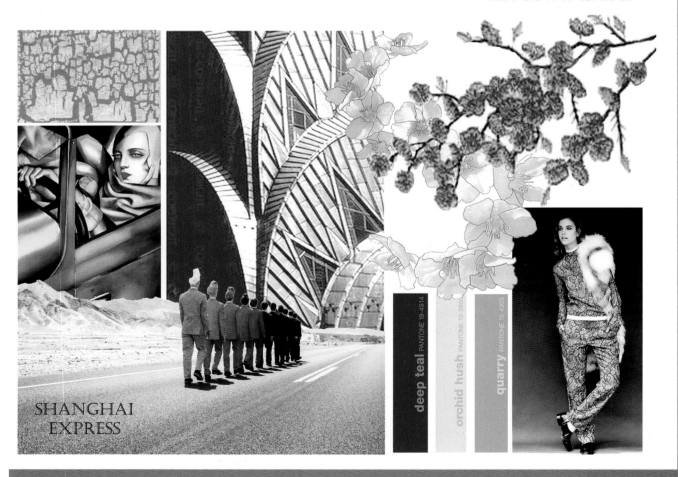

SHANGHAI
EXPRESS

deep teal PANTONE 19-4914

orchid hush PANTONE 13-3805

quarry PANTONE 15-4305

5. Fashion Figures Presentation (Matrix)

The Wild and The Natural

The Wild and The Natural: This cohesive, capsule collection also forms part of a larger collection.

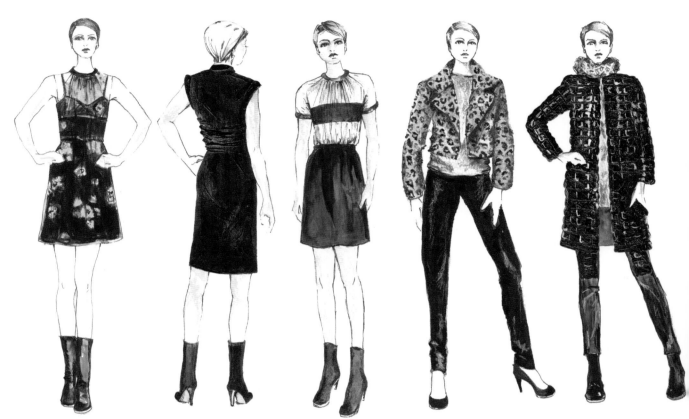

Range - left to right:

- Sleeveless printed silk georgette top and skirt, each with silk chiffon overlay detail
- Fitted leather dress with capped padded sleeve and high waist detail; leopard print or plain faux fur ankle boots
- Dress of silk chiffon and crepe
- Leopard print faux fur zipped front bomber jacket, jersey knit sleeveless top with digital screen print; slim fine wool pants (extra long leg length)
- Quilted waterproof shiny nylon coat with quilted waistcoat; leopard print faux fur snood/collar; jersey knit long sleeved top with digital screen print; stretch crepe and shiny nylon slim pants with quilted top front panels and zipped inside leg at ankle
- Printed silk long sleeved shirt; printed stretch velvet jeans; printed sheer silk organza cape with faux fur collar

Fabrics - Plains:

- Crepe, stretch crepe, silk chiffon, silk tulle, silk organza
- Stretch velvet
- Quilted waterproof nylon, shiny coating
- Wool
- Black leather
- Jersey knit (grey)
- Faux fur

Fabrics - Prints:

- Bold floral
- Leopard print and snake print

Colors:

- Black, grey, silver, prints (blues and yellow, and reds and yellows on black ground)

Figure 11.14: Presentation of the Capsule Collection:

Line drawings by Linda Jones
Fabric renderings by Peter Lambe

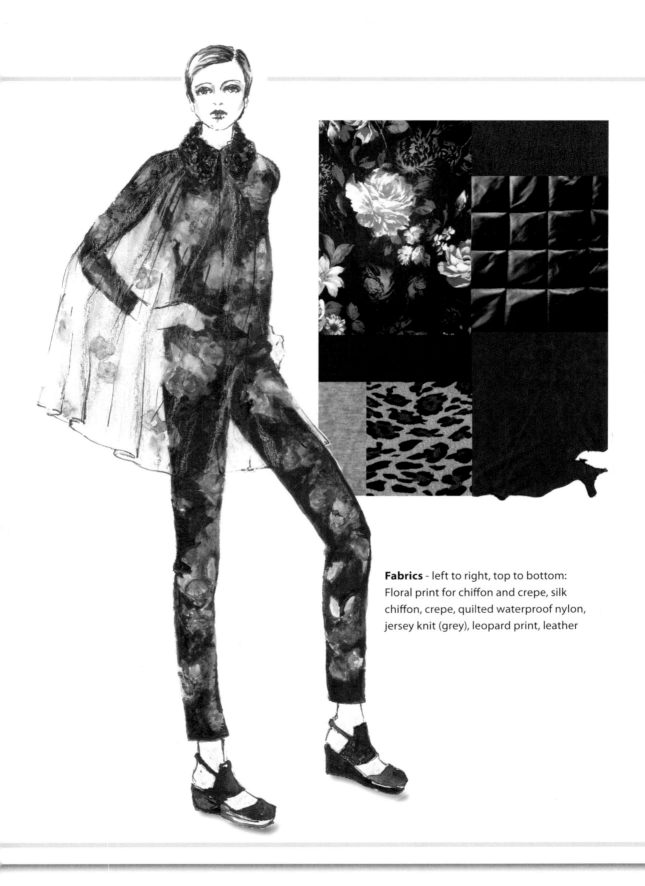

Fabrics - left to right, top to bottom:
Floral print for chiffon and crepe, silk
chiffon, crepe, quilted waterproof nylon,
jersey knit (grey), leopard print, leather

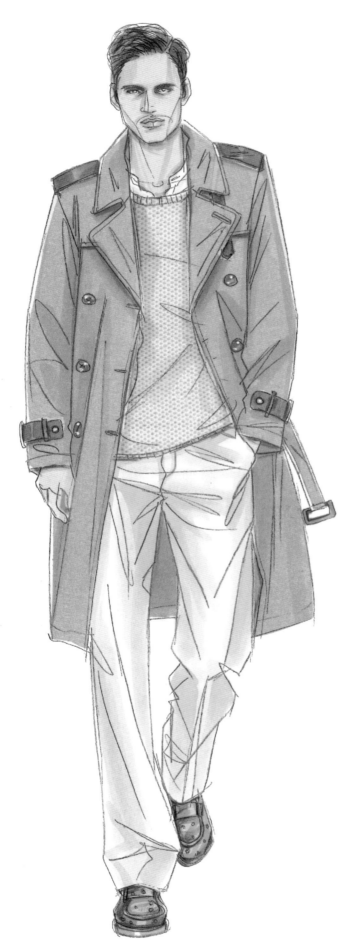

Illustration courtesy of **PROMOSTYL Paris,**
from their Menswear Trends book

12

Men

In the days of Nelson and Napoleon, men and women were equally flamboyant in their attire. However during the following 150 years, womenswear became the forerunner of fashion as menswear became more functional and subtle in design. With the *60s hippy, flower power* fad, men's desire to dress more exuberantly was rekindled and began to keep in tune with females' *passion for fashion.* More recently, designers such as Giorgio Armani, Calvin Klein, Ralph Lauren and Paul Smith, have made menswear *a must have* commercial venture and men now *crave* the latest fashions as much as women. Avant-garde designers such as Jean Paul Gaultier, have pushed the boundaries further with innovative styling and shown men that they too can be *peacocks in the fashion world!*

Overall, men's wear silhouettes change very little from season to season; the styling is mostly created through color and fabric. In industry the greater part of design work for men is presented as flats - an important skill to develop (see *Clothing Design* chapter). Although, if you choose to specialise in menswear design, drawing the male fashion figure will also be required as it presents a more enhanced look to the designs, and is used in design presentations.

This chapter covers how to draw men, the differences between the female and male fashion figures, and menswear. It then looks at a gallery of examples by other designers and illustrators to provide guidance and inspiration.

Art Box

- Drawing media, 2B Graphite pencil, fine liners, etc.
- Ruler, french curves (optional)
- A3 (14x17 inch) semi-transparent paper
- A3 (14x17 inch) Cartridge paper /preferred paper
- Fashion mags/resource folders/portfolio

1. Male Proportions and Body Shape

 Exercise 1: Drawing the Male Fashion Figure

You can use the same oval and triangle technique to develop poses for male fashion figures as described in the *Oval and Triangle Technique* chapter. A eight heads basic male figure has been developed here. When you flesh out the male figure remember that it is drawn bulkier in size and shape compared to the female fashion figure.

The male has;
- A stronger and bulkier build overall.
- Less shape in the upper and lower torso, the waist is thicker so there is less definition between the waist and the hips.
- Larger, developed body muscles.
- Broader, squarer shoulders.
- A deeper chest line (not the high, small bust as the female figure).
- Thicker and stronger looking arms and legs.
- Broader hands (not elegant).
- A squarer face and thicker neck.

Figure 12.1: Template 1 (male) by Linda Jones

The eight heads male fashion figure - use the same oval and triangle technique to create your figures as in the Oval and Triangle Technique *chapter. The male fashion figure is taller and bulkier overall compared to the female fashion figure, even the face and features are much stronger.*

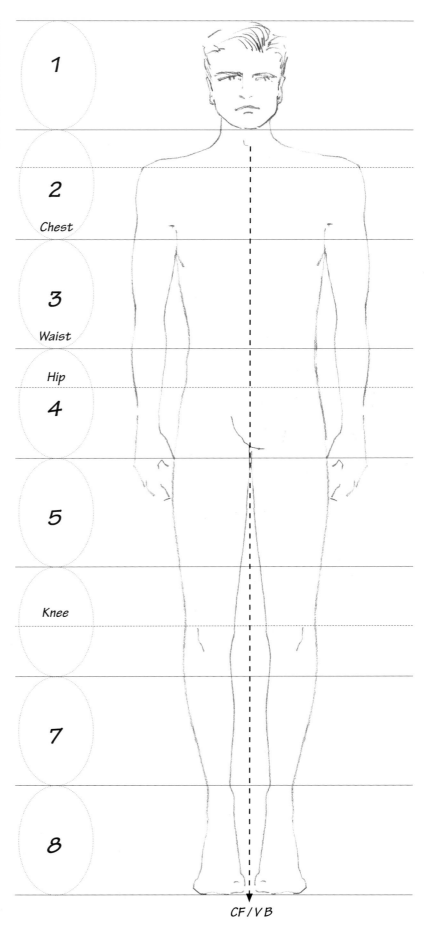

8 Heads Guide Men

1

2
Chest

3
Waist

Hip
4

5

Knee

7

8

CF / V B

2. The Male Face, Hands and Feet

Figures 12.2 -12.4 presents the male face; also see all other illustrations in this chapter for faces, hands and feet.

The male face can be divided using the same guidelines as the female face, but the features are generally drawn bolder with:

- A squarer, larger and more defined forehead and jaw.
- Narrower eyes with less eyelid - women enlarge their eyes with make up.
- Thicker, heavier, and lower eyebrows.
- A more dominant nose - draw stronger lines.
- Narrower lips with less emphasis on the shape.
- More defined ears.
- Stronger, higher hairline.
- Character lines for more rugged, mature look - every line can add ten years.

Compared to the female, male hands are (see illustrations on the following pages):

- Squarer and broader.
- Fingers are blunter.
- More boxy looking overall.

Compared to the female, male feet and shoes are (see illustrations on the following pages):

- Broader and wider.
- Shorter looking.
- Thicker ankle.
- Sturdier sole.

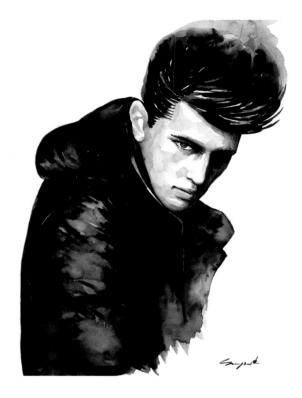

Figure 12.2 (top): **Illustration by Soo Mok**

Media: *Watercolor*

Soo's dynamic illustration of the male face shows how much larger and more defined the features are compared to those of the female

Figure 12.3 (middle): **Illustration by Yiunam Leung**

Media: *Water soluble colored pencils*

Although the male face is much stronger than the female's, here it has been softened by the use of the media. The tattooed arms help depict the masculinity

Figure 12.4 a and b (right): **Illustrations by Sarah Beetson**

Media: *Acrylics, various brush sizes and collage*

Sarah has expertly presented two colorful male faces and torsos in a more fun loving approach but still presenting their masculinity

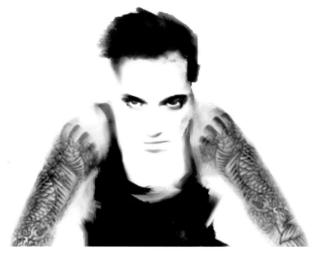

3. Male Poses

When drawing a male fashion figure beside a female fashion figure, fashion illustration dictates the male will be drawn slightly taller; the figure is scaled up accordingly (Fig. 12.5). Compared to female poses, males:

- Stand more squarely and consequently the angles of the shoulders and hips are less exaggerated.
- Place weight solidly on heels, with no pointing of the foot.
- Roll their shoulders when walking - women move their hips more.
- Swing their arms freely when moving - women's arms swing gracefully.
- Place their elbows away from the body with hands curving towards thighs - women's elbows are often placed against their body.
- Hold their wrists and hands in a less graceful way than women.
- Often stand with their feet pointing outwards - women typically point straight and sometimes inwards.

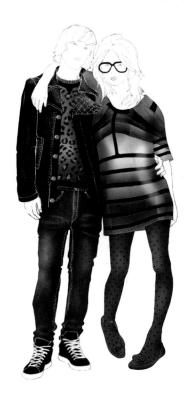

Figure 12.5 (right)**:** Illustration courtesy of **PROMOSTYL Paris,** from their Youth Market - Winter Trends book, theme **Kids At Gigs**

The male figure is drawn larger and taller than the female figure, and in a more dominant pose

Figure 12.6 a, b and c (below)**: Illustrations by Laura Krusemark**

Media: *Graphite pencil*

Laura presents the male figures in walking pose; note the male pose is more dominant and solid compared to that of the female figure poses throughout Fashion Artist

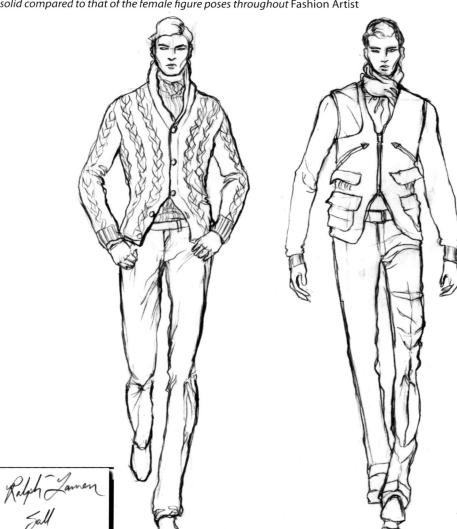

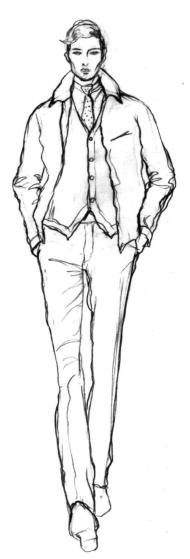

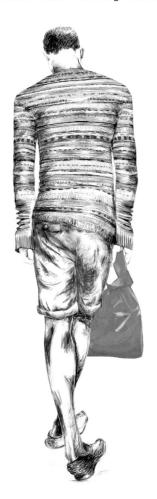

Figure 12.9 (left)**:** Courtesy of **PROMOSTYL Paris,** Menswear S/S Trends book

Media: *Hand sketched figure, brought into Photoshop and edited*

Beachwear - male figure wearing cotton knit sweater and shorts

Figure 12.10 (below)**:** Courtesy of **PROMOSTYL Paris,** Menswear S/S Trends book

The illustration has been drawn by hand and the presentation edited in Photoshop

Paradisio Collection Trends Board, presents the central figure with all the inspirational design elements and themes anchored around the figure. Figure wears cotton Hawaiian shirt and denim shorts

Figure 12.11 (opposite right)**:** Courtesy of **PROMOSTYL Paris,** Menswear S/S Trends book

Male figures wearing a soft tailoring look and casual pants

Media: *Figures sketched by hand using graphite pencil, then brought into Photoshop to apply the fabric rendering digitally*

Figure 12.12 (opposite far right)**: Illustration by Soo Mok**

Male figure wearing a softly tailored suit and tie

Media: *Figure sketched in graphite pencil and water soluble colored pencils, then edited in Photoshop to create the background*

Figure 12.13 (opposite, bottom)**:** Courtesy of **PROMOSTYL Paris,** Menswear S/S Trends book

The illustration has been drawn by hand and the presentation edited in Photoshop

Rebirth Collection Trends Board, presents the central figure with all the inspirational design elements and theme anchored around the figure. Figure wears a knitted viscose sloppy sweater with casual rolled up cotton drill pants

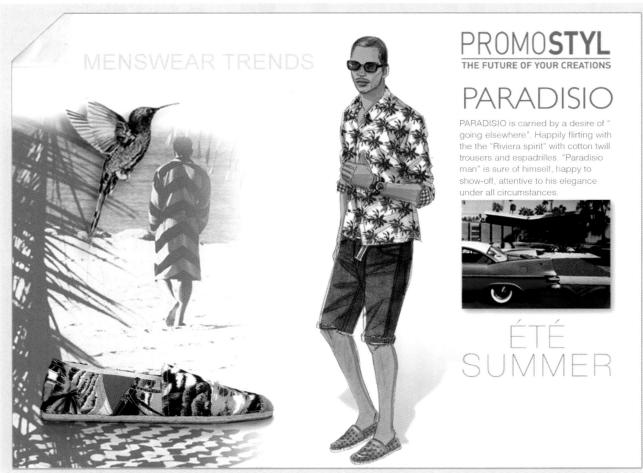

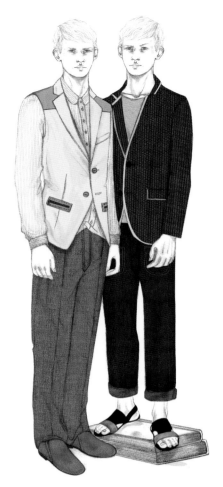

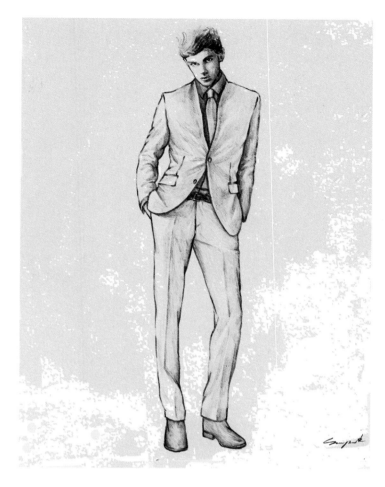

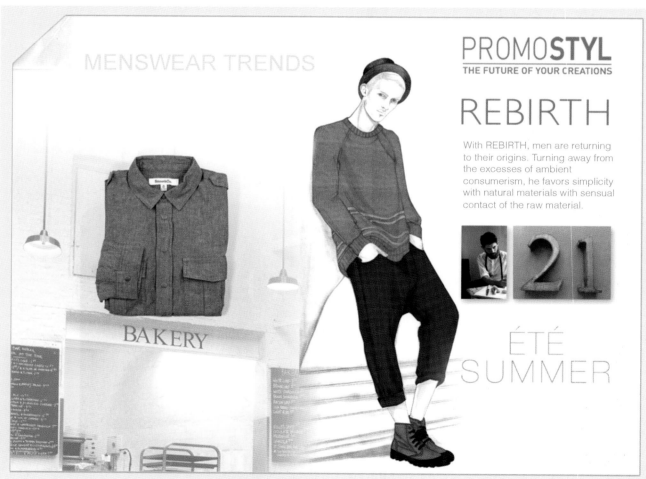

MENSWEAR TRENDS

PROMO**STYL**
THE FUTURE OF YOUR CREATIONS

REBIRTH

With REBIRTH, men are returning to their origins. Turning away from the excesses of ambient consumerism, he favors simplicity with natural materials with sensual contact of the raw material.

BAKERY

ÉTÉ
SUMMER

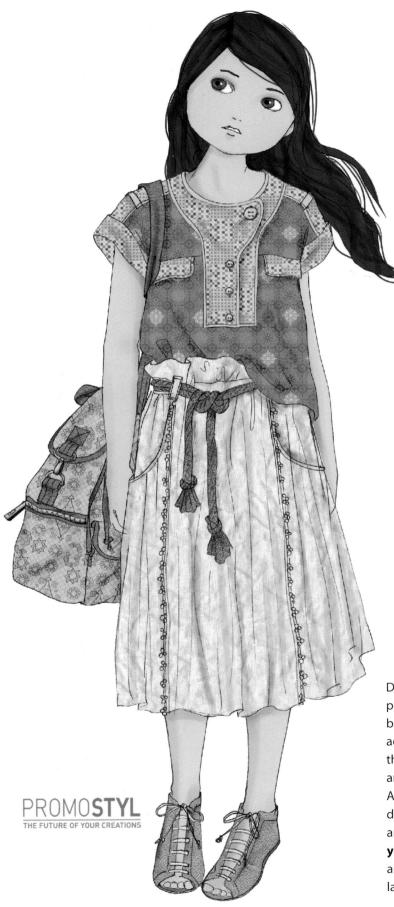

13
Children

Drawing children and designing children's clothes presents an interesting but fun challenge. Children's body shapes and poses are quite different to the adult fashion figure. They have less shapely bodies, the poses are less sophisticated and more playful, and the illustrations often have cartoon like qualities. As a child grows so the body proportions change dramatically. There are **vast differences in height** and body proportions from a **newly born child** to a **young adult.** Overall, the younger the child, the cuter and more rounded the figure, with a proportionally larger head.

Illustration Courtesy of **PROMOSTYL Paris**, Été Summer Children Trends book

1. Children's/Kids Poses

To be a children's wear designer you must be aware of the various age groups, from new borns to teens, as well as the special requirements both in clothing design and drawing the body proportions and figures. In this chapter we will take a brief look at these differences.

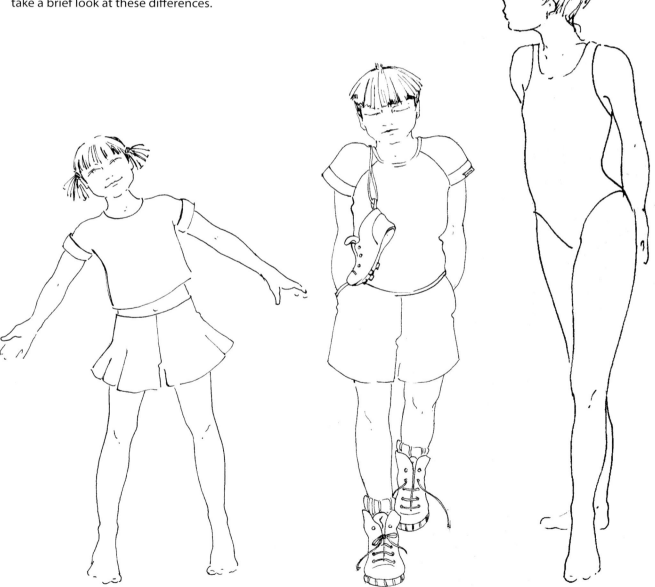

Figure 13.1 to 13.3: Illustrations by Linda Jones

Children 7 to 11 - poses progressively become less cute and take on more young adult-like gestures as they reach eleven years old

8 Heads Guide Kids

2. Children's Body Proportions and Body Shape

As with the adult fashion figure, children's fashion bodies are also measured in head depths but the number varies depending on the age of the child and increases as they get older (Fig. 13.4).

Note: You can change the appearance of your kids illustrations dramatically by adjusting the hairstyles to suit the age and also the style of clothing.

Figure 13.4: Children's Figure Template
Shows the variation in the number of heads that divide into the body from an infant to an adolescent, and how the body develops and changes in shape.

8

7

6

5

4

3

2

1

Toddler/Infant/two to three years, measure 4 heads

Small child/four to five years, measure 5 heads

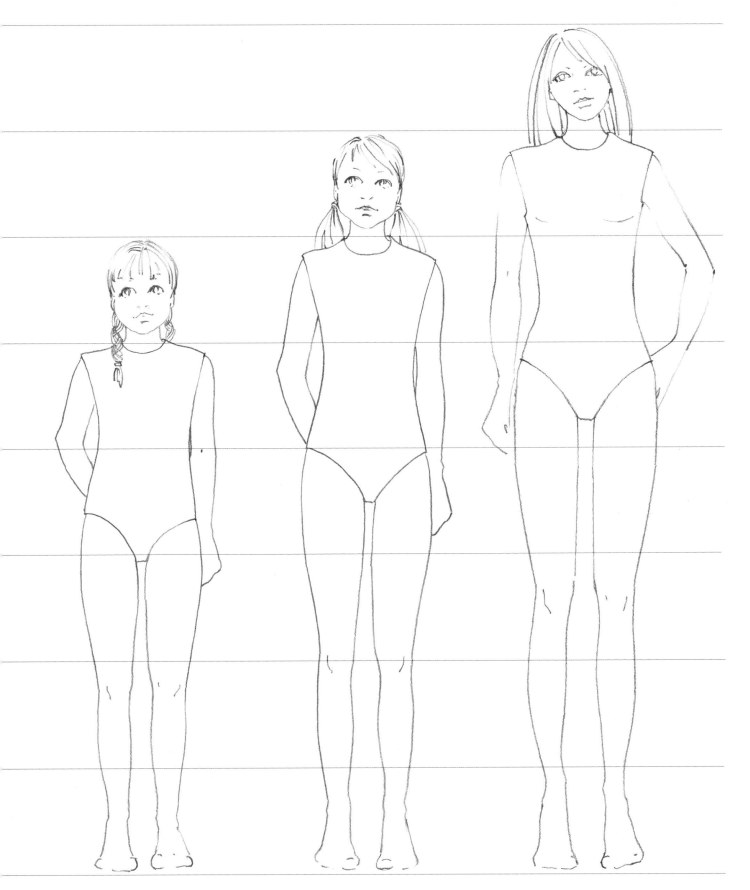

*Child, six to eight years,
measure 6 heads*

*Child, nine to eleven years,
measure 7 heads*

*Young teen/adolescent,
measure 8 heads*

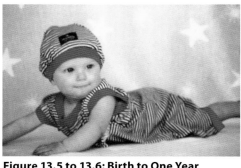

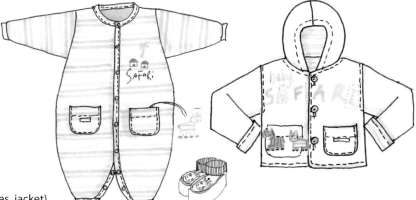

Figure 13.5 to 13.6: Birth to One Year

Photo - Courtesy of **Munko Clothing**

Flats Courtesy of **Pumpkin Patch** (romper, booties, jacket)

3. Children's Fashion Gallery

In this section we take a look at a gallery of children's photographs, illustrations and flats, from babies to ten years of age, to help understand how a child actually develops in body shape and appearance. It is particularly interesting to note the different poses children take on; this helps us to determine their age, and sketch the figures accordingly.

Babies - birth to one year old:

The head is approximately 1/4 of the total height. Their body, head, arms and legs all have a rounded look. They have big rounded eyes, and exaggerated dimples on their cheeks, knuckles and knees. At this age they are sketched either lying down or sitting propped up (Fig. 13.5).

Toddlers - one to two years old:

Fig. 13.7 and 13.8 - the head is still large in comparison to the body, and measure four heads high. Everything about them is still chubby and cute looking with no defined body shape. They have protruding stomachs and might still be in nappies (diapers) making them even more rounded. There is little distinction between boys and girls.

The face is still round with big cheeks and little jaw definition, the neck is short. The eyes are rounded with just a little definition for the eyebrows. Noses are small. The hair is beginning to have a little style.

Toddlers are in the early stages of learning to walk and can sit without support, so they are generally drawn sitting.

Children - two to three years old:

Fig. 13.10 - they are four heads in height, the difference is in the legs - the legs are now drawn straight as they are strong enough to support the body when standing. The arms and legs have more shape but are still podgy and with a slightly protruding belly.

Their faces are more defined and the neck longer; their mouth is larger and developing teeth. The hairstyle is more defined, but girls and boys still look similar in body shape.

Two year olds are walking, but are awkward in their movements, almost 'colt' like even up to three years old.

Figure 13.7 to 13.9: Babies and Toddlers

Photo - Courtesy of **Munko Clothing**
Illustration by Sandra Burke

Flats Courtesy of **Pumpkin Patch,** Toddler Girls Summer Range

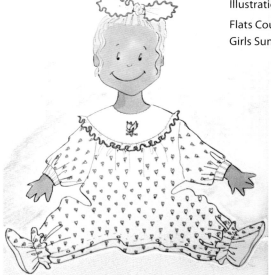

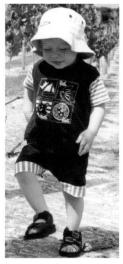

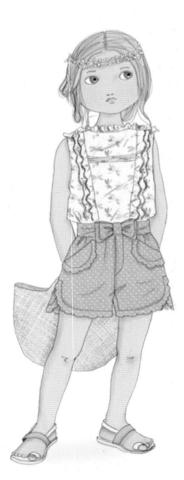

Figure 13.10 to 13.12: Two to Three, and Four to Five Year Olds

Photo - James Grant, by Sandra Burke

Flats Courtesy of **Pumpkin Patch** (hoodie, long sleeved tee)

Illustration Courtesy of **PROMOSTYL Paris**, Été Summer Children Trends book

Children at three years old: They are drawn standing in cute poses, sometimes carrying something. They still have the feeling of 'colt' like awkwardness, but are becoming very active in their movements (Fig. 13.10).

Their clothing is becoming more interesting and fashionable. Children even begin to tell their parents what they want to wear as they become more aware of other kids clothing.

Children four to five years: Fig. 13.12 and 13.14 - the children are now approximately five heads high, the growth is mainly in the legs. There are small changes in body shape as they lose baby fat, and the stomach protrudes less, but there is no defined waistline.

The face is slightly narrower, the eyes less round becoming more almond shaped, and the eyebrows are darker. The nose is more defined with a roundness at its tip. The mouth is larger as the teeth have now developed fully. The hair is more styled.

Boys and girls start to look different in body and features and, because of this, their clothing becomes a mix of both innocence and fashion.

The poses are more active and animated, but still have a slight awkward appearance.

Figure 13.13 to 13.14: Two to Three, and Four to Five Year Olds

Flats Courtesy of **Pumpkin Patch**, Toddler Girls Summer Range

Illustration Courtesy of **PROMOSTYL Paris**, Été Summer Children Trends book

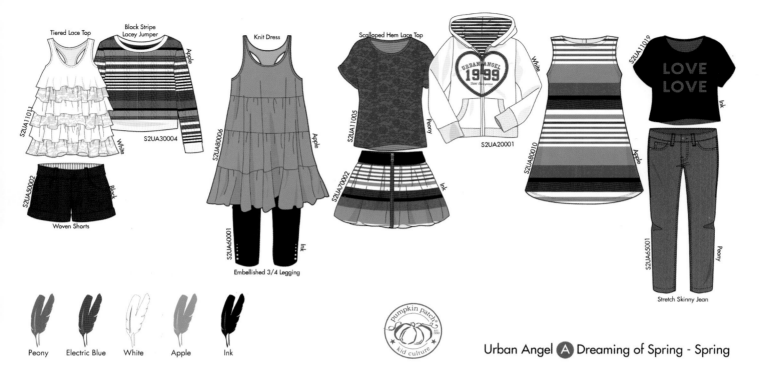

Tiered Lace Top

Block Stripe Lacey Jumper

Apple

S2UA11011

White

S2UA30004

Knit Dress

Apple

S2UA80006

Scalloped Hem Lace Top

S2UA11005

Peony

White

URBAN ANGEL 1999

S2UA20001

S2UA11019

LOVE LOVE

Ink

S2UA80010

Apple

S2UA50002

Black

Woven Shorts

S2UA60001

Ink

Embellished 3/4 Legging

S2UA70002

Ink

S2UA65001

Peony

Stretch Skinny Jean

Peony · Electric Blue · White · Apple · Ink

pumpkin patch - kid culture

Urban Angel Ⓐ Dreaming of Spring - Spring

Children 7 to 11: Fig. 13.17 and 13.18 - they are approximately six to seven heads high. Muscle gradually replaces baby fat, but the waist is not really defined. The arms, legs and torso are becoming slimmer, with knees and elbows more apparent.

Baby fat is also disappearing from the face although there is still a roundness in the cheeks, eyes are more shapely, the nose is small but becoming stronger with a wider bridge, the mouth developing shape.

Poses are now becoming less cute and taking on more young adult-like gestures.

Childrenswear Illustration and Design

Points to consider when illustrating and designing childrenswear are:

- A more stylised approach is required to that of the adult, to identify age and gender differences.
- Characterization is popular - freckles, large heads and feet, knock-knees, and captivating charm and innocence.
- The hairstyles, props, poses will all help to define the age of the child.
- If drawing children from life you must sketch quickly, as the child is unlikely to stay still for long. You might find it is much easier to take photographs to sketch from!
- Traditionally, until two years old, baby girls wear pink and baby boys wear blue.
- Kids designs are generally fun loving; cute and whimsical; bright colors and fun prints.

Figure 13.15 (top):

Flats Courtesy of **Pumpkin Patch**, Girls Summer Range

Figure 13.16 (left):

Illustration by Jonathan Kyle Farmer

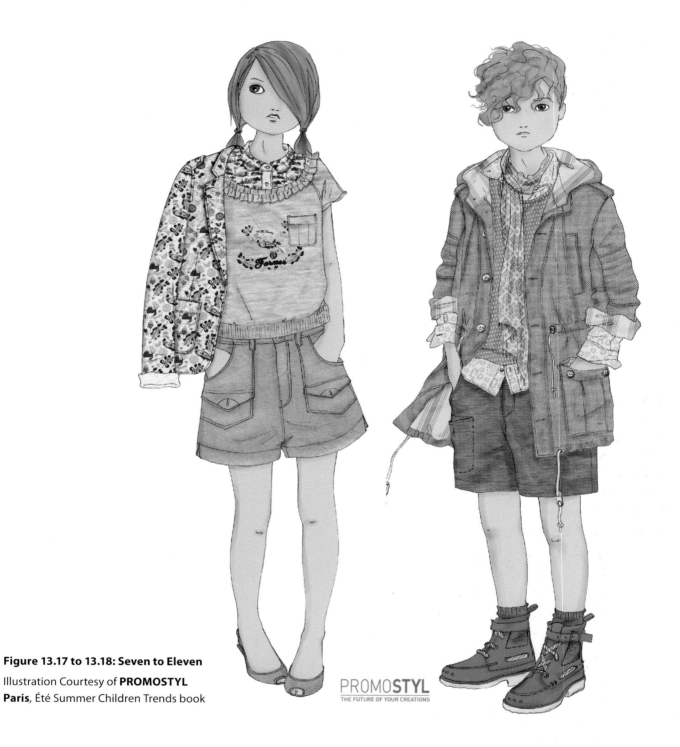

Figure 13.17 to 13.18: Seven to Eleven

Illustration Courtesy of **PROMOSTYL Paris**, Été Summer Children Trends book

PROMO**STYL**
THE FUTURE OF YOUR CREATIONS

- Styles may be theme or character driven - western, cartoon characters, sailor looks, etc.
- Color and print is important; black is used mainly for an older age group.
- Presentation formats often include characters /cartoons and, as in menswear design, are often presented in a landscape layout, which is more appropriate for small items and individual pieces of clothing.
- Research for design and inspiration: Children's literature, film, books - Cinderella, Snow White; animals (rabbits, cats), alphabet, numbers, etc.
- Characters such as Mickey Mouse, Little Mermaid, Winnie the Poo, Pokemons and Thomas the Tank Engine are copyrighted - you will need a special license to sell the garments commercially.

14
Fashion Portfolio

Your fashion portfolio is not just a collection of your work and a demonstrable example of your talent, it is also your **principle marketing tool.** In an interview situation, a creative and well planned portfolio provides visual evidence of your capabilities - it expresses your unique qualities; your range of fashion and design skills and your expertise; your design sense, drawing, illustration and presentation skills, as well as your technical skills (pattern making, sewing etc.). Your portfolio should be constantly updated, throughout your studies and career. It is your passport to success and career development.

Fashion Portfolio covers the different types of portfolios, both digital and physical, presentation and layout, what to include in the portfolio and, just as importantly, what to leave out.

Illustration by Hamza Arcan

1. What is a Fashion Portfolio?

A fashion portfolio can be a digital folder/file created as a PDF or PowerPoint slide show, etc., or a physical carry type case. It contains information about you and selected fashion imagery/artwork. To be prepared for all circumstances, it is best to have digital and physical portfolios.

Your fashion portfolio shows that you are serious about your work, you have research capabilities and particular skills. It is your:

• Professional way to collate and present visual evidence of your talent and skills - artwork, designs, illustrations, personal press reports/reviews, fashion photographs, etc.
• Method of enhancing the overall look and appeal of your design work, while keeping it in order and, in a physical portfolio, clean and tidy in plastic sleeves.
• Key marketing tool to help obtain employment or freelance work, or an entrance to a course or a degree.
• Portable and demonstrable method to present visual information - especially beneficial in an interview situation and when presenting work to clients, etc.

2. Types of Portfolio

Digital Portfolio: Your digital portfolio can be a file a folder that is your stored on your computer, your iPhone/smart phone, iPad/tablet, iPod, etc.

It can be published on the Internet by uploading to your own website, a host website (YouTube, etc.) and presented as a slide show or video to a live audience and, also, sent as an email attachment. With the rapid development of digital and social media, companies use all Internet facilities (email, websites, social network, web conferencing, etc.) as their means of visual communication. Once you create a digital portfolio you will be able to present your work to anyone anywhere in the world with a click.

Physical Portfolio: Consider:
• The ideal portable size - A3 (11x14 or 14x17 inch); A2 (18x24 inch) is more suitable if you want to work on a larger format, but obviously not as portable.
• Portfolio types vary but the **most popular** is a flat case with a handle (below left) and unzips to open like a book, displaying single or double page spreads (design work) in plastic sleeves that are removable.
• Alternatives - display portfolios with fixed plastic sleeves which fold back for a freestanding tabletop presentation (below right); a **box** or **pocket** type where work is protected. The types of portfolio with fixed sleeves are not as user friendly when you want to reorganise work quickly by simply moving the plastic sleeves.
• Good quality portfolios are made of tough plastic material or leather; they should last a life time
• Color - black portfolios look smarter and do not scuff easily.

Figure 14.1 (below left): *A3 (14x17 inch) portfolio with zipper*

Figure 14.2 (below right): *Display portfolio for a table top presentation; illustration by Linda Jones*

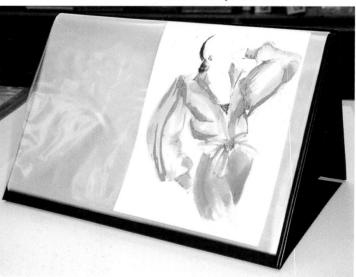

3. Portfolio Contents and Layout

The layout, order and sequence of work in a portfolio is just as important as its contents. Consider:

- **Size (physical portfolio)** - A3 (14x17 inch), A2 (18x24 inch); the size of your design presentations depends on the requirements of the design brief and/or size of your portfolio; also present digitally as a slide show (file sizes would not want to be too large for download/speed of viewing).
- **Introductory page** - start with something about yourself, unique to you, a short resume/CV, press coverage/awards (visuals/press articles displayed within the body of work), a stunning piece of artwork/design that will not date quickly; attach a business card with a logo so that you have something memorable to leave with your interviewers; also if you lost your physical portfolio it can be returned; and a 'links' section (websites, blogs, etc.).

- **Display** your best work and have a 'wow' piece to end with (wedding, evening wear).
- **Variety** - display your creative talents, design skills and flexibility by presenting a range of relevant artwork to avoid repetitiveness.
- **Selective** - present your best work and remove any weak links.
- **Creative** and graphically well presented, not necessarily wild on every page, but show design sense.
- **Organise** your portfolio either by design or season (latest first) - you could index your content.
- **Informative** - your portfolio should tell a story about you and your abilities, keep it direct and strong.
- **Clean and neat** - remove grubby marks, cut work to neatly fit, be sure plastic sleeves are the right way up.
- **Double page spreads** - present the work cohesively to create additional visual impact.
- **Orientation** - chose a specific layout (portrait or landscape), maintain flow and be consistent so the portfolio does not have to be turned continuously for viewing - if you change the page orientation the facing pages (double page spread) should be the same orientation if possible.

- **Group pages** - for order and flow, group pages which relate to the same theme.
- **Portable** - keep it light and easy to carry, do not use heavy card for mounting.
- **Update and rearrange** - always keep your work up to date; plastic sleeves allow you to present work as single or double page spreads, rearrange the order, and replace work as necessary.
- **Stand alone** - your portfolio must be self explanatory in its use of text and presentation; this is especially important as your portfolio might be viewed without you being present.
- **Back up -** if you need to send your portfolio to several venues at the same time (e.g. for an entrance portfolio on to several courses, or to show your design skills) your digital versions will be your backup.

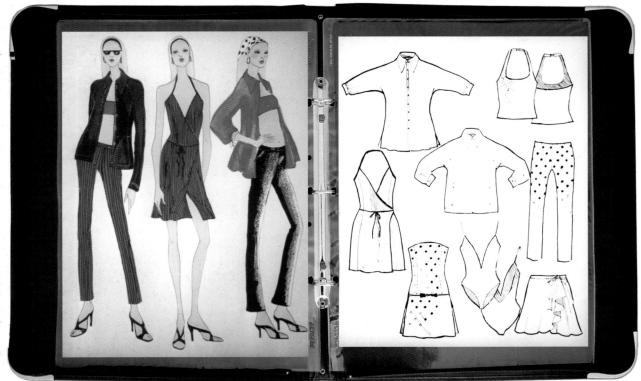

Figure 14.3: Portfolio Presentation - Linda Logan

Media: *Fine liners, markers and marker blenders - illustrations and flats hand drawn*
Double page spread, showing illustrations and flats of the collection

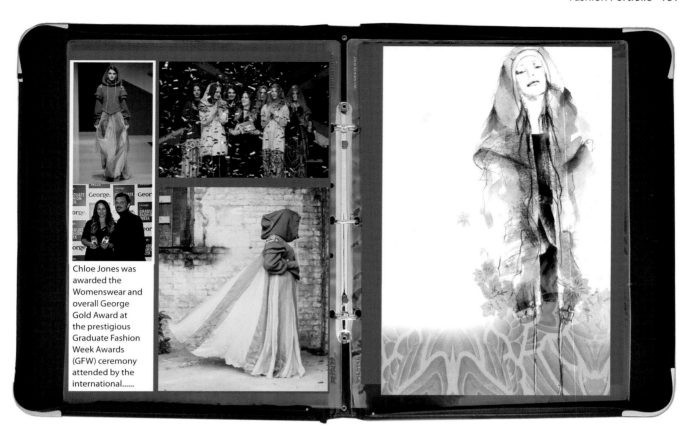

Figure 14.4: Portfolio Presentation - Chloe Jones

Media: *Watercolor and water soluble colored pencils - illustration hand drawn*

Double page spread, showing Chloe's winning designs and press coverage (edited for legibility) at Graduate Fashion Week, London; *illustration of one of the winning designs*

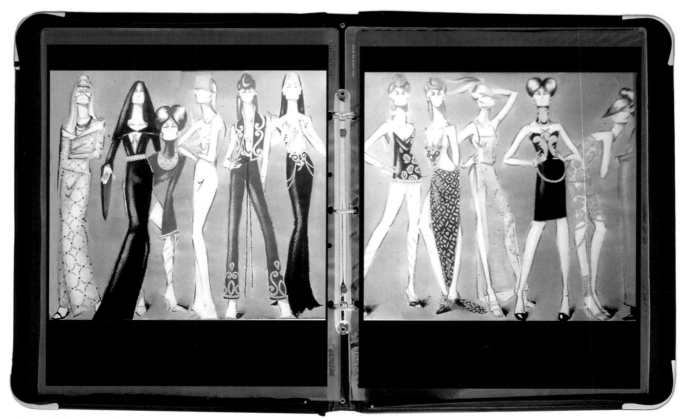

Figure 14.5: Portfolio presentation - Jason Ng

Media: *Colored pencils, markers and marker blenders - illustrations hand drawn*

A impressive double page spread of 'Versace' inspired collection in portrait view

4. Target Your Portfolio

"The mark of a professional portfolio is its focus. Targeted to a special customer and market, its design sense should be consistent from start to finish." Linda Tain *(Portfolio Presentation for Fashion Designers)*.

Think professionally and target your portfolio. The layout of your portfolio and the design work you put into it will depend on what company or educational course you are applying to, or to whom you are marketing your talents. Decide what you want your portfolio to do for you, display and direct your portfolio to that end.

You might need a portfolio for:

• An entry to a course, school, college, university; entry level portfolios should consist of a variety of formats to demonstrate design and rendering skills. Unless specified, you will need a range of work to show your capabilities in some or all of the following; your techniques and use of media, fashion awareness, design development, fashion poses, fashion flats, color and fabric sense, design work, photographs of clothing you have made, competition work, costume designs, etc.

• Applying for a position in the fashion industry - this might be for your first job or a development in your career. For your first job, present a selection of your design capabilities from fashion design development, fashion sketching and illustration, flats, color and fabric sense, design presentations, your collections (photographed and illustrated). When moving on in your career you need to show your current work and the best of what you can do. In both cases you might need to target your work to a particular company - when a company reviews a portfolio they expect to see a certain amount of similarity between your work and their products.

• Acquiring freelance work - you might need to target your portfolio specifically for the client or show your talent and skill in all areas of design.

• Marketing or presenting your latest clothing range.

• A competition - the design brief will describe what is required.

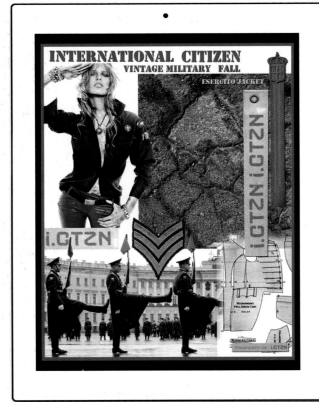

Figure 14.6: iPad Portfolio Presentation - Laura Krusemark, i.CTZN

Media: *Collage by hand, flats created in Illustrator and edited in Photoshop*

International Citizen, Vintage Military for Fall - *double page spread displaying Theme/ Mood board for the collection, and some of the collection as flats*

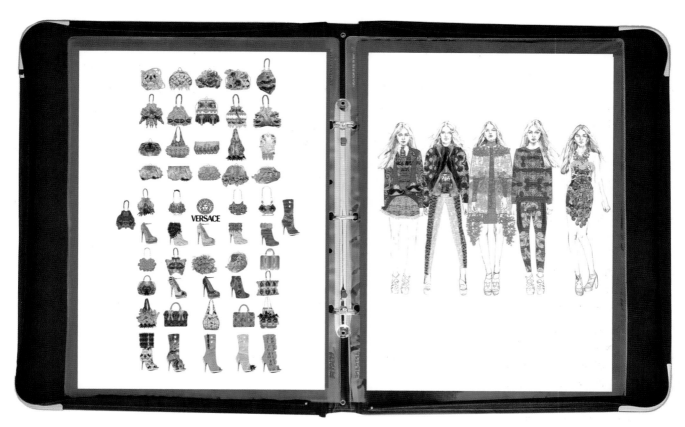

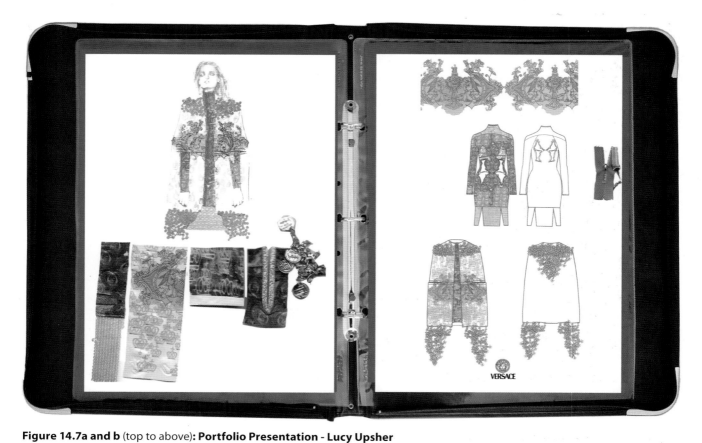

Figure 14.7a and b (top to above): **Portfolio Presentation - Lucy Upsher**

Media: *Water soluble colored pencils, collage, hand drawn illustrations, flats created in Illustrator and some fabric rendering and editing in Photoshop*

Double page spreads displaying fashion designs for Versace

Figure 14.8: Presentations by Paul Rider, Lucy Jones and Vera Chursina

Portfolio of design work for 'Bright Flowers' exhibition displaying textiles and ceramics of Central Asia (Power House Museum, Sydney); concept sketch, finished artwork, photo of garment and brochure for exhibition

5. Portfolio Layout Format

As you take on more design projects and build up your design work, consider this portfolio layout format:
- Introduction page.
- Theme one - consisting of:
- Mood/Theme/Concept Page.
- Fabric and color page.
- Rendered fashion designs on the fashion figure.
- Flats of the designs (unless already included on your design page).
- Approximately four more themes should follow, ending with a stunning piece of artwork as your **grand finale**.

Start planning and compiling your portfolio now. With the artwork you have completed in *Fashion Artist*, you have your drawing exercises (figures, rendered fabrics), fashion design presentations and life drawing exercises. You might also have some other work or photographs to include. Collate your best work and follow the presentation techniques in the *Fashion Presentations* chapter; prepare all your visuals for your portfolio. Later, as you work through various design briefs, you will have additional artwork to present and display your skills more comprehensively.

6. Design Journal/Croquis Sketch Book

A fashion design journal/croquis sketch book, which documents your thinking process and demonstrates your creativity and basic drawing skills, makes an excellent addition to your portfolio.

7. Portfolio Backup

Always keep a backup of the work in your portfolio, particularly your best pieces. This is a useful and professional approach:

- You might need to send your portfolio to several places at the same time. As discussed previously, you will also have digital versions to email or direct people to on the Internet.
- In case of loss or damage always keep several back ups.

Make a backup copy by:
- Photographing (digital), printing
- Scan your work and save on file and on separate hard drives and to the 'cloud'.
- Have your own website, host website, You Tube, etc. and upload your portfolio (select a few key pieces to create an interest).

Note: *It is important to start and end your portfolio with eye-catching work so that people* **remember** *you.*

8. Promote Your Portfolio

Finally, with a great portfolio, you want to promote it. There are many ways to do this:
- Physically by contacting people and companies directly (networking).
- Digitally by using some of the countless digital formats such as: Twitter, Facebook, Linked In (the Facebook for working professionals), YouTube, Blogs, etc.

Figure 14.9: Printed Tote by Sarah Beetson

There is no ordinary, mundane business card for Sarah, and there is no forgetting her!!! She has printed tote bags with her own image amongst her favourite celebs (see bottom of bag).

Figure 14.10: Portfolio Presentation - Sarah Beetson

Fashion design presentation for Satya James displaying not only the black cotton drill jacket front and back view, but also a mood and theme for the label and collection

Figure 14.11: Portfolio Presentation - Sarah Beetson

'Rock and Roll Band' fashion presentation displaying an extremely powerful, strong theme with not only the garments but the mood and experience for the whole collection and fashion label

Above: *One of the three types of mannequins - the dress form/ mannequin* - Mary Katrantzou Ready-To-Wear Collection, London Fashion Week.

Form: A shape, visible or tangible, for example, the **'human form'** is the shape of the body, the **'form of a fabric'** is the effect from light as it falls on the fabric, the way the fabric falls into folds and drapes.

Haute couture: French for *'high sewing'*. Haute couture is the most prestigious level of fashion. To qualify as an official 'haute couture' house, the designer/company must be a member of the *Chambre Syndicale De La Haute Couture*, a Paris-based body of designers governed by the *French Department of Industry*. 'Couture' means sewing or needlework; Haute couture is a high quality, expertly constructed garment, with no expense spared.

Layout: The arrangement of an artwork; a **'landscape layout'** is a format where the width of the illustration or artwork is greater than the height; a **'portrait layout'** is the opposite. For example, landscape is frequently used for men's flats for a shirt or pant collection, for children's presentations as the figures are generally shorter, or when there are more than several fashion figures to present; there are no strict rules.

Light box: A table or portable box with a semi-transparent surface containing a powerful light underneath; used to aide transparency when tracing over drawings.

Line: Use of line in artwork, **'boldness of line'**, a contour or outline of a design**, the 'clean lines of an illustration'.**

Line sheets/range sheets: A catalogue of all the styles available in a product range used to market the collection to the retail buyers - includes flats/working drawings of the range, the fabrics and colors available, prices, and often photographs of the products.

Look book: Hard copy or digital, showcasing a fashion designer's or fashion brand's collection in photographic form.

Mannequin: An artist's wooden figure with movable joints, useful for displaying body positions, proportions and perspective; commonly in miniature, but available in various sizes. Also: A dress form with style lines that correspond to the fit and construction lines from which clothing patterns and garments are made. A window dummy (figure) used to display clothing.

Media/ Medium (Drawing, Coloring)**:** The material or form used to create an illustration or artwork, for example, markers, pastels, pencils, wax crayons.

Mixed media: Various art materials used in conjunction with one another to form an artwork, for example, markers used with coloring pencils and gouache.

Mood (Board, theme)**:** The feeling brought about by tangible and intangible objects, images and circumstances. For example, antique cream lace, pale blues and pale pinks, or soft downy white feathers can all bring about a feeling (mood) of softness and gentle romance.

Muse: The source of an artist's/designer's inspiration - this could be a style icon, celebrity, poet, etc.

Muslin: See sample and toile.

Nine heads template: The fashion figure template subdivided into nine head depths as a guide for sketching the fashion figure.

Pattern cutting/drafting/making: The technique of creating a flat pattern from measurements and the use of blocks/slopers.

Pinking shears: Scissors that cut with a zigzag pattern to prevent the edges of fabric from fraying.

Portfolio of skills (fashion design): The fashion designer's portfolio of skills is an inclusive term used to describe the sum of the knowledge of the industry; the skills, creativity, tools and techniques within the fashion profession.

PowerPoint: Software used to create a digital presentation (for slide show/video/web/email attachments).

Preproduction: The processes necessary to produce the products/garments before production.

Presentation (Boards, digital, portfolio, fashion presentation, design presentation): The professional method used to visually display a design concept in a creative, dynamic format, enhancing individual pieces of artwork or products. The concept could be for a fashion range, a fashion mood or theme, fashion colors, fashion fabrics or fashion promotion. Individually, sketches can look flat and uninteresting, but if all the right ingredients are grouped together in a well planned layout, the theme will be strong and commercially successful. Designers and illustrators use numerous presentation techniques to enhance their artwork.

Primary data: Data obtained directly (firsthand) through questionnaires, interviews and focus groups.

Private label: Merchandise manufactured by a company to the specifications of a particular retailer and includes the store's own trademark or brand name, e.g. Barneys, Saks, Harvey Nichols.

Production: The construction process by which products or garments are made. In the fashion industry, this is the manufacture of products based on the sales forecast or after the sales of a collection have been collated.

Production sample (Sealing/sealed sample)**:** The approved sample that serves as the approved standard to which the product must be made.

Products: Goods or services the brand/designer intends to manufacture and sell.

Range: (See collection).

Render (Rendering, fabric representation, fabric illustration)**:** An illustration of a fabric using line and color to give an overall impression of fabric type, texture, print and color; this might be in flat swatch form or on the clothed fashion figure drawing.

Resource folders (Cutting files, clipping files, swipe files, picture files and personality files, fabric folders, design folders)**:** Internationally recognised names for folders (physical and digital) collating all visual references, clipped from all sources, catalogues, booklets, etc. and collated for design inspiration. These visuals, used in conjunction with sketch books, are sources of inspiration for design development through to presentation, and collections.

Roughs: These are quick drawings capturing ideas and concepts in a sketch book, and often drawn using a pencil, fine liner or marker.

Runway (Catwalk)**:** A narrow stage used for fashion shows to display the latest fashion creations on fashion models.

Sample garment (Calico, muslin, prototype, toile)**:** A trial/test garment, which has been interpreted from a designer's concept or sketch, initially made from an inferior/less expensive fabric such as calico.

Sketch book (Fashion journal, fashion diary, work book and croquis sketch book)**:** Drawing pad used to sketch innovative and creative ideas, color and fabric sensitivity. Sketch books are a visual reference data base and a valuable source of information for design projects; popular as digital sketchbook (iPad, tablet, etc.).

Specification sheet (Technical, Production drawings/specs)**:** A working drawing or flat, drawn in a technical format (not stylised), drawn to scale, documenting measurements and details pertaining to the garment and required for production and manufacturing purposes. For example, measurements and details might include the length from the centre back neck to the hem, item number, size and color of buttons.

Street fashion: What the public are wearing and the way they put it together.

Style lines: The fit, shape and seam lines and details that make up a garment and give it its shape and form.

Stylised: A drawing that has a certain look about it that identifies it with the artist's way of working or the artist's signature.

Swatch: (See fabric swatch).

Swipe files (US): (See resource folders).

Technical drawings: See specification sheet and working drawings.

Template (Fashion template, nine heads template)**:** Used as a guide when drawing fashion figures and clothing.

Toile (Calico or a muslin)**:** *Toile* – French word for a sample garment made up in a less expensive cloth (calico) used in the design and construction process.

Tone: The value, shadows and highlights; the measure of light and dark; lightness or darkness of a color

Torso: The upper and lower torso; the trunk of the human body.

Vertical balance line (V/B)**:** An imaginary line to ensure that a figure drawing is well balanced, for example, prevents the figure from looking off balance/falling over. The V/B line drops vertically from the pit of the neck to the ground; it never bends - just like a builder's plumb line.

Virtual runway/catwalk show: Digital fashion show using computer software to create digitally generated models, the clothing, the runway and special effects.

Working drawings: See Flats

Zeitgeist: The 'spirit' of the times.

Fashion Resources
The Digital and Physical World

'The Cyber Information Runway to Success': As a designer or illustrator, you can travel on the web's global information highway to search for information and advice to help you develop your designs, illustrations, presentations and portfolio. This includes researching and sourcing the fashion and textiles industry, the latest trends, historical references, fashion and textile shows, fashion and art museums and exhibitions, trend forecasting agencies and publications, illustrators, fashion designers, stylists, etc. The Internet is your international fashion directory, a Google A to Z. Social media, including bloggers, has become an essential part of the industry and a voice for a new generation of style aficionados, providing commentary at the click of a mouse.

Listed here are examples of a few essential sites and the type of information available. For more information (see the other publications in this *Fashion Design Series*), *Internet Resources* and *Further Reading* sections, www.fashionbooks.info, and Facebook page.

Industry/Trade Shows and Sourcing, Trends, Collections, Forecasting

www.apparelnews.net: Trade shows and more.

www.apparelsearch.com: Fashion industry news search for services, events, shopping globally, great source of information.

www.biztradeshows.com/apparel-fashion: Search for global clothing industry trade fairs, fashion & textile exhibitions, apparel trade shows, garment technology.

www.britishfashioncouncil.com: The British Fashion Council organises LFW and is an excellent interface between the fashion industry and fashion education. Many countries have their own fashion council.

www.cottoninc.com: Agricultural, fiber and textile research, market information and technical services, fashion forecasts and retail promotions, and global sourcing of fabrics.

www.fashion.net: Great research site, links to other sites, fashion magazines and general industry news.

www.fashioncapital.co.uk: Resources for designers, manufacturers; fashion news and trends, forums and jobs.

www.fashioncenter.com: Based in New York's Garment District - provides lists of factories, fabrics and services.

www.fashiontrendsetter.com: Online fashion forecasting, trend reporting and news e-zine.

www.fashionwindows.com: Listing fashion trends, runway shows and a calendar of events.

www.hintmag.com: Hint magazine - great articles, trends, fashion, people, collections.

www.londonfashionweek.co.uk: Great catwalk shows.

www.photographiclibraries.com: Advertising campaigns, editorial shoots and fashion shows - links to fashion, art and related sites.

www.polyvore.com: Links to fashion websites - start or create new trends, create mood and style boards/concepts, discover the hottest brands, products, trends and looks.

www.premierevision.com: Première Vision, together with Expofil, Indigo, LeCuirAParis, ModAmont, Zoom, the key fabric trade fair held in Paris, New York, Shanghai, etc.

www.promostyl.com: International trend research design agency, books and products available online.

www.showstudio.com: Fashion broadcasting initiative that invites leading creatives from the fields of art, fashion and design to collaborate on new work and transmit live events.

www.style.com: Linked with Vogue and W; video and slide coverage of the latest designer fashion shows; celebrity style, trend reports and breaking fashion news.

www.stylesight.com: Trend forecasting.

www.trendland.net: Online magazine - art, culture, design, fashion, photography and consulting.

www.weconnectfashion.com: Connecting fashion brands, retailers, and service providers, trend reports, events news.

www.wgsn.com: Worth Global Style Network, latest news and reviews of the developing fashions and trends globally.

www.woolmark.com: Learn all about the wool market, the trends and innovations.

www.wwd.com: Womens Wear Daily, American fashion retailers' daily newspaper - headlines, links to other sites.

Publications - Online, Printed

Fashion online and printed include commercial publications, for example, Elle, Harpers Bazaar, Vogue (UK, US, French, Spanish, etc), and more trade specific:

www. drapersonline.com

www.nytimes.com/pages/fashion: New York Times fashion.

www.view-publications.com

www.papermag.com

Fashion, Costume, Museums, Art Galleries

www.fashion-era.com: Research period fashion.

www.nga.gov: National Gallery of Art see the collections online and take virtual tours; excellent visual archive for researching projects and period costume.

www.vam.ac.uk: V&A museum, London - events and exhibitions, education, historical research and more.

www.vintagefashionguild.org: Excellent information/ research on vintage - Vintage Fashion Guild (VFG), international collective with members in the USA, UK, Can and Aus.

Art Galleries and Museums

British Museum, London

Centre Pompidou, Paris

Centro Cultural Banco do Brasil, Rio de Janeiro

Galleria degli Uffizi, Florence

Metropolitan Museum of Art, New York

Musee d'Orsay, Paris

Musée du Louvre, Paris

Museo del Prado, Madrid

Museo Reina Sofía, Madrid

Museum of Modern Art, New York

National Folk Museum of Korea, Seoul

National Gallery of Art, Washington

National Gallery, London

National Museum of Korea, Seoul

National Palace Museum, Taipei

Shanghai Museum, Shanghai

Tate Modern, London

Victoria & Albert Museum, London

Fashion Museums

Balenciaga Museum, Getaria, Spain

Bata Shoe Museum, Toronto, Canada

Black Fashion Museum Collection, The Smithsonian, Washington, DC

Christian Dior Museum and Garden, Granville, France

Fashion and Textile Museum, London, England

Ferragamo Musem, Florence, Italy

Gucci Museum, Florence, Italy

Kyoto Costume Institute, Japan

Metropolitan Museum of Art's Costume Institute, Manhattan

Musée Galliera, Paris, France

Museum at the Fashion Institute of Technology, Manhattan

Palazzo Fortuny, Venice, Italy

Simone Handbag Museum, Seoul, South Korea

Social Networking, Blogs

As well as Facebook, YouTube, Twitter, LinkedIn, etc., as part of your learning and interaction, check out some of the following from designers, journalists, photographers, and those that keep constantly aware of the latest fashion news:

www.ashadedviewonfashion.com: Diane Pernet, American-born journalist and editor, based in Paris, front row at fashion shows, blogs all about young talent.

www.facehunter.blogspot.com: Travelling the globe on the lookout for new subjects on the streets from Reykjavík to Vienna, Yvan Rodic focuses on personal style.

www.thesartorialist.com: New Yorker, Scott Schuman's blog has become a phenomenon, travelling the globe shooting simple portraits of well-dressed individuals including fashion insiders.

www.pinterest.com: Social networking content sharing service where members 'pin' images, videos and other objects to their pinboard.

Others include www.: advancedstyle.blogspot.com, bryanboy. com, catwalkqueen.tv, fredbutlerstyle.blogspot.co.uk, hypebeast.com, jakandjil.com, kingdomofstyle.typepad.co.uk, manrepeller.com, nymag.com/daily/fashion, parkandcube.com, patternity.co.uk, redcarpet-fashionawards.com, streetpeeper. com, stylebubble.typepad.com, themoment.blogs.nytimes. com.

New Sites: The Internet is constantly developing so *key word* search for new sites.

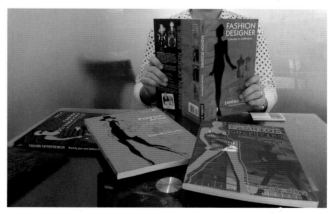

For more information (see this *Fashion Design Series*) and the Internet Resources and Further Reading:

See Website and Facebook - fashionbooks.info

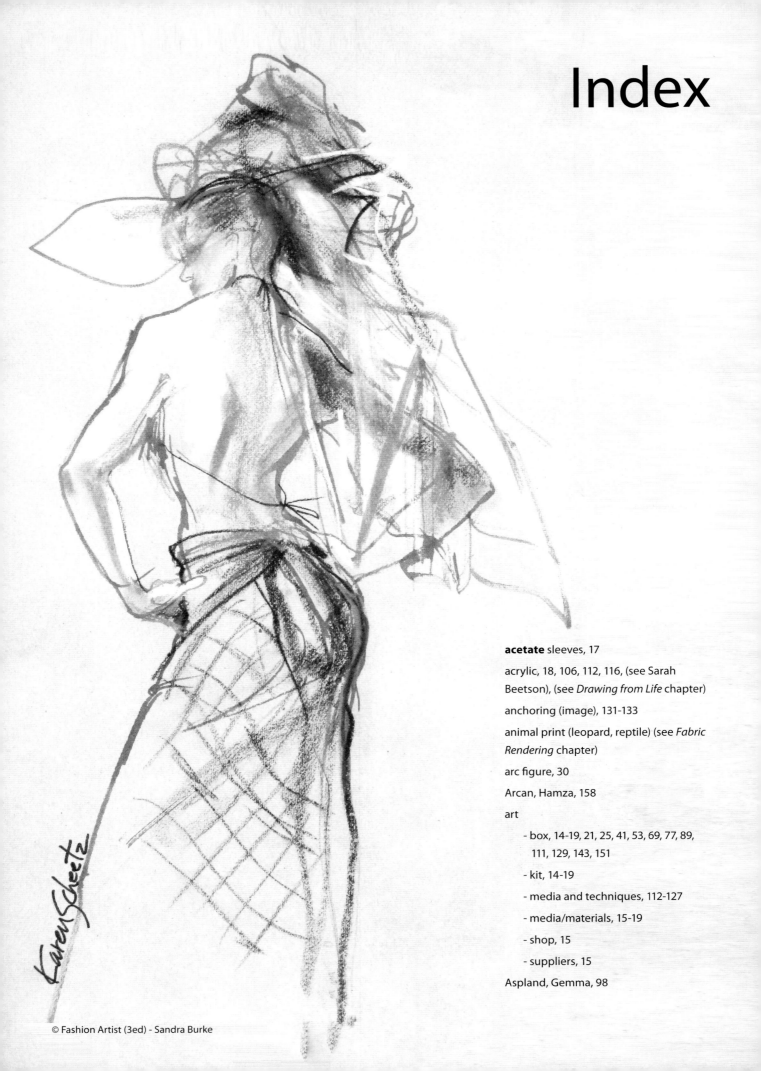

Index

Burke Publishing Book Series

Bluewater Cruising Series by Rory and Sandra Burke
Managing Your Bluewater Cruise, ISBN: 978-0-473-03822-9
Greenwich to the Dateline, ISBN: 978-0-620-16557-0
Bluewater Checklist, ISBN: 978-0-9582391-0-3

This *Bluewater Trilogy* includes a preparation guide, a travelogue and a checklist.

Project Management Series by Rory Burke
Fundamentals of Project Management, ISBN: 978-0-9582733-6-7
Project Management Techniques, 2ed, ISBN: 978-0-9876683-0-1
Project Leadership and Entrepreneurship, ISBN: 978-0-9876683-2-5
Advanced Project Management, ISBN: 978-0-9582733-7-4

These books include: An introduction to the field of Project Management, the planning and control techniques needed to manage projects successfully, and the essential leadership skills to manage the human side of managing projects.

Entrepreneur Series by Rory Burke
Entrepreneurs Toolkit, ISBN: 978-0-9582391-4-1
Small Business Entrepreneur ISBN: 978-0-9582391-6-5

These books outline the essential entrepreneurial skills to; spot a marketable opportunity, develop a business plan, start a new venture and make-it-happen, and manage a small business on a day-to-day basis.

Fashion Design Series by Sandra Burke

Book 1 - Fashion Designer – *Concept to Collection*
ISBN: 978-0-9582391-2-7

Book 2 - Fashion Artist - *Drawing Techniques to Portfolio Presentation,* 3ed
ISBN: 978-0-9582733-8-1

Book 3 - Fashion Computing – *Design Techniques and CAD*
ISBN: 978-0-9582391-3-4

Book 4 - Fashion Entrepreneur - *Starting Your Own Fashion Business,* 2ed
ISBN: 978-0-9876683-1-8

This *Fashion Design Series* will guide you through the *Fashion Design Process* introducing you to the essential design techniques and skills required to achieve a successful career in the fashion industry. Presented in easy steps, the books are packed with fashion illustrations, designs and photographs, from international designers and illustrators, to visually explain the accepted fashion industry theory and practice. These books are structured in line with fashion courses globally and designed as self-learning programs proving invaluable textbooks for fashion students and aspiring designers.

Sandra Burke, M.Des RCA (Master of Design, Royal College of Art), is an entrepreneur, fashion designer, author, publisher, and visiting lecturer to universities internationally.

websites fashionbooks.info knowledgezone.net burkepublishing.com